VISUAL ARTS RESEARCH

VISUAL ARTS RESEARCH
A Handbook

ELIZABETH B. POLLARD

Greenwood Press
New York • Westport, Connecticut • London

Library of Congress Cataloging-in-Publication Data

Pollard, Elizabeth B., 1939-
 Visual arts research.

 Bibliography: p.
 Includes index.
 1. Art—Research—Handbooks, manuals, etc. I. Title.
N85.P55 1986 707.2 86–375
ISBN 0–313–24186–4 (lib. bdg. : alk. paper)

Library of Congress Catalog Card Number: 86–375
ISBN: 0–313–24186–4

First published in 1986

Greenwood Press, Inc.
88 Post Road West, Westport, Connecticut 06881

Printed in the United States of America

∞™

The paper used in this book complies with the
Permanent Paper Standard issued by the National
Information Standards Organization (Z39.48–1984).

10 9 8 7 6 5 4 3 2 1

IN MEMORIAM

=====================

JEFFREY JOSHUA BAYER, 1942–1984

Dedicated scholar and teacher, gifted
artist,
and treasured friend

=====================

Contents

Figures

Acknowledgments

The research and compilation of any book requires the help of many people, and this one is no exception. The opportunity for its author to pursue this effort must be credited to the understanding of John W. Warren, Director of Libraries at the University of Alabama in Huntsville. The acquisition of equipment which made the writing easier was made possible by Lee F. Blitch, who helped the author attain a Kaypro II computer and Brother HR–15 printer and assisted with instruction in the use of this equipment and with problems and advice along the way. Not the least of assistance to the author was rendered by her husband, W. Grosvenor Pollard III, and her daughter, Beth, in the form of patience and household assistance.

Several publishers who graciously granted permission to quote from works to which they hold the copyright are credited throughout the text, but it seems fitting to list them here as well. Many thanks for their prompt response and cooperation. They are: H. W. Wilson, for permission to quote from *Art Index*; the staff of *RILA Abstracts* for permission to use material from that monumental source; R. R. Bowker for permission to quote from *Who's Who in American Art* and for the use of material from *Mallett's Index of Artists*; Worldwide Books for material from the *Worldwide Art Catalogue Bulletin*; Scarecrow Press for permission to use material from the *Index to Artistic Biography* by Patricia Pate Havlice; and Richard S. Hislop, editor of *Art Sales Index* for permission to quote from that useful reference.

The author owes a great deal of gratitude to the dozens of art students who, in her fifteen years as a fine arts librarian, have called to her attention their need for information and been patient and diligent in their search for it. Last but not least by any means, thanks is due Mary Robinson Sive, the editor at Greenwood Press who made this whole work possible by broaching the idea to the author and nursing her through it.

Preface

This book offers guidance in research methods and resources for art students and other scholars. An overview of the research process, from the choice of a topic through presentation of the results, is presented in chapter 1, and suggestions are made for overcoming common problems in this process. This introductory review is followed in chapter 2 by a discussion of the usual organization of art research materials in libraries, and the arrangement and use of the most commonly encountered types of reference tools. In addition, consideration is given in chapter 3 to the use of computerized databases and their value in the fine arts area.

The main portion of the book then follows up the most common information needs of college and university art students, with a review of the reference tools that are most likely to supply those needs. Chapter 4 covers sources for biographical data in all media. Art history is covered in chapter 5, and the work of art itself, including criticism, connoisseurship, and iconography in chapter 6. Techniques and materials for the various media are covered in chapter 7 and art education in chapter 8. Chapter 9 provides a list of 111 art periodicals, annotated to indicate their coverage and special features.

Reference tools cited in the various chapters which are of use to more than one area are described in full in the book's bibliography. Lists of references at the end of chapters offer more than fifty other sources for specialized information relating to the subject matter covered in that chapter. In the bibliography, the more than 450 items are grouped by

type of reference tool, and within each type they are arranged alphabetically by the author's last name. References made in a chapter to an item in the bibliography use the letter for the section in which the item appears, followed by the number of the item within the section. For example, the tenth title in section D is cited as (D.10.).

With this book in hand, the student can consult the table of contents and/or index under the category of information needed and, following the references provided, quickly locate the section that reviews the resources for that information, and then follow the bibliography references to the complete bibliographical data about the sources. In addition, for assistance in using the more complicated reference tools, there are basic instructions and examples in the general discussion. In this manner, the student is guided, from beginning to end, to methods and sources that are most likely to produce a solution to the problem at hand.

No claim is made to absolute comprehensiveness in the sources listed here, although an effort is made throughout to furnish listings and instructions for a majority of the reference tools available in most college and university libraries, and in larger public libraries, throughout the country. The emphasis is on sources in English, as these are the most accessible to English-speaking researchers at all levels, but where no adequate source in English exists, and satisfactory foreign language tools do, reference is made to those sources in the major Western European languages that will provide the information needed.

While other handbooks and guides to art research are available, this one is unique, as the focus is on the information need and the sources most likely to fulfill it. This work updates and supplements comprehensive and specialized bibliographies such as the monumental *Guide to the Literature of Art History* (A.6.) compiled by Arntzen and Rainwater in 1981, and Ehresmann's *Fine Arts: A Bibliographic Guide to Basic Reference Works, Histories, and Handbooks* (A.49.). The former offers a comprehensive catalogue of sources for the specialized area of art history, while the latter provides an annotated listing of reference sources throughout the arts. Neither, however, offers much guidance in the use of sources listed.

Such guidance is provided to some extent by Muehsam in her *Guide to Basic Information Sources in the Visual Arts* (A.84.), and by Jones in her *Art Research Methods and Resources* (A.67.), but the Muehsam work was originally published in 1978 and is inevitably somewhat outdated now. In addition, Muehsam excludes the decorative arts and art education, both of which are included here. Although Jones covers both of these areas and offers a thorough introduction to art research methods, precise instructions for the use of more complex tools, some of which baffle even the most sophisticated researcher at first glance, are still needed.

It should be pointed out that while the literature of the various media

is accessible through the indexes of other books, concentrated and clear guidance to information resources in some media, notably architecture and sculpture, is usually either buried among descriptions of general sources or totally absent. While general guidance on art research methods is provided in the present volume, an attempt is also made to provide sections that zero in on the information needs of each medium. In some cases, this requires repetition of some sources, and/or reference back to more general tools completely examined and explained earlier.

Also of note and unique to this volume is the comprehensive introduction to databases and computerized information retrieval provided in chapter 3, although Jones touched upon this area in the second edition of her book, published in 1984. However, some of the databases covered here were not then available, and her work covered only those databases specific to the visual arts. Although there are few databases directly related to the arts as yet, scholars in art history or closely related areas, such as the sociology, psychology, or teaching of art, often have interdisciplinary information needs for which ample online access is provided by most modern libraries. Researchers in the humanities have been slower to seek out such resources than those in the sciences and social sciences, but with library budgets constantly shrinking in relation to the skyrocketing cost of library materials, the availability of online access to information, and the knowledge of how to approach the use of such facilities, becomes increasingly important for effective and thorough research.

VISUAL ARTS RESEARCH

1

Introduction: Research Strategy

In this first chapter, some suggestions are offered for choosing a "good" research topic and shaping it into a satisfactory report or paper. In this regard, the first consideration lies in defining a good research topic. In order to be manageable, a research topic must be specific enough to allow for thorough coverage, yet broad enough for the student to find sufficient material. It should be interesting to the researcher if it is to be interesting to the reader when it is completed. It should have a specific point to make, a theory to prove, or a new and original viewpoint to offer. The process of putting together a topic with all these characteristics will be the first consideration of this chapter.

The next step in research is planning a strategy for gathering material and investigating the subject. This requires forethought and preliminary sleuthing in tools like the library catalogue, and reference works like encyclopedias, bibliographies, periodical indexes, and abstracting services. It also necessitates guidelines within which to work effectively, such as a preliminary outline of the final project. When these steps are completed, the researcher must collect retrospective and current material from the literature to document the study, and this is done by compiling a working bibliography. All of these steps are considered in detail in this chapter.

CHOOSING AND DELIMITING A RESEARCH TOPIC

The first task in research, and the most difficult for some people, is choosing a topic. In the typical college or university class, subjects to be

researched for term papers are often assigned by the instructor. In some cases, however, the choice of a subject, within the confines of the course, is left to the student. When faced with an assigned research project, a student's mind is often cluttered with too many possibilities, or overwhelmed with the magnitude of the assignment, and absolutely nothing acceptable comes to mind.

In the latter case, it is often helpful to review the course text for topics that lend themselves to investigation. If this fails to inspire, the student might browse through current issues of several journals in the field and observe what kind of topics other researchers have found challenging. Discussions with the instructor or with other students in the class may also spotlight a general area of the field of study that fascinates the student, and this in turn may suggest an appropriate topic.

When inspiration does strike, there are several things to be weighed in deciding just which aspect of the topic to investigate. A research topic, to be manageable within the amount of time available for study, and within the prescribed word or page length assigned, must be carefully shaped and refined. If the topic is too specialized, there may not be enough material for thorough investigation. If it is not specialized enough, there may be far too much material to cover. In addition, it is not enough to simply set out to write about a particular artist or medium. The topic must have some goal or direction in order to result in a paper that is clear, logical, interesting to read, and, more important, has some contribution to make to what has already been written on the subject.

Very often, one has a broad subject in mind for the probable area of study. Such a broad subject might be Italian sculpture, or French architecture. If the topic is to be dealt with at all comprehensively, however, it soon becomes obvious that the material on such broad subjects as these is too voluminous for anything less than a full-length book. If a term paper for an art history course is the end goal, the topic will have to be narrowed. Occasionally one starts with a very specific idea for research, only to find very little information is available. In that case, it is necessary to broaden the topic a little in order to find enough material for a paper of the required length.

When the problem is to narrow a topic to a manageable size, one way to begin is by reading a survey article in an encyclopedia or similar source to get a mental picture of the total scope. Such articles are often broken down into smaller sections at logical intervals, and this may provide some concept of the natural divisions of the subject. Often there is also a bibliography of selected sources for further study at the end of an encyclopedia article, and this is a good place to begin identifying material for the working bibliography. Another source that may help in getting both an overview and an idea of the subdivisions of a subject is the catalog in the library. By checking there under the subject that covers

the broad topic, one can find topical subdivisions of the broad subject that will be simpler to cover and fit more neatly into the prescribed size of the term paper or project to be written.

For example, in the case of "Sculpture, Italian," the subject under which the first topic mentioned is listed in most library catalogs, one will find subdivisions under periods of importance, such as the Renaissance or the Baroque, as well as under regions or countries. In the titles of books listed under some of these subjects, there may appear a name of a sculptor, or a style or movement, which catches the eye and suggests yet another direction in which the research might be aimed. Further investigation under the name of an individual, or under the name of the school or movement of which the artist is a part, will provide an idea of how much is available on smaller aspects of the chosen subject.

A similar approach may be employed for the same purpose in those periodical indexes and abstracts relevant to the subject. By looking under the general subject heading in one of these sources, one can also discover subdivisions of the topic in question that will help in delimiting the scope of the research. In addition, the material located under these headings in two or three volumes of a periodical index offers some indication of the amount of specialized and current information available for the study contemplated. Again, this also offers a source for citations to be used in the working bibliography as the research progresses.

Something in the nature of a reverse strategy may be necessary in the case of a topic that appears to be too narrow to provide enough material for study. When a preliminary check of the library catalog and periodical indexes renders only a handful of citations, it may be wise to broaden the search. For example, if the original subject checked was an individual artist, perhaps one on whom very little has been written, the school to which the artist belonged may offer more material on a topic related to and including the one of immediate interest. If this also proves too narrow, the native country and time period to which the artist and school belong are the next natural levels to investigate to broaden the search. In this manner, the student begins to shape the topic and, provided notes are kept on titles and authors that may prove productive later, also begins to gather material during this initial checking process.

PRELIMINARY OUTLINE AND WORKING BIBLIOGRAPHY

Just as a builder constructs a scaffold upon which to stand to erect a building, good research requires a framework to build upon. Once the topic has been sufficiently defined to be manageable in both scope and physical size, the strategy for gathering material must be charted. The best way to begin this process is to construct a preliminary outline on which the details of the subject can be filled in later as the research

progresses. This need not be elaborate; a simple list of the aspects of the subject to be covered will suffice. The list should be arranged in a logical order, so that as material for use in each section is located, the detail will fit clearly into place, thus making the final report or paper easier to assemble.

The preliminary outline, carefully constructed, also helps a researcher identify categories of material to be sought. (See figure 1 for a table of these categories and means of accessing them). In most cases, the beginning of the research will be concerned with retrospective facts to provide a background for the development and conclusion to follow. This kind of data is usually found in comprehensive treatises, also called monographs, or books. The development of the topic commonly requires investigating a number of facets, some particularly narrow, some broader and more important in scope and influence. The smaller segments of the subject matter, as well as the more current literature, are usually best covered in shorter works, such as articles published in journals.

If the subject matter lends itself to quantifying, other types of material will have to be consulted, such as statistical sources. As the student examines the preliminary outline, it should become obvious which types of material are likely to be necessary to cover the various facets of the research, and with this knowledge the student can begin to seek out specific sources and construct a working bibliography of materials, with notes on which ones will need to be read in entirety, consulted for individual facts or statistical tables, or scanned for relevant details.

A bibliography is simply a list of sources, written works that were consulted for information during the preparation of a research project. A working bibliography is more comprehensive than the one finally appended to the end of the written report. It is usually compiled before the material is actually read, and it consists of nearly everything the researcher can find that seems likely to contribute to the research. If notes are made on each work as more data is discovered about it, the bibliographical entries will be easier to formulate later. In addition, when the material has all been read, examined carefully for specific contributions to the research at hand, and thorough notes have been made on its contents, the final bibliography will be composed of selected items from the working bibliography.

It is frequently the case that there are other sources not directly available through the library catalog and reference sources. These may be titles appearing in the books and articles read in the course of constructing the working bibliography. Just as encyclopedias often contain good source lists at the ends of articles, the books and articles found through bibliographies, indexes, and library catalogs often contain references to other excellent sources for further study. For this reason, it

Figure 1
Information Sources and Means of Access

TYPE OF DATA	PRINTED SOURCES	ACCESS THROUGH
A. Brief Data Identification Definitions Terminology Lists of Sources	A. Reference Tools Dictionaries Encycopledias Directories Bibliographies	A. Library Cata- logs Bibliographies
B. Retrospective History & Bio- graphy Criticism Theory Survey Material	B. Books (Monographs)	B. Bibliographies Library Cata- logs
C. Specialized Current & Up to Date Small Subject Divisions Obscure Data	C. Periodicals Journals Newspapers Annuals Yearbooks Magazines	C. Current Biblio- graphies Indexes Abstracting Ser- vices

is wise to examine the bibliographic citations in all materials used for
further material. It is somewhat like a good detective following the trail
of clues to reach the solution of a case. No stone should be left unturned
in the course of the research, any more than it should in solving a
mystery.

BIBLIOGRAPHICAL STYLE

In compiling a working bibliography, it is wise to establish at the outset the bibliographical style to be followed during the entire research project. There are many good manuals that one may consult for advice on the forms for such details as footnotes and bibliography. A selection of these style manuals is listed at the end of this chapter. Many of these tools also provide helpful information on reference sources and the use of libraries, as well as on grammar, punctuation, and other elements of scholarly prose. At this point in the research the student should pick one of these manuals and be consistent in its use throughout the project.

Some instructors have specific preferences in style manuals, as do some college departments. Therefore, it is a good idea, if this is the context for the research, to check first with these sources. If they offer no preference, one can consult journals in the field for the standards accepted by scholarly publishers in the subject. Once the choice is made, the style manual should be consulted immediately for the elements to be included in bibliographical citations, and these should be used in compiling a working bibliography. This saves much time when the final bibliography is compiled.

Style manuals vary in the forms recommended for footnotes and bibliography, but the basic elements of citations will be the same. For books one will need: the author; editor or translator if any; the full title; the edition if other than the first; series and volume number if there is one; and facts of publication such as place, publisher, and date. If the book has several volumes, or if only a portion such as a chapter is used, one should also specify which part or parts were actually consulted.

For articles from periodicals, the necessary elements include: the author and title of the article; the title of the periodical; the volume and issue numbers; date; and inclusive page numbers on which the article appeared. In the case of articles from reference works, such as encyclopedias, the title or heading of the article should be included, with the author's name if the article is signed, the title and edition of the reference work, and the facts of publication for it. In addition, the volume and page where the item appears should be specified. There are many more complex forms for various types of sources, and the style manual used should be checked for examples of the exact form for each.

SELECTED STYLE MANUALS

American Psychological Association. *Publication Manual*. 3rd ed. Washington, D.C.: American Psychological Association, 1983. Especially suited for the social sciences and related art research, such as the psychology or sociology of art; the standard for most journals in social science fields.

Barclay, William R., ed. *Manual for Authors and Editors: Editorial Style and Manuscript Preparation*. Los Altos, Calif.: Lange, 1981.

Goldman, Bernard. *Reading and Writing in the Arts: A Handbook* (A.56). Revised ed. Detroit: Wayne State University Press, 1978. A handbook intended for art students and accepted by most colleges.

Jones, Lois Swan. *Art Research Methods and Resources: A Guide to Finding Art Information* (A.67.). Dubuque, Iowa: Kendall/Hunt, 1978. Excellent guidance in research methodology, as well as in bibliographical style matters, for art researchers.

Longyear, Marie. *McGraw-Hill Style Manual: Concise Guide for Writers and Editors*. New York: McGraw-Hill, 1982.

Modern Language Association of America. *MLA Style Sheet*. 2d ed. New York: Modern Language Association of America, 1970. The standard for most language and literature studies, and accepted by many other areas of the humanities.

Muehsam, Gerd. *Guide to Basic Information Sources in the Visual Arts*(A.84.). Information Resources Series. Santa Barbara, Calif.: ABC-Clio, 1978. Includes comprehensive bibliographies and guidance in research methodology, as well as style matters.

Turabian, Kate L. *Manual for Writers of Term Papers, Theses, and Dissertations*. 4th ed. Chicago: University of Chicago Press, 1973. A standard, and traditional, manual for style in all areas of the humanities and some in the social sciences as well; most frequently preferred in college and university art courses.

University of Chicago Press. *Manual of Style*. 13th ed. Chicago: University of Chicago Press, 1982. Generally acceptable in most subject areas, but particularly useful for explanations and comparisons among various subject fields.

Van Leunen, Mary-Claire. *Handbook for Scholars*. New York: Alfred A. Knopf, 1978. Especially helpful in explanations of forms and variants among subject areas; provides large numbers of good and bad examples.

Wiles, Roy M. *Scholarly Reporting in the Humanities*. 4th ed. Toronto: University of Toronto Press, 1968.

2

Searching the Library for Information

Since the first step in compiling a working bibliography is to locate retrospective information in books, the first tool to consult in the library is its catalog. The subject headings consulted should start with the most specific terms related to the topic and expand slowly to broader concepts that include the specific topic. This enables the student to locate those books that are most relevant to the research, as well as those that place the topic in its historical or stylistic context. The system of subject headings used in a given library catalog usually depends on the classification system used in that library. It is well to ask the reference librarian what classification the library uses and whether a master list of subject headings is available for public use. These two tools will help the student go directly to needed information. They take only a short period of examination to learn the basics, and will save much time and confusion later.

Classification Systems and Subject Headings

The most common classification systems used in college and university libraries are the Library of Congress classification and the Dewey Decimal system. The latter is used primarily in smaller libraries and is prob-

Figure 2
Library Call Numbers

Library Call Numbers

DEWEY LIBRARY OF CONGRESS

Subject – – – – – – 704 N – – – Subject (Art)
Subject (subdivision).073 352 – – – Subject(subdiv.)
Author – – – – – – .B5 .B5 – – – Author
Title – – – – – – – P7 P7 – – – Title
Date – – – – – – – – 1976 1976 – – – Date

ably familiar to most students from their school or public libraries. It employs a system of numbers to divide up the world of knowledge into ten major subject groupings, with the visual arts falling in the 700s. The Library of Congress classification, on the other hand, employs both letters and numbers to designate broad subject categories. The visual arts, in this system, classify in the Ns, with further subdivision by media, periods, countries, and individual artists in some cases (see the synopses of both in Appendix A).

Within the classes for the arts in both systems, numbers, sometimes subdivided by decimals, are used to specify the subject further, and second, or even third lines, of the call number indicate the author's name, the title or further subject specification. Examples of both types of call numbers are shown in figure 2, with indications of what the various parts of the number generally represent.

The ultimate purpose of a call number is to serve as a location device so that books on the same or similar subjects shelve together. It also provides a unique identification number for finding a particular title among all the similar books in the library. The call number in the Dewey system is read numerically, treating the numbers after the decimal point in a decimal fashion. The Library of Congress call number must be read alphabetically first, to locate the N section of the library, and then numerically. In both cases, each book will have its own unique number, so that once the end of the number is reached, the specific title wanted is found.

Figure 3
Example of Library of Congress Subject Headings

Painting, Abstract
 sa Abstract expressionism
 Abstract impressionism
 Constructivism (Art)
 Neoplasticism
 Shaped canvas
 Vorticism
 x Abstract painting
 Non-objective painting
 Painting, Non-Objective
 xx Painting, Modern--20th century
 --United States

Before one can find the call number for a particular book, however, it is necessary to know what subject heading to consult. Most terms that might be used for any given topic have synonyms which may be equally appropriate, and looking under all possible synonyms can be laborious and time-consuming. A list of subject headings, with cross-references, is available in most libraries, and this is a good place to determine how a subject will be listed. The system of subject headings used with the Library of Congress classification is most often the *Library of Congress Subject Heading List*,[1] and that used with the Dewey system is usually *Sears List of Subject Headings*.[2] The list for a particular library should be consulted for guidance in finding the best term to use in its catalog.

If the term consulted is not the official subject heading, such a list will provide a cross-reference to the correct term. For example, if one looks under "Abstract painting" in the Library of Congress list, instructions are given to "see Painting, Abstract." Upon consulting "Painting, Abstract," one will find a list of related terms which may suit the topic even more precisely, such as "Abstract expressionism" or "Vorticism." The precise relationships may be more easily seen by examining the actual listing from the Library of Congress list of subject headings as shown in figure 3.

Here the official subject term is given in bold-face type, and three lists of related terms are indented beneath it. The first group of related terms is preceded by a lower case "sa," meaning "see also," and these terms are also used as subject headings. They are more specific in meaning than the term under which they are listed, and may lead to more relevant material. The second list of terms is preceded by a small "x," meaning "seen from." These are synonymous terms that are not used as subject headings in the catalog. If they are consulted, a reference will be given to "see Painting, Abstract."

The third list of terms has a small "xx" before it, which means "seen also from." These terms are slightly broader in meaning, but are still related subject headings that will be used in the library's catalog. When consulted, they will yield books that include the subject under investigation, and will also lead back to the term originally consulted by the use of "see also" references. These are useful when no material can be found under a specific term, as they help determine the next logical, broader term that should be used to find related material. These same cross-references are used in the library catalog itself, but their relationships are easier to examine in the subject heading list.

When books that may be of use are located through the library catalog, it is important to copy all the bibliographical data given, as well as the entire call number. Once the working bibliography is completed, this information will be needed in order to examine all these sources and to include them in the final report or paper. Form subdivisions of the subject headings used may also lead one to reference works, such as encyclopedias, dictionaries, bibliographies, handbooks, and similar works. These will be useful to determine what material has been written on the topic under investigation, and whether or not all of it is available in the student's library or in other libraries in the area.

GENERAL REFERENCE SOURCES

There are many types of reference sources that lead to material on a topic. Some, such as encyclopedias and dictionaries, include basic information in the form of articles or definitions, as well as selected bibliographies for additional research. Typically, such tools are organized alphabetically by main subjects, frequently with an index to specific topics. A good example of this kind of tool in the visual arts is the *Encyclopedia of World Art* (C.10.). In this comprehensive encyclopedia, articles on broad topics are found in the main alphabet, with selected bibliographies of sources at the end of most articles. For more specific topics, however, one must consult the index in volume 15, and additional references to broad topics may be located in the index, since they may be discussed further in articles on related subjects.

Other tools, such as bibliographies and checklists, offer no information per se but lead the student to books, articles, theses and dissertations, and other sources for the information itself. These are more in the nature of guides or maps to lead the student through a large number of published sources, and they are usually either comprehensive or selective listings of published materials, with one or more alphabetical indexes. One good example of such a tool in the arts is the *Guide to the Literature of Art History* (A.6.) compiled by Arntzen and Rainwater.

Still other tools, such as handbooks or chronologies, include basic information, as well as bibliography in some cases, but are not basic sources themselves. These tools are generally arranged in some systematic manner, perhaps chronologically or geographically, and include access to specific subjects and titles through alphabetical indexes. A good example of this type of handbook, one that has a geographical arrangement with an alphabetical index, is Amiet's *Art in the Ancient World: a Handbook of Styles and Forms* (E.3.).

Still another major group of reference tools, also good examples of the type of sources that map the way to basic information, consists of periodical indexes and abstracting services. These tools are finding aids that guide the student to current information contained in periodicals. They provide no information themselves, only access to other sources of information. This last group offers guidance in finding a large amount of diverse and current information and it includes some of the more complex tools to use. Therefore, it may be helpful to look at these in some detail.

PERIODICAL INDEXES AND ABSTRACTING SERVICES

A periodical is, by definition, a continuing publication issued at more or less "periodical" intervals of time, under a collective title. Each issue contains articles by various authors on related topics within the scope of the particular periodical. Because the length of a periodical article lends itself to specialized research on a narrower topic than that of a book, it is likely to be published faster than the latter, and the information in it tends to be more current. In addition, because of its specialized nature, the periodical article is often a source for small bits of information on detailed topics. This can be useful for filling the gaps in a research project for which the desired information is not available in books.

An index analyzes the contents of a written work or works and tells the reader where to find specific data. It is usually alphabetical and refers the reader to specific locations. Most periodical indexes are arranged in one alphabet of authors' names and subjects, and sometimes article titles as well. Each entry provides a citation to the volume, issue, and pages where the item was published. One good index of this type

in the visual arts field is the *Art Index*[3] (H.3.). In figure 4 is a section from this index showing a reference to an article on the French sculptor Rodin. One may see by examining this citation that, in abbreviated form, all the data needed to find the actual article is included, plus a great deal more. Because of space limitations, however, a system of abbreviations is employed in this kind of index, with which the student must familiarize himself in order to make use of the data given.

In this example, it is first necessary to verify the full title of the journal in which the article was published. A list of "Abbreviations of Publications Indexed," found in the front of each volume of *Art Index*, shows that "Art in Am" stand for *Art in America*. A similar table is present in most periodical indexes, and it should always be checked, as several periodicals may have similar titles. Another list of abbreviations further into the volume clarifies such terms as "bibl f" (bibliographical footnotes), and "il." (illustrations). In addition, the instructions in the front of the volume on the use of this index (most indexes have such instructions) indicate that the numbers 68:98–9 refer to the volume (number 68) of *Art in America* and the pages where the article appears. This format is standard in most periodical indexes, and once learned will serve the student again and again. Having identified all the elements of the citation, it is then a simple matter to check the library's holdings list or periodicals catalogue to determine if volume 68, and specifically the Summer 1980 issue, of *Art in America* is available.

Like periodical indexes, abstracting services also analyze the contents of periodicals and other written works and refer the reader to the location of specific information. However, these tools offer additional help in the form of a brief summary, or an abstract, of the contents of each item indexed. Abstracting services may be arranged alphabetically or in some other way, frequently by subject classification. In the latter case, there are usually indexes to specific subjects, authors, and/or titles or key words in the abstracts. Obviously, this type of arrangement requires a two-step approach rather than a check of a single alphabet, but there are advantages to these tools which should not be overlooked.

If the data needed is highly specialized, it is often easier to determine from an abstract which article is most relevant to that need than it is to scan the complete text of several articles to find a particular fact. In such a case, it may be well worth spending a little extra time looking up sources in order to save a great deal of wasted reading time later.

The article found above through *Art Index* provides a good example of just such a case. Since it was indexed under Rodin, it is safe to assume this article contains some information about the sculptor, but the only artist's name in the title is that of Degas. An abstract may provide enough information to determine just what relationship this article has to the aspect of Rodin's work under investigation. Therefore, it may be useful

Abbreviations

Art Bull—Art Bulletin
Art Direct—Art Direction
Art In Am—Art In America
Art Int—Art International

PERIODICAL TITLES ARE IDENTIFIED
IN <u>ABBREVIATIONS OF PUBLICATIONS</u>
<u>INDEXED</u>

RODIN, Auguste, 1840-1917
Ideology of time: Degas ar
Varnedoe. bibl f Art in Am
il: Iris, messenger of th
Bronze: Burghers of Calais

Abbreviations

fasc fascicule
fl flourished

il illustrated, illustration
 illustrator

OTHER ABBREVIATIONS
IN THE CITATIONS
ARE IDENTIFIED IN A
GENERAL LIST OF
← ABBREVIATIONS

Figure 5
Examples from *RILA Abstracts; Répertoire International de la Littérature de l'Art.*
Reproduced by permission of the publisher.

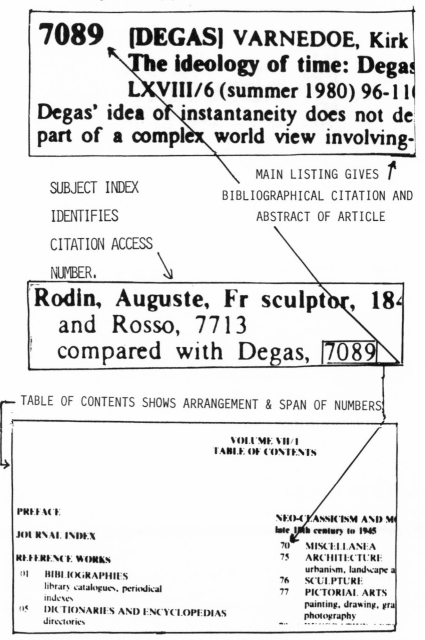

7089 [DEGAS] VARNEDOE, Kirk
The ideology of time: Degas
LXVIII/6 (summer 1980) 96-11(
Degas' idea of instantaneity does not de
part of a complex world view involving-

SUBJECT INDEX
IDENTIFIES
CITATION ACCESS
NUMBER.

MAIN LISTING GIVES
BIBLIOGRAPHICAL CITATION AND
ABSTRACT OF ARTICLE

Rodin, Auguste, Fr sculptor, 18‹
and Rosso, 7713
compared with Degas, 7089

TABLE OF CONTENTS SHOWS ARRANGEMENT & SPAN OF NUMBERS

VOLUME VII/1
TABLE OF CONTENTS

PREFACE

JOURNAL INDEX

REFERENCE WORKS

01 BIBLIOGRAPHIES
 library catalogues, periodical
 indexes
05 DICTIONARIES AND ENCYCLOPEDIAS
 directories

NEO-CLASSICISM AND M(
late 18th century to 1945

70 MISCELLANEA
75 ARCHITECTURE
 urbanism, landscape a
76 SCULPTURE
77 PICTORIAL ARTS
 painting, drawing, gra
 photography

to turn to an abstracting service such as *Répertoire International de la Littérature de l'Art*, in English *International Repertory of the Literature of Art*, and often called *RILA Abstracts* for short (H.7.), and look up the same article there.

RILA is arranged in a classified manner, as may be seen by a glance at the table of contents, so it is wise to check the subject index first under Rodin's name. From the sample entry in figure 5, it may be seen that one of the listings there is "compared with Degas, 7089." It seems likely this is the article in question, so the next step is to locate the abstract using the citation access number (not to be confused with a page number) "7089." By following the access numbers at the beginning of entries in the 7000 section, the article referenced is easily located. The citation appears in full, with the same data as that found in *Art Index*, plus the abbreviation "In En." at the end of the citation. A quick check of the list of abbreviations in the back of the volume verifies that this means the article is in English. In addition, the abstract which follows the citation identifies the sense in which Rodin is compared with Degas, enabling the student to determine if this article will, indeed, be useful in the research at hand.

Both *Art Index* and *RILA* are published in updating issues at frequent intervals. *Art Index* is cumulated annually into one alphabet, and there are indexes in each of *RILA*'s two issues per year, with a five-year cumulation. The major difference, besides the abstracts in *RILA*, is that the latter began publication in the early 1970s and each year provides about 9,000 references to books, dissertations, exhibition catalogues, and other forms of literature besides periodical articles, on an international scale. *Art Index* has been around since the late 1920s, but it covers only periodicals, the large majority of which are published in English-speaking Western countries. The choice of which to use for a given project may, then, depend on the time available for searching, the currency of information needed, the need for the convenience of locating a variety of sources in one reference tool, and whether the specificity of the topic is likely to make the presence of abstracts desirable.

NOTES

1. U.S. Library of Congress, *Library of Congress Subject Headings*. 9th ed. 2 vols. (Washington, D.C.: Library of Congress, 1980).

2. Barbara M. Westby, ed., *Sears List of Subject Headings*. 12th ed. (New York: H. W. Wilson, 1982).

3. *Art Index*. Vol. 29, November 1980 to October 1981. (New York: H. W. Wilson Company, c.1981, 1982).

3

Computerized Reference Services

Computerized databases, introduced into college and university libraries during the past decade, can speed up the search process and enable one to conduct more comprehensive searches for data than ever before. These databases are used to compile bibliographies from periodical and other literature. This development owes its existence to the technological revolution that has taken place, and to the foresight of librarians and technicians in putting the new technology to practical use.

DEFINITION AND BACKGROUND

Computerized databases are analogous to their printed counterparts, the indexes and abstracting services discussed in the last chapter. Many of them, in fact, originated in the publishing offices that provide those same indexes and abstracting services. In the 1960s and 1970s, many of the publishers of these useful tools, after relying for years on manual indexing requiring long, laborious hours of work on the part of hundreds of indexers, saw the possibilities of computers to make their operations more efficient. They began to input the contents of periodicals and other materials into computers, assign subject headings in a consistent manner for accessing them, and let the computer organize and print out the indexes.

The first attempts at computer indexing were somewhat clumsy compared to the databases available now, but they showed publishers, li-

brarians, and scholars how useful such an approach could be. The earliest computerized indexes often employed key words from the titles of the articles indexed, either with the surrounding words providing the context or simply alphabetizing these key words alone. The former type of index was referred to as a "Key Word in Context" or KWIC index, while the latter became known as a "Key Word out of Context" or KWOC index. Although these were somewhat awkward compared to today's more sophisticated databases and the printed tools derived from them, they were considerably faster to produce and therefore much more current when they did get into print than their more conventional counterparts. To some extent, this technique is still employed where currency of information is of primary importance.

In the scientific and technological subject areas, and particularly in medicine, these new computer-produced indexes were welcomed, since currency of information is so crucial in these fields. The social sciences were a little slower to accept them, but researchers in those fields experimented with them gradually. It was not long, too, before the technological revolution overtook the publishing industry, and more new information was getting into print faster and faster. Overwhelmed by such a large amount of current data to be assimilated in order for their research to be valid, scientists and social scientists became accustomed to the convenience and currency of the computer-published indexes very quickly. The fact that the terminology of these fields is precise and concrete, and thus adapts well to machine indexing, contributed to rapid acceptance of these indexes.

In the humanities, scholars were slower to recognize the value of these new indexing methods, perhaps because currency is not as crucial in these subject areas. In addition, terminology in the humanities, dealing as it frequently does with more abstract concepts, lends itself less readily to machine indexing and its necessity for precision. It may also be that, not really understanding the technology that produced these tools, humanists were in awe of them, maybe even a little suspicious. Whatever the reasons, it has been only in the last half of the last decade that computer-produced indexes and abstracts have begun to be accepted in the arts, literature, and similar studies.

Meanwhile, in the technological fields, experimentation had led to more and more effective ways to arrange and access information with the help of computers. No longer was it necessary to go from a subject index to an author or title listing of books and articles. Both could be accessed at once, and the computer could even combine subject and author's name in one search to produce a list of works on a subject by a particular author. Indeed, one could combine subject terms, geographical and time qualifiers, forms of material, and many other search characteristics into one statement. This technique could retrieve in a matter

of minutes what would have taken hours of searching and coordination of references to produce manually. In addition, if one were to try to construct subject headings for a printed index that incorporated all of these aspects, it would be too cumbersome and costly to print.

This last factor, the expense of producing in printed format a tool that offered the same convenience and ease of access as the computer provided, gave rise to the next logical step. While publishers had been developing computer-aided methods of publishing, librarians had begun to use computers to control the vast amounts of information stored in the printed works the publishers produced. Since terminals were available in many large research libraries, and since terminals could now communicate through modems with large mainframe computers at vast distances, some enterprising businessman came up with an idea that was to revolutionize reference service. A company was formed to sell access to large databases, stored in huge computers, to libraries throughout the country, via telephone lines.

The process was relatively simple for the reference librarian. Provided with a computer terminal, a video screen and/or printer, an acoustic coupler or modem, and a telephone, the librarian could dial the headquarters of the information vendor, give a password, and be connected to the computer. Around 1969, packet switching was developed, and large telecommunications networks were set up on a time-sharing basis which allowed access to the computer for less cost than long-distance dialing.[1] Once connected, the librarian typed in key terms for his search strategy, planned in advance in consultation with the researcher who needed the information, and in a few minutes, a list of citations tailored to the researcher's needs appeared on the screen or the printer.

The next step might easily have been predicted. Since publishers had been loading their computers with the data necessary to publish their indexes and abstracts for several years, the information utilities, as they became known, began to negotiate with the publishers to purchase the rights to their databases and provide direct access to them for libraries. The utility took a copy of the database used to produce a tool such as *Psychological Abstracts*, for example, manipulated the data and provided indexing terms to fit its system, loaded it into its computer, and another database was available for all its library customers. Several major information utilities have since gone into business in competition with each other. The best-known and most frequently encountered services in American libraries today are DIALOG, SDC/Orbit, and BRS (Bibliographic Retrieval Service). The use of the databases provided through these services has proven so helpful and popular that by 1979 there were 4,000,000 searches done in libraries in the United States and Canada, and the numbers are continuing to grow by the millions in the 1980s.[2]

DATABASES FOR ART RESEARCH

Although there are still only a few databases publicly available for the humanities, there are at least two very useful ones in the visual arts: *ArtBibliographies Modern* (H.4.), available through DIALOG; and *Art Quest*, an online version of *Art Sales Index* (I.1.).[3,4] These are derived from manipulation of the databases used to produce their printed counterparts, as are many of the bibliographic databases now in use in libraries.

A third database for the visual arts was made available online in 1986. It is based on another printed source discussed in the last chapter, *RILA Abstracts* (H.7.). It is available through DIALOG, and it greatly broadens the coverage available online for art history, since it covers all periods in the history of art, in publications of all types, on an international basis. In 1985, the H. W. Wilson Company, publishers of the *Art Index* (H.3.), began to put all of the databases on which their printed indexes are based online. This service is being made available to libraries as *Wilsonline* and will, when complete, include not only *Art Index* but a large number of other databases such as *Humanities Index*, *Social Sciences Index*, *Business Periodicals Index*, and *Education Index* which can be useful for some types of research in the arts.

Art scholars have other databases to rely on, however, especially if their subjects happen to be interdisciplinary in nature. For example, if there are literary overtones to a research topic, such as a comparison of motifs in literature and the visual arts, it may be profitable to consult *MLA Bibliography* in its online version, as well as one of the art databases. Or if the study is art historical, additional material may be found through a historical database such as *America: History and Life*. Art education scholars and students may well find it useful to consult an education base such as *ERIC*, as well as an art database, and if parallels are being drawn between art and music, *RILM Abstracts* may be helpful. The list is almost endless, as are the savings in time that might have been spent manually poring over several printed indexes. A list of selected databases with suggested uses for the visual arts is appended to the end of this chapter.

WHEN AND WHERE TO USE COMPUTERIZED REFERENCE

As stated earlier, computerized databases are not always the most effective route for a researcher to take, but there are circumstances in which they can be extremely worthwhile. Some of the best examples of this include interdisciplinary research projects such as those cited earlier. There are other cases, however, in which no combination of subject

headings and their subdivisions as used in the printed indexes can possibly lead precisely to the topic under consideration.

For example, perhaps a study is in progress that compares two artists from different countries or time periods. Ordinarily, it would be necessary to do separate searches under both artists' names, and additional ones under their media, with appropriate subdivisions for country and era. If it is also necessary to do this search in more than one index, the scholar may well find himself spending weeks just collecting citations, without being able to read any of the articles located. Under circumstances like these, a database search saves the researcher hours or even weeks and provides more precisely what is needed than a manual search could.

Computerized reference, unlike traditional reference, however, is frequently not free of cost. In many libraries the patron is charged some or all of the cost of the search. Depending on the complexity of the topic and the number of databases used, this can sometimes be expensive. In a case like this, it may be necessary to weigh the value of one's time against the importance of the research in progress, and the need for an absolutely comprehensive search of the literature, before deciding whether a database search is the best solution. As a general rule, if the research requires consulting only one subject, with only one or two subdivisions, a computerized search will not be cost effective. If the project under consideration requires use of the literature of more than one field, is complex in nature, and if it requires a comprehensive search of the literature, the chances are that a database search will be worth the cost.

Databases vary widely in the amount charged per hour of connect time, from $15 or $25 to over $200. Most searches take from ten to thirty minutes to complete, so it is readily apparent that only a portion of the hourly charge will be applicable, but, in addition, there are sometimes other costs to be figured into an estimate, such as a charge of fifteen to fifty cents per citation typed out online. If prints are ordered sent in the mail in order to save time online, there is usually a small charge for this as well. In addition, the cost may vary somewhat depending on which information utility the library is using, whether special discounts are available to the library for volume use, and many other factors. In most systems and libraries, these costs will average around $25 or $30 per search, but they occasionally run as high as $50 or $100 dollars for a more complex topic that uses two or more databases. These are only very rough estimates, however, and individual searches must be negotiated separately to determine what the cost is likely to be. If, after considering the research topic, its subdivisions and related peripheral areas to be covered very carefully, it is determined that a database search is worth the cost, the next step is to find a library with such a service.

Figure 6
The Decisive Factors in Using Computerized Databases

Use Printed Indexes If:	Use Databases If:
=======================	==============================
1. One subject heading will suffice.	1. Two or more subject headings are required.
2. One index provides enough data.	2. Two or more indexes/databases must be searched.
3. Economy is of the essence.	3. Time is more important than cost.
4. Selective information is sufficient.	4. The research must be comprehensive.
5. Retrospective data is sufficient.	5. Information must be as up to date as possible.

If the answer to a majority of factors on either side is
positive, this indicates the appropriate decision.

DATA BASE-ICS: NEGOTIATING THE SEARCH

Most large university and public libraries, and even many small- to
medium-size college libraries offer computerized reference, and the re-
searcher can determine with a few telephone calls which ones in the
area do. The reference department in libraries equipped for database
searches usually has one or more librarians with specialized training in
online reference and, frequently, special knowledge of the subject area
in question and the databases most likely to yield the data needed. At
the time of the initial telephone call to inquire about database searches,

it is wise to ask as well who will do the search and make an appointment to meet with the searcher to plan the strategy, determine the method of payment, and set a time for the actual search to be done.

When the researcher meets with the librarian who is to do the database search, it may be helpful to have some idea of what to expect. It will save some time, to begin with, if the topic is well defined and thought out. This is, of course, a necessary part of planning any research, but it is especially important when fishing around among aspects of a very broad topic will cost time and, therefore, money. Some of the subject terms used in the library catalog and the printed reference tools may help to pin down the best terms to use online. While the database descriptors, the online term for subject headings, may be similar to subject headings used in other sources, or completely different, they may also call to mind other more specific terms and thus make the search more precise and timesaving.

It may also be helpful for the searcher to know what printed reference sources the patron has already used, and how much material has been found through these. Not only can this avoid duplication of effort, it may suggest to the searcher what online databases will be the most effective. If certain terms have already proven too broad or too specific in the printed tools, this may help to determine which term or group of terms will be the most productive online. If the student can provide information of this type at the initial meeting it will save much cost in the final search.

Another factor to consider is the type of literature wanted in this search. If one is only interested in periodicals and exhibition reviews, for example, other types of material can usually be eliminated in planning the search strategy to be used. In addition, if the student is only interested in material in a known language, such as English, the searcher should be told this, and the search can be limited to that language. Conversely, if it is desirable to retrieve material in any language, for the sake of comprehensiveness, then the searcher should also be informed of that.

If only the most recent information available is of interest for this project, the searcher should be told ahead of time, as this will limit the number of citations likely to be retrieved and, therefore, the cost. Likewise, if historical material is required, this is important information: the searcher will then be sure to search as far back in the time coverage of the databases as is necessary.

If the topic under consideration is an interdisciplinary one, it is likely that the searcher will suggest databases in other fields which may be helpful, such as an education database for a topic in art education. If not, the student should mention the need for related material in another subject and ask if databases in that area are available and can be searched

at the same time. This will help insure that all possible angles of the topic are covered.

Once all these factors have been noted by the searcher, some time will probably be needed to check out the relevant descriptors in the databases to be used and to plan the best ways to combine them. This is known as setting up a search strategy and it will save money later if it is done well at this stage. The same strategy can often be applied in all the databases to be searched, thus saving time over typing in separate strategies in each base. At this point, then, the searcher will be able to give a rough estimate of the probable cost, based on the number of databases to be used and the number of terms to be combined in the search strategy, but the student should keep in mind that "rough" means exactly that.

Other factors may show up online that will alter the expected cost, such as an unusually large number of citations to be typed out. While considering this factor, it is wise to decide how urgently the information is needed. It is usually possible to type up citations while the patron waits or to order them printed out off-line at the headquarters of the information service and sent in the mail. This latter practice often yields copy in a neater, easier-to-read format than computer printout copy, costs less because it uses less computer time, and seldom takes more than five to seven days. A frequent compromise solution is to type out a few citations online for the patron to take with him and order the rest sent in the mail. This way the student has some material to begin the project and more to count on later.

One other possibility for online reference should also be mentioned here. This is the capability of most computerized reference services to order copies online of relevant material. This is especially useful for material that is not available at the researcher's local library or other libraries in the area, but it is also a time-saver if there is a large amount of material to be retrieved. In addition, many researchers prefer to make copies of the materials for their own use at their own pace anyway, and if these copies can be provided for them at a nominal cost, it may be preferable to order them at the time the search is done. Generally, document delivery service of this type costs a basic fee per article, plus a charge per page. The basic fee covers the staff time necessary to locate and copy the articles, the mailing costs involved, and any royalties which are due the author and publisher of the material. Delivery can usually be expected in less than a week, and if time is more important than money, this service may well be worth the small extra cost.

SELECTED DATABASES FOR ART RESEARCH

NOTE: Appendix B lists the printed equivalents of these databases where they exist.

Specific to the Visual Arts

ArtBibliographies Modern. Santa Barbara, Calif.: ABC-Clio, 1974 to date. Available on DIALOG as file 56: $60 per connect hour, $.15 per record printed off-line. Covers modern art and design literature in books, dissertations, exhibition catalogs, and some 300 periodicals; includes art history and biography, all art media, since the beginning of the nineteenth century.

Art Index. New York: H. W. Wilson, 1929 to date. Available on *Wilsonline*. Rates vary.

Art Quest. Surrey, Kent, England: Art Sales Index, Ltd., 1970 to date. $64 per connect hour for the first twenty-five hours, with discounts for each twenty-five hours in a twelve-month period thereafter. New users pay a deposit based on the rate for the first five hours of use, which is then absorbed into the usage charges. Covers paintings, gouaches, sculpture, and mixed media works of art sold at auction throughout the world; begins in October 1970, includes drawings from 1975–1976 auction season to date, sculpture since 1983; gives details of sale and description of work; provides statistical summaries and analysis on sales of over 500,000 works by some 60,000 artists of all periods and nationalities.

RILA Abstracts. Williamstown, Mass.: Sterling and Francine Clark Art Institute, 1974 to date. Available on DIALOG as File 191: $48 per connect hour, $.15 per record printed off-line.

Other Databases of Use for Art Researchers

America: History and Life. Santa Barbara, Calif.: ABC-Clio, 1964 to date. Available on DIALOG as file 38: $65 per connect hour, $.15 per record printed off-line. For research in American and Canadian art history; covers United States and Canadian history in periodical and other sources; includes references to art historical topics and events in American history relevant to art history.

Biography Master Index. Detroit: Gale Research Co. Available on DIALOG as file 88: $57 per connect hour, $.45 per record printed off-line, $.35 per record typed online. For biographies of artists and other art figures; indexes biographical data in more than 600 source publications, such as major biographical directories, and handbooks of authors, educators, etc.; citations may be located for people in or related to the art world who appear in such sources.

Dissertation Abstracts On-line. Ann Arbor, Mich.: Xerox University Microfilms, 1861 to date. Formerly *Comprehensive Dissertation Index*. Available on DIALOG as file 35: $72 per connect hour, $.25 per record printed off-line, $.05 per record typed online. Also available on BRS and SDC/Orbit. For current research in art and related areas at master's and doctoral levels, as well as historical coverage; index to dissertations at accredited American universities since the first doctorate was granted in this country; also cites Canadian dissertations and some master's theses; very useful for locating research not covered in other sources.

Education Index. New York: H. W. Wilson, 1929 to date. Available on *Wilsonline.* Rates vary.

Eric. Washington, D.C.: National Institute of Education; Bethesda, Md.: ERIC Processing and Reference Facility, 1966 to date. Available on DIALOG as file 1: $25 per connect hour, $.10 per record printed off-line. Also available on BRS as *Eric* and SDC/Orbit. For art education research; comprehensive indexing of some 700 education journals, plus complete listing of research in education available from ERIC (Educational Resources Information Center) through its microfiche documents collection or in paper copy.

Exceptional Child Education Resources. Reston, Va.: The Council for Exceptional Children, 1966 to date. Available on DIALOG as file 54, $35 per connect hour, $.15 per record printed off-line. Also available on BRS as *ECER.* For research in art education and therapy with gifted or handicapped children; covers published and unpublished sources in the subject field, including books, journals, teaching materials, and reports.

Historical Abstracts. Santa Barbara, Calif.: ABC-Clio, 1973 to date. Available on DIALOG as file 39: $65 per connect hour, $.15 per record printed off-line. For art historical research and parallel study in history; covers world history 1450 to the present, except the United States and Canada, in over 2,000 journals published in some 90 countries.

Humanities Index. New York: H. W. Wilson, 1974 to date. Available on *Wilsonline.* Rates vary.

Magazine Index. Menlo Park, Calif.: Information Access Corp., 1959–March, 1970; 1973 to date. Available on DIALOG as file 47: $84 per connect hour, $.20 per record printed off-line, $.10 per record typed online. For coverage of exhibitions, museum news, etc. in general periodicals; indexes over 370 popular periodicals, with special descriptors for reviews.

MLA Bibliography. New York: Modern Language Association of America, 1970 to date. Available on DIALOG as file 71: $55 per connect hour, $.15 per record printed off-line. For literature studies paralleling art historical research, or iconographical comparisons, etc.; indexes journals of all countries on literature, language, linguistics, folklore, and related humanistic studies.

National Newspaper Index. Menlo Park, Calif.: Information Access Corp., 1979 to date. Available on DIALOG as file 111: $84 per connect hour, $.20 per record printed off-line, $.10 per record typed online. For reviews of exhibitions, art criticism, etc., appearing in the *New York Times*, the *Christian Science Monitor*, and the *Wall Street Journal*; current items from the art world, interviews with artists, etc. may be found here for contemporary figures not covered elsewhere.

Newsearch. Los Altos, Calif.: Information Access Corp., current month only. Available on DIALOG as file 211: $120 per connect hour, $.20 per record printed off-line. Daily updates to information for *National Newspaper Index*, *Magazine Index*, *Legal Resources Index*, and *Management Contents*; includes current data on artists and the art world as well as on art law and arts administration.

Philosopher's Index. Bowling Green, Ohio: Bowling Green State University, Philosophy Documentation Center, 1940 to date. Available on DIALOG as

file 57: $55 per connect hour, $.15 per record printed off-line. For aesthetics and related information; covers books and over 270 journals in philosophy and related interdisciplinary fields.

Psycinfo. Washington, D.C.: American Psychological Association, 1967 to date. Available on DIALOG as file 11: $55 per connect hour, $.20 per record printed off-line, $.35 per record typed online. Also available on BRS as *PSYC* and SDC/Orbit. For the arts in relation to psychology and the behavioral sciences; indexes over 900 journals, as well as books and technical reports. Formerly called *Psychological Abstracts.*

RILM Abstracts. New York: City University of New York, International RILM Center, 1972 to date. Available on DIALOG as file 97: $65 per connect hour, $.15 per record printed off-line. For research on events in music history paralleling art historical events, comparative studies in art and music, etc.; covers all forms of literature on music on an international basis, periodicals, books, dissertations, reviews, and others.

Social Sciences Index. New York: H. W. Wilson, 1974 to date. Available on *Wilsonline.* Rates vary.

Social Scisearch. Philadelphia: Institute for Scientific Information, 1972 to date. Available on DIALOG as file 7: $75 per connect hour, $.15 per record printed off-line. For social science aspects of the visual arts, such as the sociology or psychology of art.

Sociological Abstracts. San Diego, Calif.: Sociological Abstracts, Inc., 1963 to date. Available on DIALOG as file 37: $60 per connect hour, $.30 per record printed off-line, $.20 per record typed on-line. Also available on BRS as *SOCA.* For research on the sociology of the arts and other data on behavioral science topics in relation to the arts; covers over 1,200 journals in sociology and related social and behavioral science disciplines.

NOTES

1. More on the history of such services may be found in Sara D. Knapp, "Online Searching: Past, Present, and Future," in *Online Searching Technique and Management,* ed. James J. Maloney (Chicago: American Library Association, 1983).

2. Ibid.

3. *Computer-Readable Data Bases: A Directory and Data Sourcebook.* (White Plains, N.Y.: Knowledge Industry Publications, 1982).

4. *Directory of Online Databases* Annual. (Santa Monica, Calif.: Cuadra Associates, 1979 to date).

4

Biographical Information: The Artist as Starting Point

Since all art begins with the creator, the artist is frequently the subject of art research. The artist is, if not the main topic, at least one of the central aspects that every researcher must consider. Thus, many art research projects begin with the need for information about the artist.

The best source for such information depends on several factors.[1] First, the choice of a source is affected by the amount of information needed and how well the artist is known. If only a brief biographical sketch is needed for background, some of the standard biographical directories, such as *Who's Who in American Art* (D.98.), will suffice, provided the artist is famous enough to appear in them. Entries in these directories are very brief, with birth and death dates (if deceased), data on childhood, education, employment, medium, major works, and frequently a list of exhibitions, sales, and collections in which the artist is represented. The example in figure 7 shows a typical entry, with its abbreviated information, from this source.

Second, the form, medium, or style within which the artist worked, and the country or period, will influence the choice of sources. A contemporary artist from the United States and some other Western nations is likely to be found in general directories. So is a major figure in art history from a non-Western nation. Some of the biographical directories for Western nations, such as Cummings' *Dictionary of Contemporary American Artists* (D.23.), will provide basic information on most contemporary artists, and well-known masters will be covered in most directories. For

Figure 7

Examples reprinted from *Who's Who in American Art,* 15th ed., with permission of the R. R. Bowker Company. Copyright © 1982 by Xerox Corporation.

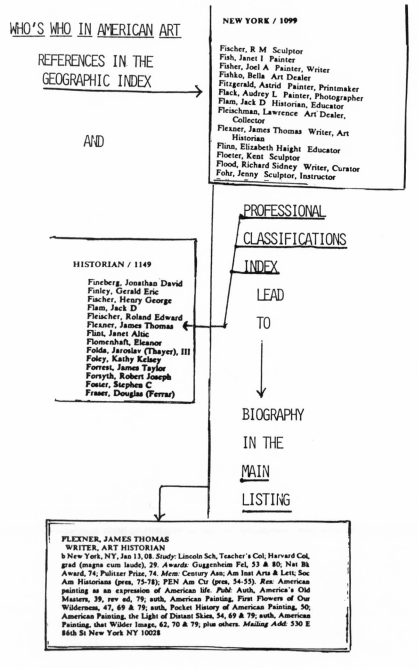

Figure 8

Example of Library Catalog Cross-reference Card

El Greco

see

Theotocopuli, Dominico, called El Greco, d. 1614.

more than the briefest of sketches, however, it will be necessary to dig much further for both.

There are four basic types of sources for biographical data.[2] There are general biographical directories covering artists as well as other famous personalities. There are more specialized directories either for artists as a whole or for specific classes, by medium, country, period, and similar subdivisions. There are indexes to biographical information, and there are books and periodicals containing bibliographies of biographical reference sources.

As with many subjects, a good place to begin is in the library catalog. If the library contains a biography in the form of a book or monograph dealing with the life and work of the artist, it will be listed under the artist's name as a subject heading. The name will be in reverse order, last name first, followed by given name and dates of birth and death. For example, one would locate a book on the painter Rubens under the heading: "Rubens, Sir Peter Paul, 1577–1640."

However, many European artists are commonly known by a pseudonym

under which the artist became famous and signed his work. A good example of this is El Greco, "the Greek." Until recently, most libraries catalogued works by or about El Greco under his real name, Dominico Theotocopuli, and made cross-references from his nickname (see figure 8).

Beginning in 1981, however, the international rules for library cataloging were changed. For that point on, all authors and artists have been listed under the name by which they are best known. Thus, El Greco now appears as El Greco, but in many libraries some entries for works cataloged before 1981 have not yet been changed, so it helps to look under both real name and pseudonyms for a comprehensive search. Cross-references similar to the example above are usually made for the variant names, so if one follows these carefully, there should be no difficulty in locating all books on a given artist.

Of course, if there are no monographic biographies on the artist, it will be necessary to identify discussions of him in broader studies. The most efficient search strategy is to begin with the most specific subject heading and proceed to broader topics that include the one under study. For example, for a French nineteenth-century painter, books on nineteenth-century painting, or histories of French painting in general, may contain information. However, reference tools can assist in identifying sources of information that may be missed using the library catalog alone. The student can turn to biographical directories, for example, both general and specific.

GENERAL BIOGRAPHICAL SOURCES

General Directories

There are many general biographical directories in which information about artists may be located. The most general, such as the comprehensive Thieme-Becker (B.76.) or Benezit (B.5.) works, cover primarily painters, some draughtsmen, and usually a few architects and sculptors. These two include all media, time periods, and nationalities, but painters and draughtsmen predominate. Both are alphabetical by artists' names, and provide biographical sketches, selected lists of works, exhibitions, and similar data. In addition, both of these works include bibliography for further research on each of the biographees.

Thieme-Becker is in thirty-seven volumes and covers about 200,000 artists up to the twentieth century. With its twentieth-century continuation by Vollmer, the *Allgemeines Lexikon der bildenden Kunstler des XX. Jahrhunderts* (B.80.), it is one of the most inclusive tools of this genre. Benezit is not quite as comprehensive, but picks up some figures that Thieme-Becker missed. Benezit is in French, Thieme-Becker in German, but with a good dictionary in hand most college-level students find they

can decipher the entries, and these two works have never been superseded by an English-language source.

A recent general directory is *Lives of Artists: A Biographical Dictionary* (D.25.) by Robert Darmstadter. Less recent but useful for artist and period information, and also in a simple alphabetical format, are the *Oxford Companion to Art* (B.55.) and the *Dictionary of Art and Artists* (B.52.) by Peter and Linda Murray. Annual directories similar to the American "Who's Who" cited above include the *International Who's Who in Art and Antiques* (D.52.) and, for contemporary figures, the *International Directory of Exhibiting Artists* (D.87.), derived from records in the database for *ArtBibliographies Modern* (H.4.) and survey questionnaires distributed to galleries and museums worldwide.

General Encyclopedias and Dictionaries

Another category which should not be overlooked in searching for artist biographies is art encyclopedias and dictionaries. These include articles on artists as well as articles on styles, schools, etc., which provide historical context for an artist. In addition, the articles in these general encyclopedias frequently include bibliographies, useful for identifying further sources. The most familiar of these in English is the *Encyclopedia of World Art* (C.10.), but because of its publication date, it is important to consult both the main alphabet and the supplementary volume published more recently. Although not as comprehensive, there are some recent dictionaries and encyclopedias that also provide more current data. These include the *Praeger Encyclopedia of Art* (C.37.), the *Visual Dictionary of Art* by Ann Hill (B.36.), the *McGraw-Hill Dictionary of Art* (C.26.), and most recently the *Encyclopedia of Visual Art* (C.16.) edited by Sir Lawrence Gowing and republished in the United States in 1983. Somewhat older, but still useful, is another British source, Dagobert Runes's *Encyclopedia of the Arts* (C.43.).

SOURCES FOR PERIODS AND SPECIAL GROUPS

More specialized biographical sources sometimes exist for various special categories. To locate the most specific source for a given artist, one must search the library catalog by subject headings for the appropriate medium and/or time period and country. Sources that cover a large number of individuals in the medium, regardless of country and era, may be found under the more general headings, and the more specialized ones under specialized headings, with subheadings for the form of reference tool, such as dictionaries or indexes.

Some biographical directories and encyclopedias are limited by time periods, or by style groupings, but cover all nationalities. These are

useful if the artist is a major one and has already been placed in context
in time or style. They often contain lengthier data than the more general
sources, but the articles are still brief enough to be read at a short sitting.
Good examples of this type have been produced by the French publisher
Larousse, and many of these have been translated into English and
republished in the United States. These include compilations by René
Huyghe on Byzantine and Medieval art, on the modern period, on pre-
historic and ancient art, and on the Renaissance and Baroque eras
(C.21.), (C.22.), (C.23.), (C.24.).

For artists of the twentieth century and some late nineteenth-century
ones as well, one may add to the *Larousse Encyclopedia of Modern Art*
(C.22.) a regularly updated directory by Muriel Emanuel, *Contemporary
Artists* (D.28.), the second edition of which was published as recently
as 1983. In addition, there are the *Oxford Companion to Twentieth-Century
Art* (B.57.) and the *Phaidon Dictionary of Twentieth-Century Art* (B.58.),
both relatively recent and containing authoritative sketches on contem-
porary figures. A very recent directory is the *International Contemporary
Arts Directory*, edited by Ann Morgan (D.68.). Another is the five-volume
Guides to Exhibited Artists (B.29), published in 1985 by ABC-Clio. The
first volume of this covers European painters, the second painters of
North America, the third printmakers, the fourth sculptors, and the final
volume covers craftspeople.

Still another one-volume source for very recent figures is Claude
Marks' *World Artists 1950–1980*, (D.61.), published in 1984, which covers
312 painters, sculptors, and graphic artists. If one is studying an artist
of large-scale works, such as Christo's "Running Fence," there is a new
bibliography and directory by Havlice, *Earth Scale Art: A Bibliography,
Directory of Artists, and Index of Reproductions* (A.62.). If it would be useful
to examine visual or audio presentations by the artist in question, these
may be located through the very recent *From Museums, Galleries, and
Studios: A Guide to Artists on Film and Tape* (F.4.). Both of these sources
were published in 1984 and contain the latest information.

For artists of specific movements in the modern period, one may
consult a series of specialized references published by Phaidon for both
biographical and background data. Each contains considerable historical
material and stylistic discussions, as well as biographical dictionaries of
major figures in the movement it covers. For surrealists, one might turn
to the *Phaidon Encyclopedia of Surrealism* (C.32.), edited by Rene Passeron;
for expressionists to the *Phaidon Encyclopedia of Expressionism* (C.40.), by
Lionel Richard; and for impressionists to the *Phaidon Encyclopedia of
Impressionism* (C.46.), compiled by Maurice Serullaz. An advantage to
these three is the addition of bibliographical references for further in-
formation on the artists and on the movements of which they are a part.
A notable disadvantage, however, is the fact that they are not alpha-

betical, but chronological in arrangement, making it essential to use the indexes to target the data needed within each.

Special groups sometimes are covered in their own directories. The emphasis on women's rights and women's contributions in recent years has prompted several good sources for women artists. However, these are not the first sources for women artists. As early as 1904, Clara Waters compiled what was, for its time, a very comprehensive tool in this area, *Women in the Fine Arts, from the Seventh Century B. C. to the Twentieth Century A. D.* (D.95.). Although standards of entry style and scholarship were not as consistent then, this tool can still be useful for some figures not covered elsewhere.

In 1985, Chris Petteys compiled and published a *Dictionary of Women Artists: An International Dictionary of Women Artists Born Before 1900* (D.78.), which covers 20,000 painters, sculptors, printmakers, and illustrators. In the past decade or so, a number of good directories for women of various countries and media have been compiled, and these will be examined in their appropriate sections. In addition, two bibliographies on women artists were published during the 1970s, one by Bachmann and Piland, *Women Artists: An Historical, Contemporary and Feminist Bibliography* (A.13.), and the other by Eleanor Tufts, *Our Hidden Heritage: Five Centuries of Women Artists* (A.108.).

SOURCES FOR ARTISTS BY COUNTRY

Some reference tools are specialized by country or region rather than by period or medium. When the artist has not yet been placed in stylistic context or within the appropriate era, but nationality is known, these are a good starting place. For German or French artists, the best place to begin would be Thieme-Becker or Vollmer, for the former, and Benezit for the latter, since any comprehensive reference work may reasonably be expected to emphasize figures from the country of origin. However, artists from these countries may also be found in other general sources, and German ones of the expressionist movement may also be located through a very specialized bibliography by Spalek, *German Expressionism in the Fine Arts: A Bibliography* (A.103.).

Sources for American artists will be covered in a separate section and in the sections for various media, but for our neighbors to the north and south, there are also some good specialized works available. For Canadian figures of all historical periods, one may turn to McDonald's *Dictionary of Canadian Artists* (D.57.), and for contemporary Canadian figures there is *Creative Canada: A Biographical Dictionary of Twentieth-Century Creative and Performing Artists* (D.22.), which, as the title implies, covers all of the arts. While there is no comparable source for Latin American artists, several bibliographies on Latin American art include

guidance for biographies as well as other information. The most current of these for historical purposes is Bailey's *Handbook of Latin American Art* (A.14.), and for data on contemporary artists there is Findlay's *Modern Latin American Art: A Bibliography* (A.52.).

For British artists of the eighteenth century, coverage is provided by the *Dictionary of British 18th-Century Art* by Ellis Waterhouse (B.83.). Figures from other periods may be located in the general sources listed above, and contemporary ones may be found in *Contemporary British Artists* (D.77.) by Charlotte Parry-Crooke, or in the annual *Who's Who in Art* (D.99.), which, though its title indicates universality, includes primarily British biographees. This latter source, however, provides only brief information, similar to other tools of the Who's Who type.

Despite its remoteness, Australia's artists have not been completely overlooked. Although no biographical sources per se exist, there is at least one very good bibliography, compiled by Elizabeth Hanks from the holdings of the State Library of Victoria, *Australian Art and Artists to 1950* (A.59.). In addition, there is a somewhat older but very useful encyclopedia, the *Encyclopedia of Australian Art* (B.46.) by Alan McCulloch which provides data on artists from "down under."

Classical Greek and Roman artists are covered in most of the general biographical sources, but for lengthier information one may turn to the bibliography by Coulson, *Annotated Bibliography of Greek and Roman Art* (A.38.). Somewhat earlier than Coulson but providing more than bibliography is the *New Century Handbook of Greek Art and Architecture* (B.2.), published in 1972. Although Islamic artists have no separate biographical directory, they may be located through an excellent bibliography by Creswell, *Bibliography of the Architecture, Arts, and Crafts of Islam to 1960* (A.39.).

The Orient in general fares somewhat better, especially China and Japan. Both countries are well covered in Munsterberg's *Dictionary of Chinese and Japanese Art* (B.51.). In addition, the Japanese have their own biographical tool in Tazawa's *Biographical Dictionary of Japanese Art* (D.91.), and further information on artists of the Orient may be found through the *Harvard Outline and Reading Lists for Oriental Art* (A.96.).

Although the majority of African art has been studied only in the context of primitive and tribal art history, that of South Africa for the last 100 years fares differently. While it does not boast a large body of literature on its own, there is at least one source that covers the art of this area separately. This was compiled by Esme Berman and published in 1983 under the title *Art and Artists of South Africa* (D.8.). It includes a biographical directory of painters, sculptors, and graphic artists since 1875, as well as a historical survey of modern South African art.

Many of the bibliographies and encyclopedias mentioned here will be reviewed in more detail in the art history chapter, but are included here when they are the sole specialized source by country for artists of those

nationalities. Likewise, many of the art historical sources will be useful to the researcher studying an artist, since they provide the background material that places the work of an individual in context.

American Artists

Perhaps because of the advanced state of reference publishing in the United States, or because American scholars have been anxious to document the artistic history of their younger nation, sources for American artists abound. As early as 1929, the first index to biographies of American artists was compiled by Ralph Clifton Smith. His *Biographical Index of American Artists* (D.86.) was reprinted in 1976 and continues to provide guidance for pre–1900 artists. In 1918, Frank Chase published an early bibliography in this area, his *Bibliography of American Art and Artists Before 1835* (A.33.), and although later bibliographies have somewhat superseded his work, it is still worthy of note. In 1972, Garnett McCoy compiled a guide to the Archives of American Art in Washington which offers a listing of original letters, papers, and documents by and about American artists. Titled *The Archives of American Art: A Directory of Resources* (A.80.), it provides a guide to primary source materials otherwise difficult to locate. In 1979 and 1980, two other comprehensive bibliographies on American art were produced, the first by Karpel, *The Arts in America: A Bibliography* (A.69.), and the second called *Olana's Guide to American Artists* (A.90.), a two-volume work modestly subtitled by its author, a "contribution toward a bibliography." In 1984, a new guide from the Archives of American Art was published that offers access to its oral history collections, taped and recorded interviews with the artists and others close to them. This tool is titled the *Card Catalog of the Oral History Collections of the Archives of American Art* (A.3.).

American artists before 1860 are covered by a biographical directory from the New York Historical Society, its *Dictionary of Artists in America, 1564–1860* (D.71.), which draws upon early documents and primary sources for the names of all artists and artisans from colonial times to date. The classic reference for American artists, however, is Fielding's *Dictionary of American Painters, Sculptors, and Engravers* (D.31.), recently updated by Glenn B. Opitz, who also published his own directory in 1983, *Dictionary of American Artists, Sculptors, and Engravers* (D.75.). An additional source for hard to find data is *A Matter of Life and Death: Vital Biographical Facts about Selected American Artists* (D.83.) by Schwab, and the recent *Dictionary of American Artists* (D.58.) by Alice McGlauflin provides additional coverage. One more source, somewhat earlier but possibly useful, is Young's *Dictionary of American Artists, Sculptors, and Engravers* (D.102.), published in 1968.

Three directories exist for brief, current data on contemporary figures:

Who's Who in American Art (D.98.), its predecessor, *American Art Annual* (D.3.), and the very recently published *Art in America Annual Guide to Galleries, Museums, Artists* (D.7.). All of these directories give birth dates and places, information on training, medium, exhibitions, current address, and the like. It is important to note, though, that the data in earlier volumes should not be considered complete and current, but should be updated through use of later sources.

Several special groups of American artists merit their own coverage in biographical sources. Not the least of these are the pioneer artists of the Wild West who are covered in a directory of their own, the *Illustrated Biographical Encyclopedia of the Artists of the American West* (D.82.). Also of note is a directory for American artists of the nineteenth century who spent large portions of their lives in Italy, believing this to be the only way to develop into mature artists. These are covered in a *Dictionary of Nineteenth-Century American Artists in Italy, 1760–1914* (D.89.) by Regina Soria.

American women artists also have their own biographical directories, most published in the last decade. Among these is *Women Artists in America, 18th Century to the Present* (D.18.) by Collins and Opitz. Divided into three alphabets, each published earlier as a separate directory, it must be used with care, however, as one must be certain to check all three alphabets. Only two years later, Charlotte Rubinstein compiled her *American Women Artists: From Early Indian Times to the Present* (D.81.), a very comprehensive tool which, to a great extent, supersedes the earlier one. Besides these two directories, there is a more recent bibliography that can help locate newer information, Eleanor Tufts' *American Women Artists: A Selective Bibliographical Guide* (A.108.).

Black American artists have also been provided with ample coverage in recent years. The only directory to date is Cederholm's *Afro-American Artists: A Bio-Bibliographical Directory* (D.17.). However, there are three useful bibliographies containing listings of biographical material on Afro-American artists. In 1978, Oakley N. Holmes published his *Complete Annotated Resource Guide to Black American Art* (A.64.). Then in 1980 Davis and Sims produced their *Black Artists in the U.S.: An Annotated Bibliography of Books, Articles, and Dissertations on Black Artists, 1779–1979* (A.43.), which includes, among other materials, a listing of theses and dissertations on black American art. Most recently, Lynn and James Igoe have published their *250 Years of Afro-American Art* (A.66.), a bibliography that supplements and updates the other two, even including some figures they missed.

INDEXES TO BIOGRAPHICAL INFORMATION

With all the places for locating biographical data, the search could be almost endless without some means of determining the most likely tool

to use. This is the purpose for the next type of reference tool to be discussed, the biographical index. This type of source indexes biographical data appearing in directories and other types of sources. There are general indexes of this sort which cover people in all walks of life, such as *Biography and Genealogy Master Index*,[3] or people who have published writings of one kind or another, such as *Author Biographies Master Index*.[4]

These sources are usually alphabetical by last names of the people covered, providing citations to biographical directories where further information may be found. Another biographical index that covers figures in all occupations, and is published in periodical format like a periodical index, is *Biography Index*.[5] This source indexes biographical data appearing in separately published monographs or in periodicals, and is used exactly like *Art Index* (H.3.). Incidentally, *Art Index* and *RILA Abstracts* (H.7.) also list articles of a biographical or critical nature under the name of the biographee, as do many other periodical indexes.

There are at least two useful biographical indexes that cover artists and other figures in the art world specifically. The first, and best-known, is *Mallett's Index of Artists* (D.60.). This index, originally published in 1935, with a supplement published in 1940 to update it to about 1939, covers artists in all media and indexes almost all of the major art biographical sources that were available at the time it was published. The second, a more recent tool that supplements but does not supersede Mallett, is Patricia Havlice's *Index to Artistic Biography* (D.39. and D.40.). Both of these tools work similarly, as will be seen from the illustrations in figures 9 and 10.

Both Mallett and Havlice arranged their indexes alphabetically by the artists' names, providing basic biographical data. Mallett indexed most of the major art biographical directories, as well as several general sources, such as the *Dictionary of American Biography*,[6] a major source for Americans in all fields, and its British counterpart the *Dictionary of National Biography*.[7] In addition, he covered several dozen of the most important specialized biographical directories for various media and nationalities, and a large number of comprehensive art historical works. Havlice indexed sixty-four later works and more recent artists in sources not already covered by Mallett. Havlice's first supplement, published in 1981, covers some seventy additional sources and adds more current coverage (D.40.). In either index, one looks alphabetically under the artist's name and compares abbreviations for the biographical sources with the bibliography of sources found in the front of each.

To illustrate how this works, figure 9 shows an example from Mallett of an actual citation, with arrows showing some of the sources to which it refers. The source lists are divided into general reference works, with alphabetical abbreviations, and additional specialized directories and histories, cited numerically. The scope of the reference sources included emphasizes the fact that a great deal of information is to be found on

Figure 9

Illustration from *Mallett's Index of Artists*, reproduced by permission of the publisher.

MALLETT'S INDEX OF ARTISTS

SOURCES OF BIBLIOGRAPHICAL INFORMATION: II

Selected volumes of biographical and critical data referred to in the Index by numbers

1 Isham, S. History of American painting. New York, 1905; with supp. chapters, by R. Cortissoz. New York, 1927.
2 Dunlap, W. History of the rise and progress of the arts of design in the United States. New York, 1834. 2 vols.; new ed., by F. W. Bayley and C. E. Goodspeed. Boston, 1918. 3 vols.
3 French, H. W. Pioneers of art in America; art and artists in Conné 1879.
4 Tuckerman, H. T. Book New York, 1867.
5 Mcspadden, J. W. Famo America. New York, 19
16 Bolton, T. Early American

HOMER, WINSLOW.
 Am. Boston 1836-1910 Scarboro, Mass.
 AOB·B·C·DAB·E·F·T·1(4)5·15·22·32·35·46·51·69·70·71·96·104·105·108·109·127·128·138·172·405·691·697·701·702·748·762·779·807·826.
HOMMEL, KONRAD.
 Bav. b. Mainz, Ger. 1883; ex. 1933 Pittsburgh, Pa. T.
HONDECOETER FAMILY.
 Dut. ac. 15-16 centuries in Holland. T.
HONDECOETER, GILLIS [or Jelis] CLAESZ D'.
 Dut. ac. 1602-1638 in Amsterdam. B·T.
HONDECOETER, GIZSBERT GILLIS D'.
 Dut. Utrecht 1604-1653 Same. B·T.
HONDECOETER [or Fondekoeter], MELCHIOR D'.
 Dut. Utrecht 1636-1695 Amsterdam.
 B·Bd·C·E·T·722.

SOURCES OF BIOGRAPHICAL INFORMATION: I

General reference works referred to in the Index by letters.

A American art annual. v. 1-31 (1898-1934). Washington, D. C.
 Contains biographical data regarding living American artists, lists of associations, sales, obituary notices, etc. Reference is to vol. 30, [1933] unless another year is indicated i.e. AX1 refers to Amer. Art Annual Vol. XI.
AO The letter O indicates that the obituary section of the volumes should be consulted.
B Bénézit, E. Dictionnaire critique et documentaire des peintres, sculpteurs, dessinateurs & graveurs, de tous les temps

The author's file of biographical material about artists, not generally listed in other reference books.

Ma Müller, H. S., and Singer, H. W. Allgemeines Künstler-Lexikon. Frankfurt a. M., 1895-1922. 7 vols.
T Thieme, U., and Becker, F. Allgemeines Lexikon der bildenden Künstler von der Antike bis zur Gegenwart. Leipzig, 1907-1934. 28 vols.
 Not yet completed.
Ta Taft, L. History of American sculpture. New York, 1st ed., 1924; new ed., 1930.

ABBREVIATIONS IN THE ENTRIES ARE INTERPRETED IN THE LISTS OF SOURCES INDEXED

Figure 10

Illustration from Havlice's *Index to Artistic Biography*, reproduced by permission of Scarecrow Press, Inc.

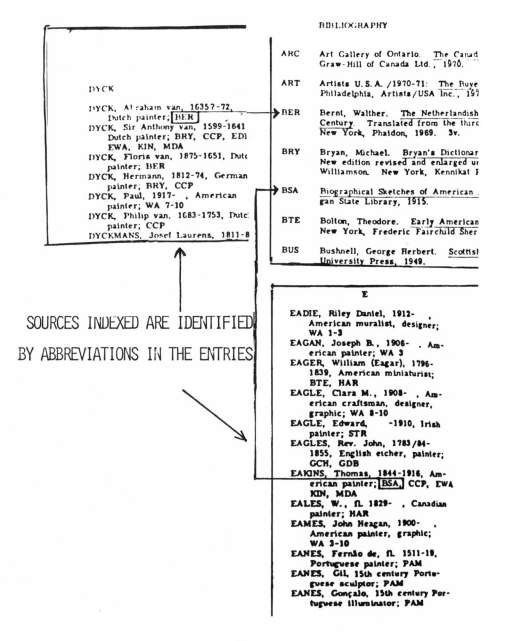

HAVLICE'S INDEX TO ARTISTIC BIOGRAPHY

SOURCES INDEXED ARE IDENTIFIED BY ABBREVIATIONS IN THE ENTRIES

major artists in the large national biographies and general encyclopedias, as well as in art sources. In figure 10, two examples of citations from Havlice's index show a more straightforward arrangement, aided by the clarity of its modern typography. Between the two indexes, however, it is possible to locate biographical data on a large percentage of the major artists of all eras and nationalities.

BIOGRAPHICAL SOURCES BY MEDIUM

Architects

The biographical literature of architecture includes all the classes of biographical reference sources, plus an additional one, a major library catalog in printed book form. One of the most comprehensive architectural libraries in this country, perhaps in the world, is the Avery Memorial Architectural Library at Columbia University. The multivolume *Catalog of the Avery Memorial Architectural Library* (A.10.) can provide good leads to architectural titles to look for in any library. The same library has produced a biographical index for architects, the *Avery Obituary Index of Architects and Artists* (A.11.). This index lists the obituaries of famous architects appearing in newspapers and periodicals, rather than listings in biographical directories. Since obituaries commonly review the life and accomplishments of the deceased, this can be a good source for biographical data.

Two excellent encyclopedic references for architects also exist. The first, although older, offers reliable information. This is Sturgis's *Dictionary of Architecture and Building* (B.74.), originally published in 1902 and reprinted in 1966. More recently, a new and monumental source for architectural biography, published in four volumes, was provided by Adolf Placzek and his associate editors and contributors in the *Macmillan Encyclopedia of Architects* (C.35.). This tool provides comprehensive biographical and critical sketches on the architects and their works, including some substantial articles on architectural firms and partnerships. Still another source for biographical and general information on architecture is a very recent bibliography by Donald Ehresmann, *Architecture: A Bibliographic Guide* (A.48.). Because it includes listings of reference works, histories, and handbooks, this tool will be covered in more detail in the art history chapter, but it should not be overlooked here, as an entire section consists of listings of works on individual architects. Still another architectural reference exists for the modern period, the *Encyclopedia of Modern Architecture* (C.33.), edited by Wolfgang Pehnt and others. A large number of the articles in this source are biographical, and some cover the history and work of architectural firms.

American

American architects are covered in a wide variety of sources, not the least of which is Lawrence Wodehouse's comprehensive bibliography *American Architects: A Guide to Information Sources* (A.116.), a two-volume guide alphabetized by architects' last names, and directing the student to books and articles about the individuals and their works. Another bibliography, although earlier in date, offers coverage of American architects and their works up to 1860 in the eastern and central United States. This is the *Bibliography of Early American Architecture* (A.95.) by Frank J. Roos, Jr. Another source for historical data on American architects is the directory by Withey and Rathburn, the *Biographical Dictionary of American Architects (deceased)* (D.100.). Living figures are located in the official directory published by the American Institute of Architects, its *American Architects Directory* (D.4.), although caution is advisable here since this tool is not updated as often as it might be. Still one other recent source provides some biographical data on American architects, the *Encyclopedia of American Architecture* (C.20.) by William Dudley Hunt, Jr. Although the emphasis here is on styles and history, there are also good biographical sketches for many individuals.

British

Great Britain, far from being outdone by the United States, also has many good sources for architectural biography. One of the earliest directories for British architects is John Harvey's *English Medieval Architects: A Biographical Dictionary Down to 1550* (D.38.), which covers most important early figures. One of the best and most comprehensive directories, including many Irish and other non-British figures, is Howard Colvin's *Biographical Dictionary of British Architects, 1600–1840* (D.19.). As may be seen from the title, this tool picks up very nearly where Harvey left off and continues into the nineteenth century. Lawrence Wodehouse then took up the gauntlet at 1840 and provided a bibliography similar to his work for Americans, his *British Architects, 1840–1976: A Guide to Information Sources* (A.117.).

Among bibliographies for British architects and architecture, one of the most comprehensive and most recent is Ruth Kamen's *British and Irish Architectural History* (A.68.), published in 1981. A little earlier, but somewhat less comprehensive, is Colvin's *English Architectural History: A Guide to Sources* (A.36.), published in 1976. With a slightly different emphasis, but still useful for some contemporary individuals not covered elsewhere, is the *Bibliography of Design in Britain, 1851–1970* (A.37.) by Coulson.

Sculptors

Sculptors, like architects, are covered in fewer separate sources than painters and draughtsmen. Many of them may be found, of course, in the general sources for the arts cited above, or in the general art dictionaries and encyclopedias for their countries. Fewer sculptors and architects are included in most of these sources, however, and so it is fortunate that in the last decade or so some scholars have concentrated their efforts on these artists.

As in many other areas, it was collectors and their interests who prompted the compilation of the first major biographical directory for sculptors. In 1969, the Antique Collectors' Club of Great Britain published a *Dictionary of Western Sculpture in Bronze* (B.47.) edited by James McKay. Although it includes only sculptors of Western nations who worked in bronze, it is a good starting place. Indeed, bronzes are the emphasis also in a more recent tool, the *Encyclopedia of Bronzes, Sculptors, & Founders, 1800–1930* (B.7.), published in four volumes from 1974 to 1980. Again, the scope of this source is limited in time and in medium, covering only nineteenth- and early twentieth-century sculptors, but it is another step in the right direction and can be helpful if the sculptor sought is within its confines. Starting in the late nineteenth and continuing through the first half of the twentieth centuries, Robert Maillard and his associates compiled a *Dictionary of Modern Sculpture* (B.50.), which was published in 1962. While this one is not limited to bronzes, the time factor still limits its usefulness.

When it comes to the sculptors of Western nations, some specialized tools provide fewer limits in scope than the more general ones. However, there are still few good sources for information on non-Western sculptors, and some of the Western ones are covered for only part of their history. French sculptors are in this category, with a two-volume directory for the seventeenth and eighteenth centuries, but none for other eras. This source, *French Sculptors of the 17th and 18th Centuries* (D.90.), by François Souchal, was published 1977–1981, so there is still the possibility that other periods will be covered by future scholars.

British sculptors have fared better than their colleagues across the Channel, but both of the major tools for their biography are somewhat dated by now. The more comprehensive of the two is Maurice Grant's *Dictionary of British Sculptors from the XIIIth Century to the XXth Century* (D.35.), which covers a large part of British sculptural history. However, it was published thirty years ago, so it is in need of updating. Fifteen years after Grant's work, Rupert Gunnis updated it by compiling a tool for the late seventeenth through early nineteenth centuries, his *Dictionary of British Sculptors, 1660–1851* (D.36.). Between the two, there

is fair historical coverage of British sculptors, but much remains to be covered of the more recent sculptural history.

Across the Atlantic, the Americans have done somewhat better in providing biographical coverage for their sculptors. Although there are only two major references for American sculptors, both published in the last decade, they do cover the history of American sculpture satisfactorily. The one biographical directory for American sculptors was published in 1984, the *Dictionary of American Sculptors* (D.76.) by Opitz. It may be supplemented, however, by the use of a bibliography by Janis Ekdahl, *American Sculpture* (A.50.), which provides guidance to sources of biographical data and background material. In addition, American women sculptors find coverage in Virginia Watson-Jones' *Directory of American Women Sculptors* (D.96.), published in 1986.

Only one other country boasts a separate source in English for information on its sculptors, and only those from the Romanesque era. That country is Italy, and the source in question was, again, published in recent years. Entitled *Italian Romanesque Sculpture* (A.55.), it was compiled by Dorothy Glass and published in 1983. It provides annotated listings for materials on the sculptors and history of sculpture in Italy during the Romanesque period.

Painters

Painting has long been the medium among the visual arts that has received the most attention from scholars, and the compilers of biographical reference works are no exception. One of the earliest biographical directories of painters, *Bryan's Dictionary of Painters and Engravers* (D.13.), was originally published in five volumes from 1926 to 1934, but has been reprinted as recently as 1964, indicating the lasting utility of the data contained in it. In 1969, John Canaday published a multivolume *Lives of the Painters* (D.15.), which updates some of the data from Bryan and adds some later figures, and in 1981, the *Larousse Dictionary of Painters* (D.53.) was translated from its original French edition and published in this country. Additional data may be found on many painters in Bernard Myers' *Encyclopedia of Painting* (C.28.), or in McColvin's earlier but useful bibliography, *Painting: A Guide to the Best Books* (A.79.).

Several somewhat narrower directories also exist for periods or schools of painters. For the late nineteenth century, there is the *Dictionary of Victorian Painters* (D.101.) by Christopher Wood. For the modern period there are two, the *Dictionary of Modern Painting* (B.44.) by Lake and Maillard, and the *Dictionary of Abstract Painting* (B.6.) by Berckelaers. For early Italian painters, there is a very recent bibliography by James Stubblebine, *Dugento Painting: An Annotated Bibliography* (A.105.).

European painters of the twentieth century may be located in a bibliography by Cutul, *Twentieth-Century European Painting* (A.41.), published in 1980. Those of individual European countries enjoy varying coverage, depending on their periods, schools, and genres. For the Netherlands, Walther Bernt compiled a comprehensive directory for the seventeenth century, his *Netherlandish Painters of the 17th Century* (D.9.), but other eras are included only in the more general sources listed above. One group of British painters are covered in Burbidge's two-volume *Dictionary of British Flower, Fruit, and Still Life Painters* (D.14.), but other genres have no similar coverage. Italian painters of all periods are included in the *Dictionary of Italian Painting* (B.18.) published in 1964, but because it encompasses so much, this tool is necessarily selective.

American painters may be found in several of the general directories cited above for American artists in general, most notably the works by Fielding and Opitz. In addition, an excellent bibliography was published in 1974 that provides more data for American painters, Keaveney's *American Painting* (A.70.) This work includes listings for materials on individuals in a separate section, as well as historical and critical material in general.

Somewhat surprisingly, Oriental painters are covered in an ample number of sources. Chinese painters are provided with a seven-volume directory by Osvald Siren, *Chinese Painting: Leading Masters and Principles* (B.69.), and their works are also covered in the *Annotated Bibliography of Chinese Painting Catalogues* (A.74.), a bibliography published in 1973. For Japanese painters, there is an *Index of Japanese Painters* (D.88.), compiled by the Society of Friends of Eastern Art.

Some specialized groups of painters provided with biographical references include painters in watercolor and miniature painters. For British watercolor painters, H. L. Mallalieu has published a *Dictionary of British Watercolour Artists up to 1920* (D.59.) in two volumes. British miniature painters may be found in Daphne Foskett's *Dictionary of British Miniature Painters* (D.33.), published in 1972. American miniaturists also have their own directory, *American Miniatures, 1730–1850* (D.97.), although this is older and should be updated by using later, though more general sources, as well. Miniaturists in general are also covered in J. J. Foster's *Dictionary of Painters of Miniatures (1525–1850)* (D.34.), although this work is selective and the emphasis is on British figures.

Graphic Artists

Within the definition of graphic arts, for the purposes of this chapter, are commercial designers, printmakers, photographers, calligraphers, illustrators, and cartoonists and caricaturists. Although it is equally important to painting and to interior decoration, design will be treated

here, as it is also an integral part of graphic and commercial art. Interior design will be treated later with the decorative arts.

Two general directories exist for graphic artists, general because they include artists in more than one medium. One of these is the *Facts on File Dictionary of Design and Designers* (D.51.) by Simon Jervis. Although it includes interior designers as well as commercial and graphic artists, it is included here as the only available source of its type. The other source, *Who's Who in Graphic Art* (D.6.), covers contemporary individuals, with a full-page entry for each artist, giving biography, address, and illustrations of major works. Originally edited by Walter Amstutz, the second edition was published in 1983. A third general directory for contemporary figures in the design field was published in 1984, entitled *Contemporary Designers* (D.20.) This work includes the decorative arts as well as the graphic arts, and provides one more source for both fields.

In printmaking, there are several possible sources one may turn to for biographical data. Not infrequently, the general directories for printmakers cover engravers primarily or solely. Such is the case with two British sources, the *Dictionary of British Steel Engravers* (D.46.) by Basil Hunnisett, and the *Dictionary of Victorian Engravers, Print Publishers and Their Works* (D.29.) by Rodney Engen. While the former is unlimited by time period, the latter covers more figures outside of engraving per se, but both can be very useful. Two bibliographies exist to guide the researcher to printmakers of other nationalities and eras. The first, published in 1979, is Lauris Mason's *Print Reference Sources: A Select Bibliography, 18th–20th Centuries* (A.83.). The second, by Mason and Joan Ludman, is *Fine Print References* (A.78.), published in 1982.

For book illustration, there are several good sources of biographical data, although no one of them includes all nationalities and eras. The British are best covered, beginning with Simon Houfe's *Dictionary of British Book Illustrators and Caricaturists 1800–1914* (D.45.). As the title indicates, this work also covers caricaturists of the same time period. Somewhat narrower in time period, but still useful is the *Bibliography of British Book Illustrators, 1860–1900* (A.15.) by Baker. The most comprehensive source for illustrators is not a directory, but a bibliography by Victor Joseph Brenni, *Book Illustration and Decoration: A Guide to Research* (A.24.), published in 1980. For contemporary illustrators, there is a very recent directory by Lucy Micklethwait and Brigid Pippin, *Book Illustrators of the Twentieth Century* (D.63.), published in 1984.

Two good directories for photographers have been published in the last fifteen years. The most comprehensive of these is the *Macmillan Biographical Encyclopedia of Photographic Artists and Innovators* (D.12.), published in 1983. This work includes those photographers and photographic inventors who have made major contributions to the development of the photographic arts and technology. The second is *Early*

Photographs and Early Photographers: A Survey in Dictionary Form (D.62.)
by Oliver Matthews, covering the early history of photography. A good
general bibliography for photography was published by Albert Boni in
1962, his *Photographic Literature: An International Bibliographic Guide to
General and Specialized Literature* (A.21.), although it is now somewhat
dated. The most current source for data on contemporary exhibiting
photographers and their works is a volume in the Modern Art Biblio-
graphical Series from Clio Press, *Photography* (A.93.), published in 1982
and scheduled for regular updating. Two special groups also covered
in separate bibliographies are black photographers, and the American
photographers, many major in importance, who worked for the Farm
Security Administration during the depression. The black photographers
are covered in *Black Photographers, 1840–1940* (A.115.) by Deborah Willis-
Thomas, and the depression photographers in *Photographers of the Farm
Security Administration* (A.45.) by Penelope Dixon and Fortune Ryan.

Besides the one source for British caricaturists mentioned above, there
is a comprehensive directory for cartoonists of all nationalities and eras.
It covers their works as completely as their lives and even contains
listings for their characters. This tool is Maurice Horn's *World Encyclopedia
of Comics* (C.19.), a monumental two-volume work published in 1976,
which is a delight to browse through as well as to use for research.
Calligraphers are not so generously covered in reference works, but there
is one good bibliography on calligraphy that also accesses biographical
data to some extent. This is *Calligraphy: A Sourcebook* (A.42.) by Jinnie
Y. Davis and John V. Richardson, published in 1982.

Decorative Artists

The decorative arts can boast a number of good general directories,
all of which have been prepared in the last ten years. Until that recently,
there was little emphasis on, or interest in, the decorative artist, as
opposed to the decorative art works. Collectors and historians have
provided excellent dictionaries of terminology, styles, and the like for
the decorative arts for more than a century. The creator of the decorative
arts, though, was considered primarily an artisan producing useful, if
often pleasant objects. In modern times, however, increased interest in
the creative individual, in whatever medium, has given rise to the de-
mand for information on artists in all fields.

Some information on this type of artist was included in the 1975 *Oxford
Companion to the Decorative Arts* (B.56.), but the emphasis here is still
mostly on the object rather than its creator. One must still turn to spec-
ialized areas of the decorative arts for the most informative reference
tools. However, there is now a directory for designers and others in this
area that provides basic data on decorative artists exhibiting in the major

galleries and museums of the world. One of the volumes in the Modern Art Bibliographical Series from ABC-Clio, it is entitled simply *Design* (A.44.) and is based on data from the databases for *Artbibliographies Modern* (H.4.), as well as from questionnaires filled out and returned by galleries and museums.

Most recent is a biographical directory published for currently active designers in many media, some in the graphic arts, but many in the area of the decorative arts as well. Published in 1984, *Contemporary Designers* (D.20.) provides biographical sketches, critical essays, and bibliography on about 600 contemporary figures. In addition, there is the comprehensive bibliography compiled in the 1970s by Donald Ehresmann, *Applied and Decorative Arts* (A.47.), which offers access to biographical as well as historical and theoretical materials.

For specialized groups within the decorative arts, there is more help. One of these groups is women decorative arts workers, who are covered in the *International Dictionary of Women Workers in the Decorative Arts* (D.79.) by Prather-Moses. This tool covers all of history up to the early twentieth century, a tall order indeed, but it does it thoroughly and accurately. For one specialized period within this genre, the late nineteenth and early twentieth centuries, there is the *Encyclopedia of Decorative Arts, 1890–1940* (C.14.) by Philippe Garner, but the emphasis here is decidedly on the object rather than the creator. It is not until one gets to specific media in the decorative arts, and/or national and period groupings of individuals, that the most help exists. A good example of this is the bibliography *American Decorative Arts and Old World Influences* (A.102.) by David Sokol. Here again, there is more information on the object, but there is also coverage of the artists as well.

For interior decoration, the major source of general information is still the 1961 bibliography by Lackschewitz, *Interior Design and Decoration* (A.72.), although it is somewhat outdated now. For the designers and builders of furniture, one of the chief elements of interior decoration, there is more guidance. The most comprehensive directory is still Hugh Honour's *Cabinet Makers and Furniture Designers* (D.44.), published in its American edition in 1969. Also published in 1969, John Gloag's *Short Dictionary of Furniture* (B.26.) offers some additional help, since it includes more than 2,600 entries, some of which are articles on designers. For Americans, however, there are two good tools, Ethel Hall Bjerkoe's *Cabinetmakers of America* (D.10.), published in 1978, and Luke Vincent Lockwood's 1967 compilation on *Colonial Furniture in America* (C.25.).

For French furniture makers, there is Hinckley's *Directory of Antique French Furniture, 1735–1800* (D.41.), which is somewhat narrow in its time span, and emphasizes the designs more than the designers, but is still useful. More recent and comprehensive is José Claret Rubira's *Encyclopedia of French Period Furniture Designs* (B.13.), although this work

still does not deal entirely with the designers. For the British, only the nineteenth century is covered, in Edward Joy's *Pictorial Dictionary of British 19th-Century Furniture Design* (B.40.).

While there are no biographical directories for metal workers as such, there is a dictionary that provides some biographical data for British and American silver- and goldsmiths. This is Michael Clayton's *Collectors' Dictionary of the Silver and Gold of Great Britain and North America* (B.14.), published in 1971. There are, however, numerous directories designed to help identify the makers of metalwork pieces, and some data on their biographies may be located through the Ehresmann bibliography cited above.

The closest thing to a biographical source for glassmakers and stained-glass artists is Phoebe Phillips's *Encyclopedia of Glass* (B.59.), published in 1981. For stained glass, however, there are three good bibliographies that may lead to biographical data. In 1980, an American one was published, entitled *Stained Glass: A Guide to Information Sources* (A.23.) compiled by Darlene Brady and William Serban, and in 1983 the British published a *Bibliography of Stained Glass* (A.51.) by David Evans. Also in 1983, an excellent bibliography for early stained glass was compiled by Madeline H. Caviness and E. R. Staudinger, *Stained Glass before 1540* (A. 31.). Directories of potters' and ceramicists' marks and signatures abound, but most include little or no biographical information. The only exception is one for Americans by Paul Evans, and the biographical data in it is minimal. Entitled *Art Pottery of the United States* (C.11.), it was published in 1964 and concentrates on the marks and identification of art pottery. Some additional biographical data may be found through Susan Strong's *History of American Ceramics: An Annotated Bibliography* (a.104.) and Ruth Weidner's *American Ceramics before 1930: A Bibliography* (A.109.). For non-American potters and ceramicists there is James Campbell's *Pottery and Ceramics: A Guide to Information Sources* (A.29.).

Other decorative artists, such as textile designers, for example, are not yet covered in biographical directories of their own. For these, one must turn either to the general art biographical sources, to the general sources for textiles (or other media), the periodical indexes, or general art bibliographies and encyclopedias.

NOTES

1. For further discussion of these factors, see Gerd Muehsam, *Guide to Basic Information Sources in the Visual Arts* (Santa Barbara, Calif.: ABC-Clio, 1978).

2. See also the discussion in Lois Swan Jones, *Art Research Methods and Resources* (Dubuque, Iowa: Kendall/Hunt, 1978).

3. *Biography and Genealogy Master Index*. 2d ed. 8 vols. and supplements for

1981–1982 (3 vols.), 1983 (2 vols.), and 1984 (1 vol.) (Detroit: Gale Research Co., 1980–1984).

4. *Author Biographies Master Index.* 2d ed. 2 vols. (Detroit: Gale Research Co., 1984).

5. *Biography Index.* Quarterly with annual and three-year cumulations. (New York: H. W. Wilson, 1946 to date).

6. *Dictionary of American Biography.* 17 vols. and supplements to date. (New York, New York: Charles Scribner's Sons, 1930).

7. *Dictionary of National Biography.* 22 vols. and supplements to date. (Oxford, England: Oxford University Press, 1882–1953).

5

Art History Sources: Putting the Artist in Context

GENERAL SOURCES AND CONSIDERATIONS

The study of art history is primarily concerned with placing the artists and their works into the context of the eras in which they lived. No one lives in a vacuum; artists of all times have been influenced by such forces as their fellow artists, other people, historic events, and the socio-economic climate in which they lived. By the same token, they have left an impression on their surroundings, and both sides of this picture make up what is known as art history.

Investigations of an art historical nature use many of the sources discussed in other chapters in this book, such as biographical material, analytical and critical sources, iconographical sources, and many others. There is a core of references, however, that is aimed primarily at leading the student to the sources for the history of art. It is this group of tools that will be discussed in this chapter.

Bibliographies

One of the best bibliographies with which to begin an art history project is the *Guide to the Literature of Art History* (A.6.). Compiled by Arntzen and Rainwater, this is a comprehensive tool that provides listings of all types of materials for art historical research, most with annotations to aid in choosing the most helpful sources. Its predecessor,

the *Guide to Art Reference Books* (A.32.) by Chamberlin, includes some earlier sources. Other bibliographies may also be useful, such as Ehresmann's *Fine Arts: A Bibliographic Guide to Basic Reference Works, Histories, and Handbooks* (A.49.), second edition, 1979; the somewhat earlier *Art Books: A Basic Bibliography of the Fine Arts* (A.75.) by Lucas; or its predecessor, the *Harvard List of Books on Art* (A.76). In addition, many early art bibliographies may be found through Theodore Besterman's *Art and Architecture: A Bibliography of Bibliographies* (A.19.).

Many handbooks and guides to art research also contain bibliographies to help the student begin art historical research. Such tools include the 1965 work by Neville Carrick, *How to Find Out About the Arts: A Guide to Sources of Information* (A.30.), and Bernard Goldman's *Reading and Writing in the Arts* (A.56.), the revised edition of which was published in 1978. Both of these are good places for the beginning student to start. Two sources also published in 1978 are even more comprehensive, Lois Swan Jones' *Art Research Methods and Resources* (A.67.) and *Guide to Basic Information Sources in the Visual Arts* (A.84.) by Gerd Muehsam. All of these books also provide advice on research methods and bibliographical style and, for that reason, can be especially helpful for the art history student.

Some media and topics about which it is difficult to find information in selective bibliographies may be covered in more general ones. A comprehensive series of such general sources was recently published by R. R. Bowker, beginning with *Art Books, 1950–1979* (A.8.), published in 1980. A 1981 volume, *Art Books, 1876–1949* (A.7.), picked up earlier works, and the 1984 version, *Art Books, 1980–1984* (A.9.) carries the coverage up to the present. All three of these volumes are arranged by subject, with indexes by author and title, and books in print at the time of publication are indicated. The volume for 1950–1979 also contains an international directory of museums that have published catalogues of their permanent collections, with listings for the catalogues, and an added feature in the volume for 1876–1949 is an international listing of periodicals.

The catalogs of major art libraries in universities or museums also serve as bibliographies, especially since they usually provide the subject approach not always available in other bibliographies. One of the most widely available library catalogs in printed form is that of the New York Public Library. Entitled *Dictionary Catalog of the Art and Architecture Division of the New York City Research Libraries* (A.87.), it was published in thirty volumes in 1975, and the *Bibliographic Guide to Art and Architecture* (A.20.) updates it annually. Students using these catalogs should be sure to check both the original catalog and the annual supplements in order to cover both early and later materials. Another large library catalogue worthy of special note is the *Catalogue of the Harvard University Fine Arts*

Library (A.60.), published in fifteen volumes in 1971 and including the fine collection of auction sales catalogues at Harvard. For modern art as well as historical research, the *Catalog of the Library of the Museum of Modern Art* (A.85.), published in fourteen volumes in 1976, is helpful, and for all areas of art research the forty-eight volume *Library Catalog of the Metropolitan Museum of Art* (A.89.), second revised edition published in 1980, is an excellent choice.

Dictionaries and Encyclopedias

The dictionaries and encyclopedias of art mentioned in other chapters are also useful for art historical research. Some, however, are especially aimed at this area. Specifically, Pierce's *From Abacus to Zeus: A Handbook of Art History* (B.60.), second edition 1977, emphasizes historical terms and topics, and includes references to iconographical subjects. The longer articles in some multiple volume encyclopedias also treat historical topics in detail, especially in the *Encyclopedia of World Art* (C.10.) and Sir Lawrence Gowing's *Encyclopedia of Visual Art* (C.16.). Two somewhat shorter but still useful encyclopedias, each in five volumes, are the *McGraw-Hill Dictionary of Art* (C.26.), published in 1969, and the *Praeger Encyclopedia of Art* (C.37.), published in 1971.

Shorter dictionaries are good quick sources for terminology and identification, and some include historical subjects in their coverage. One of the earliest, the *Encyclopedia of the Arts* (C.43.) by Dagobert Runes, was originally published in 1946 and reprinted in 1982. The *Visual Dictionary of Art* (B.36.) by Ann Hill, and the *Oxford Companion to Art* (B.55.), edited by Harold Osborne, are similar in their emphasis on art styles and movements as well as terminology. The *Adeline Art Dictionary* (B.1.) covers mostly terms, but can be useful for clarification of some of them. Two others which cover both art history and biography are Peter and Linda Murray's *Dictionary of Art and Artists* (B.52.) and the very recently revised *Thames and Hudson Dictionary of Art and Artists* (B.71.), edited by Nikos Stangos.

Indexes and Abstracts

To cover the most recent developments and specialized portions of a topic, the student needs periodical literature as much in art historical research as in other areas. While indexes to this material exist for many media and specialized areas of the arts, there are several good ones that are general in coverage as well, and these are excellent sources for art historical material.

Both *Art Index* (H.3.) and *RILA Abstracts* (H.7.) have been covered in some detail in chapter 2, but they are also useful in this area. For his-

torical purposes, it is important to keep in mind that the former goes back to 1929, while the latter began publication in 1975, but both cover historical topics thoroughly. Students dealing with nineteenth- or twentieth-century topics will want to try *ArtBibliographies Modern* (H.4.), and its predecessor *LOMA: Literature on Modern Art* (H.14.), since their emphasis is on this period. Another recent source for periodical information is the *Arts and Humanities Citation Index* (H.5.), which works a little differently than other periodical indexes. Its purpose is to trace references from one article to another, providing a logical chain of citations on a given topic. When an article on a subject is located in it, one finds a list of other articles in which it is cited, as well as articles which have been cited by the author as sources.

Two other indexes available in some libraries are printed versions of indexes produced internally in major art libraries. The first, the *Index to Art Periodicals* (H.6.) of the Ryerson Library at the Chicago Art Institute, was published in eleven volumes in 1962 and is updated with supplements. The other, from the Art Reference Library of the Frick Museum, its *Frick Art Reference Library Original Index to Art Periodicals* (H.13.), was published in twelve volumes in 1983.

SOURCES BY COUNTRY AND REGION

Art history sources for various countries and regions include such tools as bibliographies, dictionaries and encyclopedias, and handbooks, but some areas are better covered than others. America is very well covered, for example, as are the early classical civilizations, but Great Britain and other European countries tend to be better covered in sources that are specialized by medium. Individual countries in the western hemisphere are generally amply covered, but a few, such as those in Latin America, are covered only in sources that include all of the continent.

Ancient Greek and Roman Art

Since most of Western art history looks to the ancient schools of Greece and Rome for its origins, the art history of these civilizations is intimately tied in with that of the Western world in general. However, until the last ten or fifteen years, there were few reference tools covering this very important subject separately, although histories were numerous.

There is one very thorough bibliography for the art of the Greeks and Romans, the *Annotated Bibliography of Greek and Roman Art* (A.38.), by William Coulson, published in 1972. In addition, there is a good dictionary for Greek art, the *New Century Handbook of Greek Art and Architecture* (B.2), published in 1972 and edited by Catherine B. Avery.

Although no similar tool exists for the art of the Roman civilization, some information on its influences may be found in sources that deal with the early art history of the European countries that were once part of the Roman Empire. In addition, both Greek and Roman art are covered in Pierre Amiet's excellent volume published in 1981, his *Art in the Ancient World: A Handbook of Styles and Forms* (E.3.).

Islamic and Oriental Art

Outside of those for individual media, there are only a few reference tools dealing specifically with the art of the Islamic and Oriental nations. One very good bibliography is available for Islamic art and artists, however, by Creswell. Entitled *Bibliography of the Architecture, Arts, and Crafts of Islam to 1960* (A.39.), it was published in 1960 and has not been updated, so it is important to fill in later data from general sources and periodical articles.

The arts of the Oriental countries are covered adequately by two bibliographies. The most comprehensive, the *Harvard Outline and Reading Lists for Oriental Art* (A.96.), was edited by Benjamin Rowland, Jr., and the third edition appeared in 1967. Slightly later but limited to Chinese art is Tung-Li Yuan's *T. L. Yuan Bibliography of Western Writings on Chinese Art and Archaeology* (A.121.), published in 1975. There is, however, a very recent dictionary for China and Japan by Hugo Munsterberg, his *Dictionary of Chinese and Japanese Art* (B.51.), published in 1981.

European Art

On the European side of the Atlantic, the best coverage in English-language sources is for British and German art. British art was provided with its own annual bibliography from 1934 to 1948 in the *Annual Bibliography of the History of British Art* (A.73.), produced by London University's Courtauld Institute. Unfortunately, nothing more was published after these first six volumes, but the existing ones are still useful for some topics. In 1981, Ellis K. Waterhouse compiled a *Dictionary of British 18th-Century Art* (B.83.) which offers some additional information on that one period. However, other periods may be found in general art reference sources such as the *Encyclopedia of World Art* (C.10.), and in many media there are specialized references for Great Britain.

The art and architecture of the Balkan area is unique among the Slavic countries for being covered in an English-language source. Compiled by Slobodan Curcic and published in 1984, *Art and Architecture in the Balkans: An Annotated Bibliography* (A.40) lists material in thirteen languages on the art of Albania, Bulgaria, Yugoslavia, and the Balkan Peninsula, and it includes a listing of forty-one major periodicals.

The art of France, Germany, and many other European countries is best covered in sources published in non-English languages, such as Benezit (B.5.) for French artists, and Thieme-Becker (B.76.) for German ones. Some material in English may be located in general encyclopedias and bibliographies of art, as well as in comprehensive histories and in periodical articles. Individual media are often provided with good reference tools as well. Some coverage is also provided for these countries in sources that cover a particular period or movement rather than a medium. A good example of this type of source is John M. Spalek's *German Expressionism in the Fine Arts: A Bibliography* (A.103.), published in 1977.

Australian and African Art

The arts of Australia and Africa have only recently received attention from art historians, perhaps because of their relative isolation from other areas of the world. In addition, the arts of these two regions have been considered part of the folk and primitive arts, both less studied than European and classical art, until the twentieth century brought improved communications and transportation, making them better known to the rest of the world. In 1969, Alan McCulloch compiled the first modern source for Australian art, his *Encyclopedia of Australian Art* (B.46.), published in England. Then, in 1982, Elizabeth Hanks edited and published a comprehensive bibliography for this area, her *Australian Art and Artists to 1950: A Bibliography Based on the Holdings of the State Library of Victoria* (A.59.). A good bibliography on African art was compiled by Dominique Coulet Western and published in 1975, her *Bibliography of the Arts of Africa* (A.111.). Even more recently, Esme Berman has produced a work on South African painters, sculptors, and graphic artists which includes a historical survey of the art of that region since 1875. Published in 1983, it is entitled *Art and Artists of South Africa* (D.8.).

Latin American Art

The countries south of the Texas border have had little coverage in art historical references until the middle of this century. Scholars have begun to realize, however, that there is more to Latin American art than the fascination of the primitive and derivatives from the Spanish. In 1948, Robert Chester Smith and Elizabeth Wilder prepared their *Guide to the Art of Latin America* (A.100.), and it remained the only good source for this area until the 1980s. Then, in 1983, James A. Findlay compiled his *Modern Latin American Art: A Bibliography* (A.52.) to cover the recent artists of that region, and in 1984, Joyce Waddell Bailey provided the first of a projected four-volume *Handbook of Latin American Art* (A.14.),

a comprehensive bibliography which is to cover all media and all periods in the Latin American countries. Until this is completed, students will want to supplement the earlier bibliography and the Findlay work with articles from general art historical sources, plus material from the *Handbook of Latin American Studies*,[1] an annual bibliography that covers all aspects of Latin American culture.

American Art

The part of the North American continent that is now the United States enjoys ample art historical coverage in a variety of reference sources. The very early art of the new nation and its colonial period is covered by Frank H. Chase's *Bibliography of American Art and Artists Before 1835* (A.33.), and the less formal media which classify as folk art are covered by Simon J. Bronner in his 1984 publication, *American Folk Art: A Guide to Sources* (A.26.). A selective bibliography for American art history was compiled by David M. Sokol and published in 1976, his *American Architecture and Art: A Guide to Information Sources* (A.101.), and in 1979 the Smithsonian Institution published a four-volume, comprehensive bibliography edited by Bernard Karpel, *The Arts in America: A Bibliography* (A.69.).

The Archives of American Art, with its collection of papers, letters, and other materials relating to the history of art in America, is one of the most important repositories of primary sources for researchers in this area. Its resources were given excellent coverage in a directory edited by Garnett McCoy and published in 1972, *The Archives of American Art: A Directory of Resources* (A.80.). A guide to its collection of recorded interviews with artists and their associates was published in 1984, entitled *The Card Catalog of the Oral History Collections of the Archives of American Art* (A.3.). Another important library for American art history is that of the Whitney Museum of American Art. Its catalog was published in book form in two volumes in 1979 (A.113.).

Two good dictionaries are also available for American art, both published in the 1970s. The first was published by the Encyclopedia Britannica Corporation in 1973 and is entitled, predictably, *The Britannica Encyclopedia of American Art* (C.4.). It contains essay-type articles on all phases of American art history, many with bibliographies for further research. In 1979 an excellent dictionary by Matthew Baigell was published, his *Dictionary of American Art* (B.3.), with shorter, but still authoritative articles.

Afro-American Art

In the late 1970s and early 1980s, the emphasis on Afro-American art and artists prompted the publication of three very good sources on this

formerly neglected area of study. The first, compiled by Oakley N. Holmes and published in 1978, was a *Complete Annotated Resource Guide to Black American Art* (A.64.). In 1980, a bibliography by Lenwood G. Davis and Janet Sims was published, their *Black Artists in the U. S.* (A.43.), which includes books, periodical articles, and dissertations, and offers access to material on black artists and their works previously unlisted in any reference source. In 1981, another comprehensive bibliography appeared, by James and Lynn Moody Igoe, called *250 Years of Afro-American Art* (A.66.). With the paucity of research in this area up to the present, all three of these sources can be very useful, since each adds to and complements the other.

SOURCES BY PERIOD

Detailed information on particular periods or movements within art history can sometimes be found through specialized sources. Many such sources exist, and may usually be found through the library catalog by looking under such headings as "Art—History" with chronological sub-divisions, or under special phrase headings like "Impressionism in art."

Primitive and Ethnic Art

Early art by primitive societies, or contemporary art of particular cultures or ethnic groups, is sometimes covered only sketchily in general art history sources. A specialized bibliography can be useful, therefore, in tracking down specific materials pertaining to this field. Such a bibliography, dealing with the art of ethnic groups and tribal societies, was published in 1982: *Tribal and Ethnic Art* (A.106.). The art of prehistoric and ancient societies is also covered in a 1967 reference edited by René Huyghe, the *Larousse Encyclopedia of Prehistoric and Ancient Art* (C.23.).

Medieval and Renaissance Art

The art of the early periods of Western civilization is also provided with specialized reference tools. For the Byzantine and medieval eras, there is Huyghe's *Larousse Encyclopedia of Byzantine and Medieval Art* (C.21.), published in 1963. The same editor compiled a similar source for the Renaissance and Baroque periods the following year, his *Larousse Encyclopedia of Renaissance and Baroque Art* (C.24.). An even more specialized source was published in 1984 dealing with the influence of classical sculpture on the artists of the Renaissance. Compiled by P. P. Bober and R. O. Rubenstein, it is entitled *Renaissance Artists and Antique Sculpture: A Handbook of Sources* (F.5.), and it traces the ancient sources from which Renaissance artists drew their inspiration.

Modern Art

The art of the modern period is covered by several good reference tools, including three encyclopedias. The first, also by Huyghe, is the *Larousse Encyclopedia of Modern Art, from 1800 to the Present Day* (C.22.), published in 1965. The *Phaidon Dictionary of Twentieth-Century Art* (B.58.), second edition 1978, brings this coverage further up to date, and Harold Osborne's *Oxford Companion to Twentieth-Century Art* (B.57.), published in 1981, further updates the available material. In addition, in 1984 a bibliography by Doris L. Bell, *Contemporary Art Trends, 1969–1980: A Guide to Sources* (A.18.), provided access to many less well-known movements and trends.

Several movements and styles of the modern period of art history are covered in separate reference works. Art nouveau, for example, is covered in an annual bibliography edited by Richard Kempton, *Art Nouveau: An Annotated Bibliography* (A.71.). For impressionism, the student may consult Maurice Serullaz's *Phaidon Encyclopedia of Impressionism* (C.46.), published in 1978, and for expressionism, there is Lionel Richard's *Phaidon Encyclopedia of Expressionism* (C.40.) of the same year. Also in 1978, the same publisher produced the *Phaidon Encyclopedia of Surrealism* (C.32.), edited by Rene Passeron. It is worth emphasizing, also, that the modern period has its own index to the periodical literature in *Art-Bibliographies Modern* (H.4.) and its predecessor, *LOMA: Literature on Modern Art* (H.14.).

SOURCES BY MEDIUM

Architecture

Bibliographies

Until the late 1970s, bibliographies for architectural history were few. As early as 1965, there were specialized ones on architectural topics published in the volumes of the *Papers of the American Association of Architectural Bibliographers* (A.91.), edited by William B. O'Neal, and these continue to the present. The first systematic bibliography for all architecture, however, was Valerie J. Bradfield's *Information Sources in Architecture* (A.22.), published in London in 1983, and in 1984 Donald Ehresmann produced his *Architecture: A Bibliographic Guide to Basic Reference Works, Histories, and Handbooks* (A.48.). Even such tools as these often omit the unplanned, utilitarian architecture which is native to nearly every part of the world, but this was covered by Lawrence Wodehouse in 1980 in his *Indigenous Architecture Worldwide: A Guide to Information Sources* (A.118.).

Before these general bibliographies, there were library catalogs which

served some of the same purposes. From the United States, there is the *Catalog of the Avery Memorial Architectural Library of Columbia University* (A.10.), published in a second, enlarged edition in 1968. From the same library, there is also the *Avery Obituary Index of Architects and Artists* (A.11.) which serves as a guide to biographical matter. In addition, from 1937 to 1983, the *Catalogue of the Library of the RIBA* (A.97.) was published by the Royal Institute of British Architects.

Bibliographies on some special aspects of architecture also exist, including the literature of design and applied architecture. Lawrence Von Bamford has edited a fine bibliography for this purpose called *Design Resources: A Guide to Architecture and Industrial Design* (A.16.), published in 1984. An earlier volume limited to British architecture and design was published by the Design Council. Entitled *Bibliography of Design in Britain, 1851–1970* (A.37.), it was edited by Anthony J. Coulson and published in 1979.

In recent years, a large body of literature has appeared on the topic of historic preservation, the practice of conservation and restoration of historic buildings and environments. This literature, of special interest to architectural historians, has been covered in specialized bibliographies in the last five years. The first of these, published in 1980, is Arnold L. Markowitz's *Historic Preservation: A Guide to Information Sources* (A.82.). Since many preservation endeavors have required government funding and/or protective legislation, much material is available in the form of government documents, especially from the Congress of the United States. In 1982, Richard Tubesing compiled a guide to these materials entitled *Architectural Preservation and Urban Renovation: An Annotated Bibliography of United States Congressional Documents* (A.107.). In the same year, the President's Advisory Council on Historic Preservation published a handbook for this information, its *Where to Look: A Guide to Preservation Information* (A.112.).

There are also some good bibliographies dealing with the architecture of individual countries. For the American scene, for example, there is Henry Russell Hitchcock's *American Architectural Books* (A.63.), which lists materials of all kinds on architecture, building, planning, and related topics that were published in America before 1895. Many of these items relate not only to American architecture but to world architectural history as well. Another work that deals with early American architecture exclusively is Frank J. Roos, Jr.'s *Bibliography of Early American Architecture* (A.95.), published in 1968. It lists works on American architecture and its history before 1860 in the eastern and central regions of the country.

For British architectural history, one may consult two very useful bibliographies. The first, published in its second edition in 1976, is *English Architectural History: A Guide to Sources* (A.36.) by H. M. Colvin. The more recent one, covering both British and Irish architecture, was pub-

lished in 1981. Edited by Ruth H. Kamen, it is entitled *British and Irish Architectural History: A Bibliography and Guide to Sources of Information* (A.68.).

Dictionaries and Encyclopedias

Some general and specialized encyclopedic works are also available for architectural history. These are useful for locating summary information and citations to further sources. Encyclopedia sources of a general nature for architecture include a few from the 1960s and 1970s, but most are very recent. One of the classic earlier reference works is the *Illustrated Glossary of Architecture, 850–1830* (B.35.), compiled by John Harris and Jill Lever and published in 1966. Another, which has been a standard source since the nineteenth century, is Sir Banister Flight Fletcher's *History of Architecture on the Comparative Method for Students, Craftsmen, and Amateurs* (B.24.), revised by J. C. Palmes and published in its eighteenth edition in 1975. As the title indicates, this is primarily a history, but one that is so encyclopedic in nature and coverage that it often serves the same purposes as a reference work. Another tool of this same type is Fritz Erwin Baumgart's *History of Architectural Styles* (B.4.), which was translated from the original German and published in this country in 1970.

Some more recent sources include the *Encyclopedia of Architecture: Historical, Theoretical, and Practical* (C.31.), edited by Wyatt Papworth and published in 1982, and Henri Stierlin's *Encyclopedia of World Architecture* (C.47.) published in 1983. Also in 1982, Herbert Pothorn produced his *Architectural Styles: An Historical Guide to World Design* (C.36.), and the monumental *Macmillan Encyclopedia of Architects* (C.35.), edited by Adolf K. Plazcek, appeared. In 1984, a work oriented toward identification and study of architectural detail was compiled by John Theodore Haneman, his *Pictorial Encyclopedia of Historic Architectural Details and Elements* (C.18.). The same year, a different type of reference for architecture was published in its second edition, John Julius Norwich's *World Atlas of Architecture* (C.29.), with the emphasis on the architecture of various countries, regions, and cities.

Terminology and brief articles on styles and architectural details may be found in a dictionary such as the classic one by Russell Sturgis, the *Dictionary of Architecture and Building* (B.74.), originally published in 1902 and reprinted in 1966. Another such source is Henry Hodgman Saylor's *Dictionary of Architecture* (B.67.), which appeared in 1952. For architecture and architects of the modern period, one may consult the *Encyclopedia of Modern Architecture* (C.33.), edited by Wolfgang Pehnt and others, or Warren Sanderson's more recent *International Handbook of Contemporary Developments in Architecture* (C.44.).

There are also encyclopedias that treat the architecture of one country or region separately. For American architecture, for example, one may turn to the *Encyclopedia of American Architecture* (C.20.) by William Dudley

Hunt, Jr., or even more specific, Lester Walker's *American Shelter: An Illustrated Encyclopedia of the American Home* (C.50.), which treats only domestic American architecture. For British architecture there is *English Architecture: An Illustrated Glossary* (B.16.) by James Stevens Curl, and Cyril M. Harris's *Historic Architecture Sourcebook* (B.34.). The latter, incidentally, emphasizes British architectural history, but it is so thorough in its coverage that it is useful in studying architectural history in general. Even more specialized works also exist, for regions, limited periods of time, and special types of buildings. A good example of the latter is Michaell W. Meister's *Encyclopedia of Indian Temple Architecture: South India, Lower Dravidadesa, 200 B. C.-A. D. 1324* (C.27.).

Periodical Indexes

For access to periodical literature on architectural history, the student has several choices besides the familiar art indexes. Since 1950 the *Architectural Index* (H.1.) has appeared regularly and indexes a large number of major journals in this area. In addition, the Avery Architectural Library at Columbia University has provided the *Avery Index to Architectural Periodicals* (H.8.), the second edition of which was published in fifteen volumes in 1973. Perhaps the most comprehensive indexes to this literature, however, are published by the library of the Royal Institute of British Architects in England. Its *Comprehensive Index to Architectural Periodicals, 1956–1970* (H.15.) was published on microfilm in 1971. This was supplemented from 1966 to 1973 by the *RIBA Annual Review of Periodical Articles* (H.16.), which was superseded from 1972 to date by the RIBA's *Architectural Periodicals Index* (H.17.).

Sculpture

Students of sculptural history are not as highly favored as those who deal with architecture. There are only a few sources that treat sculpture and sculptors separately, although many of the general encyclopedias and bibliographies include them, and these should not be overlooked. In addition, it is important to note that the annual *Art Sales Index* (I.1.) now includes sales of sculpture on an international basis, making it possible to find data on auction prices, as well as descriptions of individual sculpture pieces, something that was nearly impossible before August of 1983.

There is one comprehensive encyclopedic tool for sculptural history, published in 1969. Compiled by James MacKay for collectors and connoisseurs of sculpture, it is entitled *Dictionary of Western Sculpture in Bronze* (B.47.), and it covers only the medium of bronze. Another, more recent tool covers this same medium but only for nineteenth- and early twentieth-century works. This is Berman's *Encyclopedia of Bronzes, Sculp-*

tors, and Founders, 1800–1930 (B.7.), published in four volumes from 1974 to 1980. A third source for sculpture of the modern period is Robert Maillard's *Dictionary of Modern Sculpture* (B.48.), translated from the French and published in the United States in 1962.

In recent years, some excellent bibliographies on the sculpture of various countries and periods have been prepared. This trend, if it continues, will make the work of students and other scholars much easier. A case in point is Janis Ekdahl's *American Sculpture: A Guide to Information Sources* (A.50.), published in 1977. Another, even more recent, is *Italian Romanesque Sculpture: An Annotated Bibliography* (A.55.) by Dorothy F. Glass, published in 1983. Both of these are excellent sources for the countries and/or periods covered and should serve as models for future sources.

Painting

The history of painting is blessed with several good reference works, especially for that of the western hemisphere. General sources are more limited, but they are available. The most comprehensive in scope is Eric Raymond McColvin's *Painting: A Guide to the Best Books* (A.79.), but it has not been updated since its original publication in 1934. More recent, but limited to watercolor, is the *Bibliography of Water Colour Painting and Painters* (A.77.) by Samuel Thomas Lucas, published in 1977. The single best source for the history of painting in general, and one which includes bibliographical references, is still Bernard S. Myers' *Encyclopedia of Painting* (C.28.), published in its fourth revision in 1979.

Sources limited by country or period are more plentiful. For the modern period, for example, there is the *Dictionary of Modern Painting* (B.44.) by Carlton Lake and Robert Maillard, published in its third edition in 1964. In addition, the abstract painting of the modern era is covered by a comprehensive work by Ferdinand Louis Berckelaers, his *Dictionary of Abstract Painting* (B.6.), which includes a history of the subject, published in 1957. The Italian painting of the Dugento period is covered in James H. Stubblebine's *Dugento Painting: An Annotated Bibliography* (A.105.), and Italian painting as a whole finds its source in the *Dictionary of Italian Painting* (B.18.) published by the Tudor Publishing Company in 1964.

The painting of European countries in the modern era is provided with its own bibliography by Ann-Marie Cutul in her *Twentieth-Century European Painting* (A.41.), published in 1980. Portrait painting of Great Britain is covered by a monumental work edited by Richard Ormond and Malcolm Rogers, although its emphasis is as much on the subjects of portraiture as on the paintings themselves. Their *Dictionary of British Portraiture* (B.54.), projected to include four volumes, began publication in 1980. An equally monumental source for Chinese painting is Osvald

Siren's seven-volume *Chinese Painting: Leading Masters and Principles* (B.69.), originally published in 1956 and reprinted in 1974. The year before, Hin-Cheung Lovell published his *Annotated Bibliography of Chinese Painting Catalogues and Related Texts* (A.74.), and American painting was provided, that same year, with a comprehensive bibliography by Sydney Starr Keaveney, his *American Painting: A Guide to Information Sources* (A.70.).

Graphic Arts

Design

For the history of design as treated with the graphic arts, there is one very current bibliography, published in 1983 as part of the Modern Art Bibliographical Series from ABC-Clio Press, and entitled simply *Design* (A.44.). Prior to the 1980s, however, students had another source to turn to, the *Catalog of the Library of the Graduate School of Design* (A.61.) at Harvard University, which was published in book form in 1968. For coverage of the periodical literature, one can use an index called *Art Design Photo* (H.2.), which covers modern art, graphics, design, and photography.

Drawing and Illustration

The art of drawing, often covered in reference sources that treat painting or art techniques, is sometimes considered a part of the graphic arts because of its close relationship to illustration. Its history is closely intertwined with that of art in general, so it is wise to consult general art history references for most purposes. However, for students of American drawing, there is one specialized bibliography, *American Drawing: A Guide to Information Sources* (A.46.), compiled by Lamia Doumato and published in 1979.

Book illustration is admirably covered in a recent bibliography by Vito Joseph Brenni, his *Book Illustration and Decoration: A Guide to Research* (A.24.), published in 1980. There is also a good source for late nineteenth-century British illustrators by Charles Baker, published in 1978 and entitled *Bibliography of British Book Illustrators, 1860–1900* (A.15.). Illumination, an early cousin of illustration, is usually included in graphic arts and drawing and painting references, but for locating reproductions of illuminated manuscripts, a source which indexes such reproductions from a major collection, such as *Illuminated Manuscripts in the Bodleian Library, Oxford* (A.92.) by Otto Pacht and J. J. G. Alexander, is most useful.

Prints

Prints are one of the most popular of the graphic arts for collectors, whether woodcuts, steel or copper engravings, or other types. They are covered in a number of good sources, including the catalog of the New York Public Library's excellent collection on the subject. Entitled *Dictionary Catalog of the Prints Division of the New York City Research Libraries* (A.88.), it was published in five volumes in 1975. In 1979, the second edition of Lauris Mason's fine bibliography, *Print Reference Sources: A Select Bibliography, 18th–20th Centuries* (a.83.), appeared. The most recent and comprehensive tool, however, by Mason and a colleague, Joan Ludman, is the 1982 *Fine Print References: A Selected Bibliography of Print-Related Literature* (A.78.). Also recent is the excellent bibliography on the prints of Japan compiled by Leslie E. Abrams, entitled *History and Practice of Japanese Printmaking: A Selectively Annotated Bibliography of English-Language Materials* (A.1.).

Photography

A much younger art form than prints, photography nevertheless has made its way into the world of fine art, and with it have come several good reference works for researching its history. In 1962, Albert Boni edited the first comprehensive bibliography on photography, entitled *Photographic Literature: An International Bibliographic Guide to General and Specialized Literature* (A.21.). Twenty years later, the Modern Art Bibliographical Series covered photography in a volume simply entitled *Photography* (A.93.), and in 1983, Penelope Dixon and Fortune Ryan produced their *Photographers of the Farm Security Administration: An Annotated Bibliography, 1930–1980* (A.45.), covering some of the most important photographic innovators of this country.

Some good dictionaries and encyclopedias for photography have also been provided, one of the earliest being *Early Photographs and Early Photographers: A Survey in Dictionary Form* (D.62.) by Oliver Mathews, published in 1973 in England. The next year, the two-volume *Focal Encyclopedia of Photography* (C.13.) was published in the United States. In the same year, the *Dictionary of Contemporary Photography* (B.73.) by Leslie Stroebel and Hollis N. Todd was published. The annual *International Photography Index* (D.50.) has provided access to the periodical literature since 1979, and in 1982, David N. Bradshaw compiled a useful guide to the photography collections of the world that are available for study in his *World Photography Sources* (D.11.).

Miscellaneous

Somewhat orphaned in the world of fine arts, more important to the commercial art world, is the art of caricatures and cartooning. It has not

been entirely forgotten by compilers of reference books, however, since in 1976 Maurice Horn compiled the *World Encyclopedia of Comics* (C.19.) in two volumes. This work includes not only biographical articles on cartoonists, but histories of various comic strips and characters and the art of cartooning as well.

Another art which has found its niche only in recent years is calligraphy, the art of fine lettering. It has also been considered a child of commercial art and covered only in technical references. However, in 1982, Jinnie Y. Davis and John V. Richardson provided it with its own fine source for historical, biographical, and technical information in their *Calligraphy: A Sourcebook* (A.42.).

Decorative Arts

The decorative arts as a class are covered in several useful references, most importantly in a comprehensive bibliography by Donald L. Ehresmann, *Applied and Decorative Arts: A Bibliographic Guide to Basic Reference Works, Histories, and Handbooks* (A.47.), published in 1977. Dictionaries and encyclopedias for this area include the *Illustrated Dictionary of Ornament* (B.70.) by Maureen Stafford and Dora Ware, published in 1974, and the 1975 *Oxford Companion to the Decorative Arts* (B.56.) by Harold Osborne. Both provide thorough articles on terminology, styles, decorative details and elements, and techniques and materials. These subjects, plus some biographical material, may also be found in Robert Harling's *Studio Dictionary of Design and Decoration* (B.33.), published in 1973, and the *Facts on File Dictionary of Design and Designers* (D.51.) by Simon Jervis, published in 1984. Limited in time span but covering an important period historically is Philippe Garner's *Encyclopedia of Decorative Arts, 1890–1940* (C.14.). For American decorative arts history, especially its relationship to its European roots, there is also an excellent bibliography by David M. Sokol, published in 1980, entitled *American Decorative Arts and Old World Influences* (A.102.). In addition, since 1982, access to the periodical literature in this area has been provided by the *Design Index* (H.11.).

Antiques

The most popular collectibles in the realm of the decorative arts are those items of furniture, utensils, and the like known as antiques. Material for the serious student of antiques is not as plentiful as popular literature for the collector-hobbyist, but there are good sources available. One of the most comprehensive bibliographies which lists those sources is Linda Campbell Franklin's *Antiques and Collectibles: A Bibliography of Works in English, 16th Century to 1976* (A.53.). Somewhat earlier and more

geared to the hobbyist, but also helpful for the student, is the *Random House Encyclopedia of Antiques* (C.39.), published in 1973. The most generally useful reference, but considerably earlier, is the *Dictionary of Antiques and the Decorative Arts* (B.9.) by Louise Ade Boger and H. Batterson, published in its second edition in 1967. It includes glass, furniture, ceramics, and metal, as well as articles on terminology, periods, styles, and the like. Additional information on specific classes of antiques is available in many of the more specialized sources listed in the sections that follow.

Interior Decoration

The practice of interior decoration utilizes all of the decorative arts, and for this reason it is included here before more specific categories of decorative objects. Besides the more general bibliographies, dictionaries, and encyclopedias listed above, and the specialized sources that follow, there are two excellent bibliographies that cover this field. The first, published for the American Institute of Decorators in 1961, is entitled *Interior Design and Decoration* (A.72.) and was compiled by Gertrude Lackschewitz. It may be updated by consulting the 1974 edition of a classic bibliography by Augustus Sherrill Whiton, *Interior Design and Decoration* (A.114.). More current information may, of course, be found in the *Design Index* (H.11.) and other indexes to the periodical literature.

For brief definitions of terms, styles, materials, and techniques in interior decoration, the student will find Lillian Weiss's *Concise Dictionary of Interior Decorating* (B.84.) most helpful. A somewhat more comprehensive work published in 1976 which provides lengthier and more detailed information is the *Encyclopedia of Interior Design and Decoration* (C.7.), compiled by A. Allen Dizik.

Furniture

There are several good reference sources for information on furniture of various countries and periods, but for general and comprehensive coverage, the classic *Encyclopedia of Furniture* (C.1.) by Joseph Aronson, third edition, 1965, cannot be disputed. For British furniture of the nineteenth century, there is the handy *Pictorial Dictionary of British 19th-Century Furniture Design* (B.40.) by Edward Joy, published in 1977. Although aimed at the collector rather than the scholar, dictionaries like this one can be helpful for identification purposes and general descriptive data. For American furniture of early colonial times up to the present century, much information can be found through Charles J. Semowich's 1984 bibliography, *American Furniture Craftsmen Working Prior to 1920* (A.99.).

Ceramics

Pottery and porcelain, as well as the history of ceramics in general, find their most complete coverage in a 1978 bibliography by James Edward Campbell, *Pottery and Ceramics: A Guide to Information Sources* (A.29.). In addition, Louise Ade Boger compiled a comprehensive work, published in 1971, which provides ample information on styles, terms, forms, and the like, her *Dictionary of World Pottery and Porcelain* (B.8.). If more is needed, especially illustrations of styles and details, the student should consult the *Illustrated Dictionary of Ceramics* (B.66.) by George Savage and Harold Newman, published in 1974. This latter source covers over 3,000 terms on wares, materials, processes, etc., with clear illustrations for each definition.

American ceramics are thoroughly covered by two very recent bibliographies. The first, by Ruth Irwin Weidner, was published in 1982 and is entitled *American Ceramics Before 1930: A Bibliography* (A.109.). The second, published only a year later, is entitled *History of American Ceramics: An Annotated Bibliography* (A.104.), and was edited by Susan R. Strong.

Glass

Glass as a decorative medium has come into its own only in the last few years. Whether it be blown, etched, or stained glass, it is covered comprehensively in two recent sources. The first is an encyclopedia published in England in 1981, the *Encyclopedia of Glass* (B.59.) by Phoebe Phillips. About the same time, the library of the Corning Museum of Glass produced the first supplement to an index published earlier, its *History and Art of Glass: Index of Periodical Articles, 1956–1979* (H.10.). Between the two works, most available information from twentieth-century sources on glass may be located. One earlier encyclopedia also provides much information on the history of decorative glass. Published in 1977, it is Harold Newman's *Illustrated Dictionary of Glass* (B.53.), which includes articles on terminology, processes, and materials, as well as a historical survey and entries on styles, forms, and the major glassmakers, designers, and decorators.

Stained glass has been a subject of interest to art historians for as long as there have been studies on the cathedrals of the baroque and gothic eras. Its coverage in reference sources was brought up to date only recently, however. In 1980, Darlene Brady and William Serban published a selected bibliography on the subject entitled *Stained Glass: A Guide to Information Sources* (A.23.). In 1983, a comprehensive bibliography by David Evans was published in England, his *Bibliography of Stained Glass* (A.51.), and the same year in the United States, a bibliography for the early history of stained glass was compiled and published by Madeline

H. Caviness and E. R. Staudinger, *Stained Glass Before 1540* (A.31.). These three tools provide for most information needs of students in this area.

Textiles

Textiles are yet another important element in interior design and decoration. Some of the most famous of the medieval decorative arts are the elaborate tapestries made by craftsmen of that era. The textile arts in modern times have taken on a new dimension with the advent of soft sculpture, as well as with the use of synthetics which provide a whole new gamut of properties with which the artist can work.

There are several useful bibliographies on textiles, all published in the 1970s. In 1973 Valerie H. Ralston compiled a selective one called *Textile Reference Sources* (A.94.), which identifies the reference tools appropriate for a given project. Two sources published in 1975 include a bibliography from the American Crafts Council which emphasizes technical aspects of the textile arts, *Bibliography, Fiber* (A.2.), and another by Lavonne B. Axford which emphasizes techniques, her *Weaving, Spinning, and Dyeing* (A.12.). The Axford work also includes a directory of materials suppliers. The most comprehensive historical reference on textiles, however, appeared in 1958. The *Encyclopaedia of Textiles* (C.12.), edited by Ernst Richard Flemming, includes decorative fabrics of all eras and nationalities to the beginning of the nineteenth century.

Beginning in 1976, Cecil Lubell compiled one of the most useful of references for textiles, a directory of collections worldwide. It consists of three volumes to date, each covering a different area of the world and including listings and illustrations of the most important museum collections of textiles. The first volume is *The United States and Canada* (D.56.), the second *The United Kingdom-Ireland* (D.55.), and the third volume, published in 1977, is *France: An Illustrated Guide to Textile Collections in French Museums* (D.54.).

American textiles are covered in at least two excellent reference sources, one a bibliography, the other an encyclopedic work. The bibliography is limited to domestic textiles, and it was compiled by Beverly Gordon and published in 1978 under the title *Domestic American Textiles: A Bibliographic Sourcebook* (A.57.). The encyclopedia, by Florence Montgomery, covers the last of the seventeenth century through most of the nineteenth, and it appeared in 1984 as *Textiles in America, 1650–1870* (B.49.).

NOTE

1. *Handbook of Latin American Studies.* Annual. (Gainesville, Fla.: University Presses of Florida, 1935 to date.)

6

The Art Work as Starting Point

There are several types of information commonly needed concerning the work of art itself. If the research is historical, the student generally needs to identify the object in terms of its creator, nationality, and period. It may be necessary to investigate the influence that the history and sociology of the period had on the artist and the art work. One may also want to compare this artist's works to other artists and works of that country and era.

If stylistic analysis is the purpose of the study, the student needs to determine the movement or style, such as impressionism or neoclassicism, to which the work belongs, identify its characteristics, and compare this particular work to other works of that style. If it belongs to a particular genre, such as landscape, still life, or portrait, the student needs to identify the characteristics of the genre and compare the work to others of that genre from the same, and possibly other, periods, countries, and styles. Investigating the style displayed by the artist in other works may shed some light on this particular work.

If the student wishes to study the subject matter of the work and its representation in this and other works, or determine what symbolism may have been employed by the artist, iconographical reference works will be needed. On the other hand, if a determination of the possible value of the work is sought, an entirely different type of source, such as an index to art sales, or a handbook of values, is called for. Each kind

of information requires different types of sources, although some of them may overlap in purpose.

HISTORICAL AND GENERAL SOURCES

Although historical materials have been covered in an earlier chapter, some of those sources may well be of use in a study of the work of art as well. For example, articles on styles, periods, and genres in encyclopedias like the *Encyclopedia of World Art* (C.10.) will contain data for comparing the item with others of its kind either historically or stylistically. An article on landscape painting in most art encyclopedias will identify the essentials of landscapes from many eras and styles, and cite specific examples of landscapes for comparison purposes. This information can then be applied in analyzing a particular work.

One should not overlook the possibility that there is a full-length treatise on the work in question. This is particularly likely if the work is a famous or outstanding example of its genre or style. A check in the library catalog under the name of the artist and the title of the work will quickly determine if such a book is available locally. In addition, books on the artist or compatriots of the time may discuss this particular work. Histories of a medium often provide criticism and analysis of important examples of the medium. In all of these cases, it is important to check the indexes in the books available for references to the item being studied.

It is more often the case, however, that the work under investigation is not important enough for a book-length study, and perhaps not even for a major discussion in a biographical or historical treatise. In these cases, it will be necessary to identify a bibliography on the work contained in some other source. Many indexes to periodical literature offer this kind of coverage, usually under the artist's name first, then the name of the work. *Art Index* (H.3.), for example, includes articles on a work in this manner, and they may also be identified this way in the subject index to *RILA Abstracts* (H.7.). Several very good bibliographies on periods, styles, media, or countries which were identified in the biographical and historical chapters may also uncover other possibilities.

Directories to other libraries and to organizations active in the field may identify sources within commuting distance that can offer help as well. For example, students in this country will find the *Directory of Art Libraries and Visual Resource Collections in North America* (D.42.) an excellent source for locating libraries in their area that contain materials not available at their own libraries. In addition, the current edition of the *International Directory of Arts* (D.49.) will locate galleries, museums, and the like worldwide where art works may be viewed for study, and Paul Cummings' *Fine Arts Marketplace* (D.24.) will help in locating publishing

sources of art materials, commercial galleries, dealers, and similar sources.

Students working with folk or ethnic art will need some guidance in locating material on these works which may not be available through general art bibliographies. They are covered in some detail in two very recent bibliographies. The more general is *Tribal and Ethnic Art* (A.106.), published in 1982 as part of the Modern Art Bibliographical Series. For students of American folk art, there is Simon Bronner's *American Folk Art: A Guide to Sources* (A.26.), published in 1984.

Those who find themselves faced with unfamiliar terminology will find the *Illustrated Dictionary of Art Terms* (B.65.) a handy reference, or the *Dictionary of Art Terms* (B.22.) by Elspass, and those working with the modern era may want to consult Walker's *Glossary of Art, Architecture, and Design Since 1945* (B.81.), a good quick reference for newer terminology. For terms which do not show up in these, there is an index to the location of art terms in various sources, the *Fine and Applied Art Terms Index* (B.78.) by Urdang and Abate.

INDEXES TO REPRODUCTIONS AND ILLUSTRATIONS

Ideally, of course, the student should study the work of art by examining it first hand. Occasionally, one can do this in a local museum or gallery, perhaps even starting there to choose the work to study. However, this is only possible in a large city or cultural center. The more common situation is to find oneself miles from the original work, faced with studying it from reproductions. Such reproductions of famous or important works are available in many sources.

Histories or biographies often contain full-color illustrations of the works discussed, as do periodical articles. If there is a catalogue of the collection of which the work is a part, this may provide an illustration as well, although such catalogues sometimes offer only small black-and-white illustrations, primarily for identification purposes. Oeuvre catalogues and catalogues raisonnés, discussed in more detail below, often contain good reproductions. There may be a series of volumes, known as a corpus, that undertakes to catalogue all known works of a particular genre or medium. These usually contain excellent reproductions. A good example of one of these is the *Corpus Vasorum Antiquorum*, or corpus of ancient vases.

The problem, then, becomes one of finding a source containing an illustration of the work in question among all of these riches. What is needed for this task is an index to illustrations and reproductions. Such indexes exist for most media and forms, and some attempt to provide indexing to all art works. The corpus volumes, catalogues raisonnés,

oeuvre catalogues, and many periodical articles with illustrations are indexed in *Art Index* (H.3.) and *RILA Abstracts* (H.7.), with abbreviations indicating which objects are reproduced in the catalogue or article, or with reproductions of art works listed following the articles about the artist. However, it is often faster to locate an illustration or reproduction in an illustration index.

The best-known index of this sort was compiled by Lucile Vance and Esther Tracey, and published in its second edition in 1966. This *Illustration Index* (G.17.) has since been continued for illustrations in later published works by Marsha Appel in a work by the same title, *Illustration Index* (G.1.), but updated at five-year intervals. Both sets are alphabetical by subject of the art works, and cover a large number of books and periodicals containing reproductions. To pick up the few they miss, there are some other sources one can use. One was published only a year after the second edition of the Vance and Tracey work, Ellis's *Index to Illustrations* (G.4.). It also covers both books and periodical articles, in one alphabet of subjects and personal names. In 1974, the Hewlett-Woodmere Public Library published its *Index to Art Reproductions in Books* (G.7.), which covers reproductions of painting, sculpture, graphics, photography, stage design, and architecture in sixty-five books.

In 1978, Pamela Parry put together an index to modern art reproductions in her *Contemporary Art and Artists: An Index to Reproductions* (G.14.), and for art reproduced in popular literature, there is Clapp's *Art in Life* (G.2.), which provides one alphabet of artists, titles, and subjects, and Havlice's *Art in Time* (G.5.), with one alphabet of artists and titles, but no subject access. The former was published in 1959, the latter in 1970. In 1981, Yala Korwin picked up the gauntlet for painting, drawing, prints, and other flat art works published in 250 English-language books published from 1960 to 1977 with an *Index to Two-Dimensional Art Works* (G.9.). Drawings are further covered by Moskowitz's 1962 work, *Great Drawings of All Time* (B.50.), a four-volume compilation arranged by regions of the world. For the very contemporary development known as earth scale art, there is Havlice's *Earth Scale Art* (A.62.), a bibliography which also includes a directory of artists and an index to reproductions of the works.

There are also some illustration indexes geared to specific media. For example, for prints, Pamela Parry has produced the *Print Index: A Guide to Reproductions* (G.15.), and Martha Moss did the same kind of work for photography anthologies in her *Photography Books Index* (G.12.), which offers a subject guide to the photographs reproduced in books. For painting, Patricia Havlice compiled a two-volume *World Painting Index* (G.6.), and there are several others which will be discussed under painting below. For sculpture reproductions, nothing has yet surpassed Clapp's *Sculpture Index* (G.3.), a comprehensive work published in two

parts in 1970 and 1971, which serves as a guide to reproductions of sculpture of all nations and periods. Manuscript illuminations from the Bodleian Library reproduced in published works are indexed by Ohlgren in his *Illuminated Manuscripts: An Index to Selected Bodleian Library Color Reproductions* (G.13.).

THE OEUVRE CATALOGUE AND CATALOGUE RAISONNÉ

Other good sources, when available, are the oeuvre catalogue and the catalogue raisonné. These are scholarly catalogues that attempt to identify all the works of an artist and the order in which they were produced. They are frequently arranged chronologically, as in the catalogue *Chardin*[1] by Georges and Daniel Wildenstein, or sometimes by medium if the artist was active in more than one medium. Usually they have indexes which allow the researcher to access the material on a specific work easily. They list pertinent data about each work such as the medium, size, provenance (ownership), the history of its sales, major exhibitions in which it has been shown, the collection or museum where it is presently housed, and sources of more information about it.

Catalogues raisonnés are generally more comprehensive than oeuvre catalogues, although considerable information may be found in both. A good example of the catalogue raisonné is the two-volume *El Greco and His School*[2] by Harold E. Wethey, published in 1962. An excellent oeuvre catalogue is *Rembrandt Paintings*[3] by Horst Gerson. Others may be found through the library catalog, using the artist's name as subject, with the subdivision "Catalogues."

COLLECTION CATALOGUES

Once the ownership of a work has been determined from a source such as those above, it may be possible to find a listing for it in the catalogue of the collections of the museum where it is housed. For example, the catalogues of the National Gallery in London, some of the best published, were produced in twelve volumes of text, each with a companion volume of black-and-white illustrations, between 1959 and 1971,[4] and they are updated by the museum's bulletin and the trustees' report. Similarly, the catalogues of the Metropolitan Museum of Art in New York have been published in fifteen volumes,[5] and those of many other major museums are available in published form. In many cases, these gallery and museum catalogues contain illustrations of most or all of the works included, and in some, there will also be a list of sources of information on each of the works. Since these catalogues often are very expensive, no library can own all of them. However, if there is a

large research library in the area it may contain the catalogue in question, so this possibility should also be checked.

Some of the larger museums, such as the Metropolitan Museum of Art, or the Museum of Modern Art, publish a regular bulletin that contains articles about special items or groups of items in their collections. Many of these also include bibliographies on specific works. In addition, some museums, such as the Albright-Knox Art Gallery for example, publish annual reports that contain similar articles and bibliographies. Both museum bulletins and annuals are indexed in *Art Index* (H.3.) and in *RILA Abstracts* (H.7.).

EXHIBITION CATALOGUES

There are many art works, however, that are only sketchily covered in museum catalogues, or that are privately owned and for which there is no collection catalogue available. For these works, there may be an exhibition catalogue that offers at least some information, perhaps even a reproduction. Sometimes, an encyclopedia or periodical article on the artist will list exhibitions where works of this artist have been shown. From that data, the student may be able to locate a catalogue of one or more exhibitions through a bibliography such as that found in *World Museum Publications 1982* (A.119.), or through the *Worldwide Art Catalogue Bulletin* (A.120.). This latter publication appears quarterly and lists exhibitions in major museums worldwide, with reviews of the catalogues published for these exhibitions. Figure 11 shows the ample list of indexes included in each issue, as well as the relationship of the index entries to the location of the reviews.

Exhibition catalogues frequently contain introductory matter of a critical or analytical nature by an established art scholar. This material may be useful to the study, and it is also likely that the catalogue will contain a bibliography on the artist and the works, or at least a list of other exhibitions in which the artist is represented. Either may help in tracking down further information. For these reasons, exhibition catalogues are often the best way that data on contemporary artists may be located, if not the only one. A student studying an American art work may find a catalogue suited to that purpose listed in the *Collection of Exhibition Catalogs* (A.4.), published by the Archives of American Art in 1979 and listing those housed in its library.

Sometimes guides to museums will list regular exhibition schedules or bibliographies of catalogues published by the museums. Lacking other access, a letter to the museum where a particular exhibition was held may produce information about the existence of a catalogue. For these reasons, Lila Sherman's *Art Museums of America* (D.84.) or Foreman and Fundaburk's *Pocket Guide to the Location of Art in the United States* (D.32.)

Figure 11

Illustration from *The Worldwide Art Catalogue Bulletin,* reproduced by permission of the publisher.

THE WORLDWIDE
ART CATALOGUE

BULLETIN

INDEX OF ARTISTS

INDEX OF TITLES

INDEX OF ARTISTS

Only artists accorded significant textual and/or pictorial documentation in the catalogues reviewed are included in this index.

INDEX OF WESTERN ART

This index combines a geographical and chronological arrangement of the catalogues reviewed, under the following headings:

INTERNATIONAL SURVEYS
AMERICAN ART
ANCIENT GREEK AND ROMAN ART
AUSTRALIAN/NEW ZEALAND ART
BYZANTINE ART
CANADIAN ART
CENTRAL AND SOUTH
 AMERICAN ART
EASTERN AND WESTERN
 EUROPEAN ART
RUSSIAN AND SOVIET ART

INDEX OF WESTERN ART

Sculpture

SPECIALIZED INDEXES

PROVIDE EASY ACCESS

HENRY MOORE: 60 YEARS OF HIS ART
Metropolitan Museum of Art, May 14-September 30, 1983. Published by Thames and Hudson Inc., New York. Text by William S. Lieberman. This major retrospective of Moore's work, the first of its scope in the United States since 1946, paid special tribute to the artist's versatility. Featuring work in all sizes, from all periods and in all Moore's various media, the exhibition included sculptures in wood, stone and bronze, drawings in pencil, ink, crayon, watercolor and chalk, and several etchings and lithographs. Of the over 250 works exhibited, more than half are reproduced in the catalogue, including 112 sculptures, 25 drawings and nine prints. Offering a fully representative selection of Moore's work from 1921 to 1982, the catalogue plates are arranged to highlight the pivotal stages, motifs and media involved in his artistic development. An initial group of plates shows Moore's early carvings (a subject treated in detail in another exhibition; see this *Bulletin,* 17821); a second deals with his stringed forms; and a third with his moving drawings from the underground shelters of the Second World War. A lengthier section presents Moore's principal themes, such as family groups, reclining figures, helmet heads, kings and queens, and other figurative forms, as well as such more abstracted pieces as his knife-edge forms, animal heads or torsos, and architectonic sculptures. Featured prints include etchings from his *Elephant Skull* and *Sheep* albums and lithographs from the *Stonehenge* album, while the final section presents Moore's recent variations on his sculptural themes. Lieberman in his introductory essay sketches Moore's life and career, tracing the development of his personal style and examining the recurrent mother and child theme and the stylistic debt owed to ancient Mexican and African primitive sculpture. Curiously, he observes, Moore's extraordinarily innovative contributions to 20th-century sculpture are sometimes overlooked, perhaps because of his talent for communicating directly and without confusion. This highly pictorial and well-produced catalogue offers eloquent testimony to Moore's exploration and originality over six decades. Complete entries with concordances. Biographical chronology. Selected bibliography. Very good to excellent reproductions.
*128 pp. with 154 ills. 29 x 23 cm. LC 83-70580
ISBN 0-500-23376-4*
•18208 Hardcover $24.95

98

may be fruitful sources. There is also the *Traveler's Guide to America's Art* (D.73.) by Jane and Theodore Norman, and *Art Museums of New England* (E.20.) by Faison, both of which may provide some help. Information in the *Art in America Annual Guide to Galleries, Museums, Artists* (D.7.) may also help to locate the latest data on exhibitions in this country. For other countries, there are often similar guides. An example of one of these which is available in English is *Roberts' Guide to Japanese Museums* (D.80.), revised edition published in 1978.

ICONOGRAPHICAL SOURCES

Sources for iconography vary from general encyclopedia and periodical articles, critical and historical treatises, to highly specialized reference sources, advanced treatises, and other works. Since iconography takes into account the subject matter of the art work, it requires delving into the source of the subject matter. This sometimes involves using material from Greek and Roman mythology, the Bible and other Christian writings, non-Christian religious treatises, and histories of Eastern and Western antiquity.

Many good dictionaries and encyclopedias exist for all of these areas, and it is not the function of this handbook to list all of them. It is sufficient to note that comprehensive and selected lists of these sources may be found in the bibliographies and handbooks mentioned in the history chapter and in the bibliography at the end of the text. Three very good sources for such lists are Lois Jones' *Art Research Methods and Resources* (A.67.), Gerd Muehsam's *Guide to Basic Information Sources in the Visual Arts* (A.84.), and the *Guide to the Literature of Art History* (A.6.) by Arntzen and Rainwater.

Since iconography involves the study of symbolism as used in art, dictionaries of symbolism can be most useful. One such dictionary is the *Dictionary of Symbols* (B.12.) by Cirlot, and another more specifically aimed at art is Hall's *Dictionary of Subjects and Symbols in Art* (B.31.). Symbols from mythology and folklore are picked up in Jobes' *Dictionary of Mythology, Folklore, and Symbols* (B.39.), published in 1961, and those from classical literature are identified in Preston's *Dictionary of Pictorial Subjects from Classical Literature* (B.62.).

Christian art has its own system of symbols, particularly those used for various saints, and there are several good sources that will help identify them. The *Index of Christian Art at Princeton University: A Handbook* (E.28.) by Helen Woodruff serves as a guide to a large collection of photographs of Christian art begun at Princeton in 1917 and still continuing. Another good guide is Gertrude Schiller's *Iconography of Christian Art* (C.45.), a two-volume reference translated into English and published in this country in 1972. Still another tool of value is Ferguson's

Signs and Symbols in Christian Art (B.23.), a dictionary with illustrations from Renaissance paintings.

Visual references such as the illustrations found through the indexes mentioned above can also help with iconographical study through comparison of works with similar subject matter. Handbooks that identify forms used in earlier periods of art history can also offer aid in this area. A series of such tools has been published by Rizzoli, including Amiet's *Art in the Ancient World* (E.3.) and Christe's *Art of the Christian World, A.D. 200–1500: A Handbook of Styles and Forms* (E.12.). In addition, a comprehensive system of classification has been devised for iconographic features, and the guide to this, by Henry Van de Waal, entitled *Iconclass: An Iconographic Classification System* (F.22.) may help if its seventeen volumes are available locally. Any guide to reproductions and illustrations that provides a subject approach may identify similar works on the same subject and therefore be useful for comparison purposes. One of the best examples of such guides in the area of painting is the series of volumes by Isabel and Kate Monro, the *Index to Reproductions of American Paintings* (G.10.) and the *Index to Reproductions of European Paintings* (G.11.). Others will be noted in the sections on various media below.

CONNOISSEURSHIP SOURCES

Connoisseurship is the practice of identifying the origin and value of art objects. It is frequently practiced by collectors, museum curators, and dealers, and sometimes by the student doing art historical or stylistic research. The latter uses the sources of connoisseurship primarily for identifying the origins of an art work.

Identification Sources

If, for example, one is examining a painting for which the artist's signature is unfamiliar, sources that identify the signatures of known painters are needed to identify the painting's origin. If, perhaps, there is not enough of the signature present to be certain what letter it begins with, aspects of its style may place it within a period or movement for which there is a biographical source that reproduces artists' signatures. Once such source which is useful in just about any medium or period is the *Classified Directory of Artists' Signatures, Symbols, and Monograms* (D.16.).

Sources for such investigations vary widely, and the student must exercise great ingenuity to place some art objects. Picture sources, such as the indexes to illustrations discussed above, sometimes help, especially if they have a subject index, since by examining reproductions of

art on the same or similar subject matter, one may be able to pin down the artist, or at least the period and style of the work. Sometimes a handbook may be used to identify the style or form to which the work belongs, thus identifying a group of artists, one of whom may have produced the object. Depending on the medium with which the student is working, different handbooks exist to help with this kind of search.

Determination of Values

When it comes to establishing the value of an art work, there are a number of indexes to art sales that can help. Although prices can be highly subjective, depending on the market and trends in popularity as much as intrinsic merit, this type of reference does offer some guidance. If the work in question is listed in such a source, one can determine what price has been paid for it in previous sales. If it is not listed, the question is a little more tricky, but comparable works in medium, size, period, style, and other works by the same artist help to place the general price range that applies. One still must keep in mind the currency involved in the sale, the rate of exchange at the time of sale, and inflation in currencies over the years.

Most sale indexes list primarily paintings, drawings, and the graphic arts, since these are the items most frequently sold by art auction houses. For decorative objects and sculpture, there is some guidance available in the collectors' handbooks listed below under antiques and collectibles, but the process of valuation is still risky at best. One of the most current sales indexes is *Art Sales Index* (I.1.), published in England and edited by Richard Hislop. Since it is printed from computerized databases, it is also available online. The annual volumes list sales of paintings, drawings, and graphic works, and , since August of 1983, sculpture, at major auction houses worldwide, with date and place of sale, full description of the work, and the price paid in both American dollars and British pounds. These annual volumes are updated frequently by microfiche supplements. Figure 12 shows some of the listings from this tool, with the abbreviations used in the entries and the chronological index, which identifies the auction house and location and the name or number of the sale.

The same publisher provides specialized listings for various periods and nationalities included in the annual *Art Sales Index* (I.1.), with some being published in ten-year cumulations. For example, American artists are covered since 1981 in annual volumes entitled *Auction Prices of American Artists* (I.2.), while twentieth-century figures and impressionists are covered by a ten-year cumulation, *Auction Prices of Impressionist and 20th-Century Artists, 1970–1980* (I.3.). For nineteenth-century artists there is *Auction Prices of 19th-Century Artists* (I.4.), published in 1981 and covering

Figure 12

Illustration from the annual cumulation of the *Art Sales Index*, reproduced by permission of the publisher.

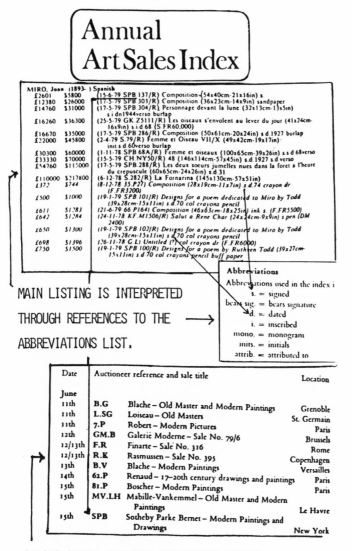

a ten-year period, and the same year a ten-year volume was produced for earlier masters, *Auction Prices of Old Masters* (I.5.). All of these cumulations have the same basic format as their parent index, with the main additional feature being tables for major figures that show the range of prices paid for their works and the high, low, and average price during the period covered.

SOURCES BY MEDIUM

Architecture

If a building is the art object being studied, Herbert Pothorn's *Architectural Styles: An Historical Guide to World Design* (C.36.) may help identify it, or Haneman's *Pictorial Encyclopedia of Historic Architectural Details and Elements* (C.18.) may pinpoint the architectural ornaments used. If the building is American, one of the best sources is Blumenson's *Identifying American Architecture: A Pictorial Guide to Styles and Terms, 1600–1945.*[6] This offers unusually clear black-and-white illustrations of architectural details, as well as identifying examples of the main styles of American architecture, in a small, but very useful, format. A guide by Hunt, *American Architecture: A Field Guide to the Most Important Examples* (D.47.) identifies where one can see similar works for comparison, and if the building is a home, Walker's *American Shelter: An Illustrated Encyclopedia of the American Home* (C.50.) may offer assistance.

Sculpture

If one is trying to identify a sculptural work, one of the best places to begin is Jane Clapp's *Sculpture Index* (G.3.), a two-volume work that identifies sculpture illustrations in books and other sources by sculptor and subject matter. The volumes are organized by geographical regions, so it is first necessary to determine what part of the world the sculpture may have come from, or to be certain to check all sections. If terminology is a problem, help is available in Verhelst's *Sculpture: Tools, Materials, and Techniques* (B.79.).

For American sculpture, there is an excellent catalogue by Albert Gardner, *American Sculpture: A Catalogue of the Collection of the Metropolitan Museum of Art* (F.8.). Other museum catalogues will help, as will exhibition catalogues, located through the sources discussed above. Of special note is the fact that since August 1983, *Art Sales Index* (I.1.) has included sculpture in its listings. These do not cover all of the possibilities, of course, but many of the more general sources mentioned earlier include sculpture as well as other media and should be checked in an investigation of this sort. General dictionaries and encyclopedias of

sculpture should also be consulted, as many of them contain good reproductions and bibliography. These are, however, good examples of the range of material needed to cover any medium.

Painting

Paintings are provided with a large number of sources for research, from dictionaries and directories of collections to indexes of reproductions. These last are most helpful in studying the art work itself and thus will be covered most completely here.

The most comprehensive index to reproductions of paintings has already been noted above, Patricia Havlice's *World Painting Index* (G.6.), but it is by no means the only one. For older works, a good source is UNESCO's *Catalogue of Colour Reproductions of Paintings Prior to 1860* (F.20.), tenth edition, published in 1978. Somewhat earlier but covering some additional sources is Bartran's *Guide to Color Reproductions* (F.3.), second edition, 1971. A little different in purpose, but a good source of color illustrations of prominent paintings, is the New York Graphic Society's *Fine Art Reproductions of Old and Modern Masters* (F.16.), a frequently updated catalogue of the color reproductions available for sale from this source. It is provided with an index to subjects, which adds to its value as a source for study, and the illustrations are in color. Later paintings are covered in another UNESCO catalogue, its *Catalogue of Colour Reproductions of Paintings, 1860–1963* (F.21.), the eleventh edition of which came out in 1981.

One other type of painting that occasionally must be identified by the art scholar is that used in early manuscripts as illustration and decoration: manuscript illumination. Some of these works are covered in the painting sources, or in general references that include all media, but there is also at least one good specialized source just for this purpose. Entitled *Illuminated Manuscripts: An Index to Selected Bodleian Library Color Reproductions* (G.13.), it was compiled by Thomas M. Ohlgren and published in 1978. It locates full-color reproductions of manuscript illuminations from this important collection that have appeared in books and periodicals.

Graphic Arts

In the graphic arts, there are more tools for identification and pricing in some media than others. Prints and illustrations are frequently covered in sales indexes, but such sources do not yet exist for photography, for example. Bibliographies, dictionaries, and encyclopedias specific to each medium may offer some guidance, and where indexes to illustrations include these media, they are also helpful.

Prints

Prints are the graphic art best covered in reference works, including most of the types of sources mentioned above. The two bibliographies mentioned earlier, *Fine Print References* (A.78.) by Joan Ludman and Lauris Mason, and *Print Reference Sources: A Select Bibliography, 18th–20th Centuries* (A.83.) by Mason will list additional sources to those specified in this chapter. Among the best general sources, however, are *Picture Researcher's Handbook* (D.30.) by Hilary and Mary Evans and Andra Nelki, and Ann Novotny's handbook to collections in North America, *Picture Sources 3* (D.74.). The former is international in scope, offering information on major print collections and libraries worldwide, and both of these sources were published in 1975. Published in 1983, Pamela Jeffcott Parry's *Print Index* (G.15.) provides direction to reproductions of prints.

Two collectors' handbooks are available that help in the pricing of prints. The earlier, *Guide to the Collecting and Care of Original Prints* (B.87.) by Carl Zigrosser and Christa M. Gaehde, was published in 1965. It may be supplemented and updated by information from Ellen Kaplan's 1983 publication, *Prints: A Collector's Guide* (E.23.). Both of these tools offer guidance on the selection and care of prints, as well as on establishing values. Another 1983 publication identifies print values specifically, *Printworld Directory of Prints and Prices, 1983* (F.18.) by Selma Smith. This tool is also updated annually, making it the best source for current data.

Another good source for identifying prints is the catalogue of the prints of a particular country, period, or group of artists. Several series of such catalogues have been produced for the European countries, not the least of which, still in progress, is Walter L. Strauss's *Illustrated Bartsch* (F.19.), an English translation and expanded presentation of a monumental catalogue first produced by the German scholar Adam Bartsch.[7] It covers all known prints by European artists from the fourteenth through the nineteenth centuries, and the translated version offers, wherever possible, quality reproductions to facilitate identification.

A similar series of catalogues has been done by Arthur M. Hind for Italian and British works, but with a more limited time span. His *Early Italian Engraving: A Critical Catalogue* (F.10.) was published in seven volumes from 1938 to 1948 and includes reproductions, but does not cover more modern works. His similar catalogue in three volumes, *Engraving in England in the Sixteenth and Seventeenth Centuries* (F.11.) provides some coverage for early British engravings, with reproductions and critical introductions. Dutch, Flemish, and German prints are being covered by F. W. H. Hollstein in two major sets of volumes, both still in progress. His *Dutch and Flemish Etchings, Engravings, and Woodcuts: ca. 1450–1700* (F.12.) consists of 15 volumes to date, and was begun in 1949, while his

similar work, *German Engravings, Etchings, and Woodcuts: ca. 1400–1700* (F.13.) began publication in 1954.

Photography

Photography, having developed so recently, has fewer good sources for identification of early works. There is one excellent index published in 1980 and compiled by Martha Moss, however, which locates illustrations in photography anthologies. Entitled *Photography Books Index* (G.12.), it is arranged by subject and identifies the sources for illustrations of many important works in the history of photography. An earlier British work by Oliver Mathews, *Early Photographs and Early Photographers* (D.62.), published in 1973, provides a dictionary-form reference tool for most early works.

Many of the bibliographies, dictionaries, and general references discussed in earlier chapters also offer useful data on photography. Although the two sources mentioned above are best suited for this type of study, the more general tools should be consulted when the work needed is more difficult to locate. Another possibility may be an organization, collection, or museum within traveling distance. To determine what is available in the area, a directory such as *World Photography Sources* (D.11.) by David Bradshaw should be consulted, using the index of places to help locate nearby resources for this type of help.

Decorative Arts

The decorative arts are well covered in some areas, less so in others. Antiques, a favorite of collectors, are provided with good references in most categories. Certain types of antique objects, such as furniture, ceramics, metalwork, and the like, perhaps because the market is good for them, are amply covered, while others have only minimal reference sources and must be sought in more general references.

Several general sources cover a wide range of media in the world of antiques. One of the best recent ones is the *Random House Encyclopedia of Antiques* (C.39.), published in 1973, but the *Pictorial Encyclopedia of Antiques* (C.9.) by Jan Durdik, published in 1970, may also be helpful for identifying styles, decorative elements, and makers. There is also a very useful bibliography by Linda Campbell Franklin, *Antiques and Collectibles: A Bibliography of Works in English, 16th Century to 1976* (A.53.) which will help locate other sources not listed here. Other general works include Louise Boger and H. Batterson's *Dictionary of Antiques and the Decorative Arts* (B.9.), the second edition of which was published in 1967, the *Collector's Dictionary* (B.30.) by Henry Hainworth, and the *Antique Buyer's Dictionary of Names* (D.21.) by Arthur Wilfred Coysh.

The determination of values is aided by handbooks such as P. S.

Warman's *Antiques and Their Prices* (B.82.), fifteenth edition, 1980. To some extent, values are also covered in many of the general sources above. Some important aspects of materials, decoration, and construction are also found through Dennis Young's *Encyclopedia of Antique Restoration and Maintenance* (B.86.). Specialized handbooks and dictionaries exist for various periods, countries, and types of objects, such as Charles Platten Woodhouse's *Victoriana Collector's Handbook* (B.85.), and a selection of these is presented below.

American

One of the best sources for the decorative arts of America is the *Index of American Design* (G.8.), a microfiche collection with detailed indexes covering all the decoration and design elements of American history. For students in libraries where this tool is not available, however, there are other good sources to consult. Two of the best general ones are Carl William Drepperd's *Dictionary of American Antiques* (B.20.), and the newer *Objects: U. S. A.* (D.72.) by Lee Nordness.

The Victorian period in America is covered in detail in the *World of Antiques, Art, and Architecture in Victorian America* (C.3.) by Robert Bishop and Patricia Coblentz. For determining values, there is also a handbook by Dorothy Hammond, the sixth edition of which just appeared in 1984, her *Pictorial Price Guide to American Antiques* (D.37.).

Furniture

Furniture is one of the favorite objects of antique collectors, and it is also a good barometer of decorative taste through the ages. The most comprehensive source for information on furniture of all eras and countries is Joseph Aronson's *Encyclopedia of Furniture* (C.1.), the third edition of which appeared in 1965. Another long-respected tool for British and American furniture in particular is the *Short Dictionary of Furniture* (B.26.) by John Gloag. A revised and enlarged edition of this classic with over 2,600 entries was published in 1969. Also appearing in 1969 was the first American edition of the best biographical directory for furniture makers, Hugh Honour's *Cabinet Makers and Furniture Designers* (D.44.). Most recently, Charles Boyce has compiled and published his *Dictionary of Furniture* (B.10.) in 1985.

American furniture is provided with several specialized references, one of the earliest and best-known being Wallace Nutting's *Furniture Treasury (Mostly of American Origin)* (C.30.), published in three volumes in 1928. Early American furniture is also covered in Luke Vincent Lockwood's two-volume work, *Colonial Furniture in America* (C.25.), the third edition of which appeared in 1967 in a combined one-volume format. Both of these works provide many illustrations to assist with identifying

furniture pieces, and many of the general antique references also are useful for American furniture. The builders and designers of American furniture are provided with their own biographical directory by Ethel Hall Bjerkoe in her *Cabinetmakers of America* (D.10.).

French provincial, Louis XIV, and other continental furniture styles have proven popular in American homes. Several general furniture sources will provide some information on all of them, but eighteenth-century French furniture is especially well covered in the *Directory of Antique French Furniture, 1735–1800* (D.41.) by F. Lewis Hinckley. Another popular European influence in decorating is that of Great Britain, and the furniture of that country also has its own reference source, Ralph Edwards' *Dictionary of English Furniture* (B.21.), the revised edition of which was published in three volumes in 1954.

Ceramics

Two very good dictionaries exist that will help in identifying pieces of ceramic work. The first, the 1974 *Illustrated Dictionary of Ceramics* (B.66.) by George Savage and Harold Newman, covers terminology and materials in over 3,000 articles, as well as styles, patterns, and shapes. The second, published in 1981, concentrates on forms and shapes in pottery. Entitled the *Illustrated Dictionary of Pottery Form* (B.25.), it was compiled by Robert Fournier. Both of these works will help to place ceramic works in time, region, and style when they have no identifying marks.

For ceramic items with marks or signatures, identification is facilitated by several excellent references. The Kovels, Ralph and Terry, have authored many collectors' handbooks and guides, and their *New Dictionary of Marks: Pottery and Porcelain, 1850-Present* (B.42.), the most recent edition of which was published in 1985, is one of the best known in this field. Another work, published in 1980 in its fourth edition, is the *Handbook of Pottery and Porcelain Marks* (F.7.) by J. P. Cushion and W. B. Honey. Also produced in 1985 is Elisabeth Cameron's *Encyclopedia of Pottery and Porcelain, 1800–1960* (C.5.), which is even broader in time coverage. All of these, however, are selective, since they cover such vast territory. For ceramic pieces of known national origin, it is wise to consult a more specialized source first.

A semispecialized reference tool that covers all Europe and the Orient is William Chaffers' *Marks and Monograms on European and Oriental Pottery and Porcelain* (C.6.), its fifteenth revised edition published in two volumes in 1965. More specific, and thus possibly more useful for works of known national origin, are works such as Robert E. Roentgen's *Marks on German, Bohemian, and Austrian Porcelain 1710 to the Present* (C.41.). American pottery is similarly covered in Paul E. Evans' *Art Pottery of the United States* (C.11.), published in 1964, and British ceramics are covered by

Geoffrey A. Godden's *Encyclopedia of British Pottery and Porcelain Marks* (C.15.), published the same year.

Metalwork

Sources for metalwork, for the most part, are confined to gold- and silversmithing, but these are admirably covered. Some of the best and most helpful are limited to a particular country, and again it is important to look for illustrations and reproductions of signatures as useful aids to identification.

By way of example, the British goldsmiths through the first part of the nineteenth century are thoroughly covered in Arthur Grimwade's *London Goldsmiths 1697–1837* (B.27.). This source is based heavily on documentary records from the archives of the guild to which the gold-smiths belonged, and therefore very reliable, but it is limited to London figures. Another work that covers English goldsmiths and their marks from all of the British Isles is Charles James Jackson's *English Goldsmiths and Their Marks* (B.38.), the second edition of which appeared in 1921 and was reprinted in 1964.

While the metal best covered for the British Isles is gold, American metalsmiths find their best coverage in the area of silver. The Kovels, mentioned before in connection with ceramics, have also produced an excellent work for American silver, their *Directory of American Silver, Pewter, and Silver Plate* (B.41.), published in 1961. As is evident in the title, it includes pewter and silver plate as well as sterling silver, and is one of the few to do so. Another more recent work which supplements this one is Dorothy T. Rainwater's *Encyclopedia of American Silver Manufacturers* (B.64.), which was published in 1975 and also offers reproductions of marks found on American silver.

NOTES

1. Georges Wildenstein, *Chardin*, trans. Stuart Gilbert (Greenwich, Conn.: New York Graphic Society, 1963), rev. and enlarged ed., ed. Daniel Wildenstein (1969).

2. Harold Edwin Wethey, *El Greco and His School*, 2 vols. (Princeton, N.J.: Princeton University Press, 1962).

3. Horst Gerson, *Rembrandt Paintings*, trans. Heinz Norden, ed. Gary Schwartz (New York: Reynal, 1968).

4. National Gallery (London), *[Catalogues]* (London: William Clowes and Sons, Ltd., 1959–1971). Individual volumes have separate titles.

5. Metropolitan Museum of Art, *[Catalogues]* (New York: The Museum, 1940–1973). Individual volumes have separate titles.

6. John C. Blumenson, *Identifying American Architecture*, rev. ed. (New York: W. W. Norton, 1981).

7. Adam Bartsch, *Catalogue raisonné des desseins originaux des plus grandes maîtres anciens et modernes* (Vienna, Austria: A. Blumauer, 1794).

7

Techniques and Materials

Students occasionally need information on the materials from which art works are constructed, or on the techniques by which they were created. Historical studies sometimes require a knowledge of technical details in order to understand why an artist worked in a particular way, or how a style developed. Style analysis as well is often aided by insight into art materials and methods. Knowledge of techniques and materials also assists in establishing the authenticity of a work for collectors and curators. Most importantly, art students in studio courses must attain an intimate understanding of their materials and learn how to manipulate them.

GENERAL SOURCES AND CONSIDERATIONS

Information on this topic is sometimes available through general art dictionaries and encyclopedias, especially those that treat terminology in detail, such as the *Thames and Hudson Dictionary of Art Terms* (B.45.), or the *Dictionary of Art and Artists* (B.52.) by Peter and Linda Murray. Illustrated sources like Ann Hill's *Visual Dictionary of Art* (B.36.) frequently provide illustrations of processes and materials. Additional information may be found by consulting bibliographies such as Donald L. Ehresmann's two excellent sources, *Fine Arts: A Bibliographic Guide* (A.49.) and *Applied and Decorative Arts: A Bibliographic Guide* (A.47.).

More often, however, the data provided by such general tools must

be supplemented by that in specialized ones for various media, either reference handbooks or "how-to"manuals for the practicing artist or craftsman. Such materials may be located through the library catalog by looking under the term for the medium, such as painting, with the subdivision "technique" or under the more general heading "Artists' materials." Some very general sources may also be found under the heading "Art—technique."

The periodical literature will provide articles on specific art materials and processes, and these are accessible through tools like *Art Index* (H.3.). If one is looking for information on very recent or experimental materials and techniques, *ArtBibliographies Modern* (H.4.) is the index of choice, since it stresses the contemporary. Indexes for specific media should be considered also if the research is focused on one medium.

Certain concepts common to all media are accessible through bibliographic tools compiled for just those concepts. The elements of design, for example, are covered by the entries in volume three of the Modern Art Bibliographical Series from ABC-Clio Press, entitled *Design* (A.44.). Likewise, Mary Buckley has prepared a very comprehensive bibliography on color, her *Color Theory: A Guide to Information Sources* (A.27.), published in 1975. Other such concepts and the terminology for them may be traced to their sources by using Lawrence Urdang's recent *Fine and Applied Art Terms Index* (B.78.).

The practicing artist or craftsman needs sources of practical business information for marketing purposes. For this type of information, there are several good reference tools, some of which are updated regularly. The craftsman can find almost all necessary information in Michael Scott's *Crafts Business Encyclopedia* (B.68), including suppliers of source materials, relevant legal information, and outlets for craft items. Artists have a good basic tool in Betty Chamberlain's *Artist's Guide to the Art Market* (E.10), and in the annual volumes of the *Fine Arts Marketplace* (D.24.), edited by Paul Cummings. Further information on galleries, museums, dealers, suppliers, and associations may be found on an international scope in the biennial *International Directory of Arts* (D.49.), or on a national scale in directories like the *American Art Directory* (D.2.). For fellow artists with similar interests, as well as organizations sponsoring exhibits and projects in the arts, one may turn to Helen A. Shlien's *Artists' Associations in the USA: A Descriptive Directory* (D.85.).

SOURCES BY MEDIUM

Architecture

Information on the materials and techniques of architecture may often be found in the general bibliographies and encyclopedias of art, but bibliogra-

phies specifically treating architecture, such as Donald L. Ehresmann's *Architecture: A Bibliographic Guide* (A.48.), are even more likely to yield material in this area. Early material on the specialized area of city and regional planning is even covered in a separate bibliography, *Bibliography of Planning, 1928–1935* (A.65.) by Theodora K. Hubbard and K. McNamara.

Definitions of terminology and brief identification of techniques and details in architecture may be found in dictionaries such as James Stevens Curl's *English Architecture: An Illustrated Glossary* (B.16.), which is comprehensive enough to apply to the architecture of all nationalities, even though the emphasis is British. Two more recent dictionaries are even more comprehensive, however. These are the second edition of the *Dictionary of Architecture, Building Construction and Materials* (B.17.), published in two volumes in 1983, and the third edition of the *Architectural and Building Trades Dictionary* (B.63.), edited by R. E. Putnam and G. E. Carlson and published the same year. Although somewhat older, David D. Polon's *Dictionary of Architectural Abbreviations, Signs, and Symbols* (B.61.) can be invaluable in deciphering plans and blueprints and determining the architect's intentions. Additional technological information is available in Pedro Guedes's *Encyclopedia of Architectural Technology* (C.17.) and in Joseph Gwilt's *Encyclopedia of Architecture* (C.31.), as revised by Wyatt Papworth and published in 1982.

For the architectural student or the practicing architect, there are several handy references that provide virtually all the technical, legal, and business detail needed. The first, and perhaps most useful for practicing architects despite its age, is the *Handbook of Architectural Practice* (E.2.), the eighth edition of which was published in 1958 by the American Institute of Architects. For industry standards, *Time-Saver Standards for Building Types* (E.17.) has been the indispensable work for many years. The second edition of this under its present title was edited by Joseph DeChiara and Joseph Callender and published in 1980.

The classic reference for architectural graphics is *Architectural Graphic Standards* (E.25.), edited by Robert T. Packard in its seventh edition and published in 1981. Architects and students interested in historical preservation or the renovation of older buildings for present day use will also want a copy of Lawrence Grow's *Old House Catalogue* (B.28.), published in 1976. This source lists products and suppliers for use in restoring and decorating period buildings from colonial times to the early twentieth century.

The specialized periodical indexes for architecture will also provide very current information on newer materials and techniques, as well as on recent standards and architectural laws. For this purpose, the student should not overlook the *Architectural Index* (H.1.), published since 1950, or its British counterpart, the *Comprehensive Index to Architectural Peri-*

odicals, 1956–1970 (H.15.), published by the Royal Institute of British Architects, along with its successors, the *RIBA Annual Review of Periodical Articles* (H.16.), published from 1966 to 1973, and the *Architectural Periodicals Index* (H.17.), published since 1972.

Sculpture

Students of sculpture do not have as many dictionaries and bibliographies to turn to for information on materials and processes as students in other media do. There is some data in the general sources listed in the first section of this chapter. The periodical indexes for art also offer help with newer techniques and materials of sculpture. However, for most details of a technical nature, sculptors must turn to handbooks, manuals, and even textbooks for assistance.

A good source for help in this area is Ronald Coleman's *Sculpture: A Basic Handbook for Students* (E.14.), published in 1968. In the same year, a *Sculptor's Manual* (E.13.) was provided by Geoffrey Clarke. Both of these offer instructions in basic sculptural methods, but both are also somewhat dated by now. Likewise, Bainbridge Copnall's *Sculptor's Manual* (E.15.) of 1971 and Wilbert Verhelst's *Sculpture: Tools, Materials, and Techniques* (B.79.), while they are standard sources for this area, are not much more up-to-date. The most recent tool that provides some assistance for the student is designed not for creating sculpture, but for restoring it. This is the *Restorer's Handbook of Sculpture* (E.4.) by Jean Michel André, which was translated into English and published in this country in 1977. While it deals primarily with the techniques and materials of earlier sculptural works, it offers general advice that can be of use to the modern-day sculpture student, and to the student of sculptural history as well.

Drawing and Painting

There are numerous textbooks and handbooks for the student of drawing or painting that provide guidance in methods and materials. In addition, much information on these two media may be located in general references, since this is often where their emphasis is placed. For the researcher or student who needs more specialized sources, however, a few are suggested here that will provide authoritative information in a handy format.

One of the most recent, and most widely accepted, sources for drawing is Gerald F. Brommer's *Drawing: Ideas, Materials, and Techniques* (E.7.), second edition, 1978. Although more of a student's manual than a reference tool, it serves the purpose, and it provides more data, in more depth, than the general reference sources. A similar tool for painting is

Painting: Materials and Methods (E.1.) by Alexander Abels, published in 1968.

There is a good dictionary for this type of material in the area of painting. By Frederic Taubes, it is entitled *Painter's Dictionary of Materials and Methods* (B.75.) and was published in 1971. A more recent tool, but one limited to contemporary oil painting and organized as a manual, is the *Contemporary Oil Painter's Handbook* (E.11.) by Clifford T. Chieffo, published in 1976.

Graphic and Commercial Arts

The graphic artist or student researching the graphic arts may consult several general sources that cover the basics of all the graphics media. In 1968, George A. Stevenson produced one of the most comprehensive encyclopedias for this area, his *Graphic Arts Encyclopedia* (B.72.), which is still a standard source for terminology, processes, and techniques. Another standard for practicing artists is John Quick's *Artists' and Illustrators' Encyclopedia* (C.38.), the second edition of which appeared in 1977. Two handbooks that also supply authoritative information in this area are Janet N. Field's *Graphic Arts Manual* (E.21.) of 1980 and the *Commercial Artists' Handbook* (E.26.) by John Snyder, published in 1973.

Graphic artists also have recourse to some specialized tools for specific problems in the practice of their art. For design, for example, there is the *Graphic Designer's Handbook* (E.9.) by Alastair Campbell, published in 1983. For reproduction of their designs, they can refer to Felix Brunner's *Handbook of Graphic Reproduction Processes* (E.8.), a standard since it appeared in 1962. If design ideas are a problem, the graphic artist can turn to numerous clip-art services which provide copyright-free pictures for reproduction in advertising, brochures, and other commercial uses. These are available in multiple volume collections from several publishers, such as Dover[1] and Hart.[2] There are also regular subscription services like Clipper[3] and Volk[4] that provide this type of material in periodical format. Most recently, a collection of some 750 such designs has been published in a large reference volume called *Designs on File* (E.18.) to supply this need in a single, easily accessible source. Should the graphic artist need to locate suppliers of materials, printers and reproduction services, or similar adjuncts to the profession, there is the *American Register of Printing and Graphic Arts Services* (D.5.), published in 1981, to serve as a directory.

Some specific graphic techniques have their own specialized sources as well. For photography, for example, there is the two-volume *Focal Encyclopedia of Photography* (C.13.), published in 1974, and for calligraphy there is *Calligraphy: A Sourcebook* (A.42.) by Jinnie Y. Davis and John V. Richardson. For prints and printmaking, several sources cited earlier in

the history chapter and the chapter on the art object also yield information on techniques and materials. One of the few, however, that deals with early printmaking techniques in detail is a bibliography by Gavin Bridson and Geoffrey Wakeman published in 1984. Entitled *Printmaking and Picture Printing* (A.25.), it offers access to materials on both technical and industrial aspects of printmaking in nineteenth-century Britain, many of which apply equally well to the history of prints in Europe and this country.

Decorative Arts

Materials and techniques in the decorative arts in general are covered in three excellent general references. The first, published in 1974, is the fourth edition of a standard bibliography by Augustus Sherrill Whiton, *Interior Design and Decoration* (A.114.). Although its emphasis is on interior design, this field includes many of the other decorative arts and crafts, so the entries in this source are also useful for many of those areas. The same observation may be made of an encyclopedia by A. Allen Dizik published in 1976, the *Encyclopedia of Interior Design and Decoration* (C.8.). Somewhat broader in coverage than either of these, although slightly older, is Robert Harling's *Studio Dictionary of Design and Decoration* (B.33.), published in 1973. All three of these general tools offer a good introduction to the entire field of the decorative arts, as well as specific details and sources for the area of interior design.

Interior Design and Decoration

In the slightly narrower area of interior decoration, including antiques and various decorative objects, there are a number of good bibliographies and encyclopedias cited in the history chapter and the connoisseurship section of the last chapter. Besides these, however, there are some sources dealing more specifically with techniques and materials. Two of these treat interior design and decorating as a whole. These are the *Concise Dictionary of Interior Decorating* (B.84.) by Lillian Weiss, published in 1973, and the annually updated *Interior Decorator's Handbook* (D.48.), published since 1922.

For data on the objects used in decorating, such as furniture, glass, ceramics, metalwork, and antiques in general, there are two references covering this entire category. The first is a comprehensive dictionary by Louise Ade Boger and H. Batterson entitled *Dictionary of Antiques and the Decorative Arts* (B.9.). Published in its second edition in 1967, it includes entries on periods and styles as well as techniques and terminology. The other, aimed primarily at antiques and collectors, is Dennis Young's *Encyclopedia of Antique Restoration and Maintenance* (B.86.), published in 1974. This source provides detailed descriptions of processes,

including instructions for their duplication, thus providing one of the most practical tools in this area.

Handicrafts

Many decorative objects are produced by amateurs utilizing skills commonly known as handicrafts. Such crafts as basketry, needle arts, macramé and other knotting techniques, for example, while they may be treated as arts in some contexts, are usually grouped under this umbrella. Objects produced by craftspeople serve many decorative and useful purposes in the modern home, and when elevated to the level of fine art by professional practitioners, frequently turn up in museum exhibitions. When this happens, the same reference sources that provide information for the amateur on how they are produced can be valuable to the student or researcher who wants to study them as art.

Handbooks and manuals dedicated to specific groupings of crafts may be found in most neighborhood bookstores, and some which treat their crafts historically and theoretically often turn up in library reference collections. Of these, the ones with the most potential reference value are those that treat all or more than one craft medium. These sources, as numerous as the popular ones, vary widely in their coverage and authority. Three of the best and most comprehensive are given here as examples of the kind of material for which the student should search.

One of the most useful crafts references, by Maria and Louis Di Valentin, is the *Practical Encyclopedia of Crafts* (C.7.), published in 1970. It covers nearly all categories of crafts, grouping them by the basic materials of which they are made, such as glass, metal, leather, fiber, etc. Clear instructions are provided, with many step-by-step drawings, and sources of supplies are suggested. Another similar tool is the *Illustrated Encyclopedia of Crafts and How to Master Them* (C.42.) by Grace Berne Rose, published in 1978, and still more recent is the 1980 compilation by Laura Torbet, her *Encyclopedia of Crafts* (C.48.). All three of these are excellent sources for the layman, as they are written in clear, simple language and are heavily illustrated.

Pottery and Ceramics

Information on the techniques and materials used by potters and ceramicists may be found through at least one excellent bibliography, *Pottery and Ceramics: A Guide to Information Sources* (A.29.) by James Edward Campbell, published in 1978. Materials listed here include handbooks and manuals, as well as reference dictionaries and encyclopedias. The student wishing thorough "how-to" directions may turn to the fourth edition of Glenn C. Nelson's *Ceramics: A Potter's Handbook* (E.24.), or to one of several dictionaries.

Among the dictionaries and encyclopedias, the most comprehensive

is probably the *Illustrated Dictionary of Ceramics* (B.66.), published in 1974. By George Savage and Harold Newman, it includes over 3,000 entries on techniques and processes, materials, styles, shapes, patterns, and wares. More specific to techniques and materials, however, is the *Potter's Dictionary of Materials and Techniques* (B.32.) by Frank Hamer, published in 1975. Another source, different in approach, is Robert Fournier's *Illustrated Dictionary of Pottery Form* (B.25.), which appeared in 1981 and covers patterns, shapes, the processes that produce them, and the uses for which they are intended.

Glass

Decorative and functional items made of glass are an important ingredient in any decorative scheme. For that reason, understanding the methods of constructing them may be just as important for the student of the decorative arts as learning the history of glass-working and -staining. For this purpose, there is an excellent *Illustrated Dictionary of Glass* (B.53.) by Harold Newman, published in 1977, which covers both history and technique. In addition, Phoebe Phillips' *Encyclopedia of Glass* (B.59.), which appeared in 1981 in both England and the United States, offers supplementary information to its predecessor. Both provide descriptions of styles, processes, and materials, as well as articles on the noted glassmakers, painters, and stainers in history. Still a third work, more specific to the techniques and materials of glass work, is Milton K. Berlye's *Encyclopedia of Working with Glass* (C.2.).

Textiles

Yet another important element in decorating, for color and texture as well as warmth and insulation, is textiles. The student wanting information on their fabrication has numerous manuals and histories to choose from. For reference to these, a selective bibliography by Valerie H. Ralston entitled *Textile Reference Sources* (A.94.) was published in 1973. It provides easy access to many important materials, among them such standard handbooks as that by Verla Leone Birrell, *Textile Arts: A Handbook of Weaving, Braiding, Printing, and Other Textile Techniques* (E.6.), first published in 1959 and reprinted in 1973. A somewhat more current source, in the form of a bibliography, is Lavonne B. Axford's *Weaving, Spinning, and Dyeing* (A.12.), published in 1975.

NOTES

1. Dover Publications, Inc., 180 Varick Street, New York, N.Y. 10014.
2. Hart Publishing Co., Inc. 12 E. 12th Street, New York, N.Y. 10003.
3. Clipper Creative Art Service, Dynamic Graphics, Inc., 6000 N. Forest Park Drive, P. O. Box 1901, Peoria, Ill., 61656.
4. Volk Clip Art, Box 72L, Pleasantville, N.J. 08232.

8

Art Education Information Sources

GENERAL SOURCES AND CONSIDERATIONS

Some materials listed in other chapters in this book will also be useful for art educators and students in the field. This is particularly true of art history materials and the handbooks and manuals on various media listed in the last chapter. Depending on the facet of art education being investigated, materials in other chapters should also be consulted, such as the biographical materials and the general dictionaries and encyclopedias listed in several sections. More specialized materials may be located, however, using the resources to be discussed in this chapter.

There are two excellent bibliographies to lead students of art education to the materials they need for just about any research topic. The first, published in 1969, is the *Annotated Bibliography of Art Education* (A.5.) compiled by Vincent Arnone and Hugh M. Neil. For a decade it was the only general guide to materials in this field, but in 1978 Clarence Bunch updated and supplemented it with his very comprehensive *Art Education: A Guide to Information Sources* (A.28.). This tool covers every aspect of art education from nursery school through college-level instruction, providing listings of sources on curriculum and lesson-planning, classroom activities, administration, funding sources, evaluation of programs, counseling and career guidance, and many other areas. In addition, for special educational needs and therapeutic applications of the arts, one can consult Kathleen Mileski Hanes' *Art Therapy and Group Work: An Annotated Bibliography* (A.58.).

To keep up to date on current trends in art education, or to research a more recent development, there are several indexes to the periodical literature which should prove informative. Much art education material is covered in *Art Index* (H.3.), under such headings as "Art—Study and teaching" or the headings for individual media with the "Study and teaching" subdivision. In addition, the education indexes cover specifically instructional developments, theory, technique, and similar topics. The most familiar of these is *Education Index* (H.12.), which works exactly like *Art Index* (H.3.), but there are two others published by the Educational Resources Information Clearinghouse that can also be useful. These are *ERIC's Current Index to Journals in Education*,[1] often called *CIJE*, which covers journal literature, and its *Resources in Education*,[2] which covers documents on current research that have been collected at the *ERIC* offices. These are available in the *ERIC* microfiche collection, available in many libraries, or from the *ERIC* distribution service.

PLANNING

One of the most important factors at every level in art education is planning: designing individual lesson plans; planning the curriculum; structuring the program throughout a school or an entire school system. Sources that may help with this process at various levels include the bibliographies listed above, as well as more specialized materials for different levels and purposes.

In the area of curriculum planning, there is an excellent bibliography prepared by Ralph G. Beelke for the National Art Education Association and published in 1962, his *Curriculum Development in Art Education: An Annotated Listing of Publications Prepared for the Teaching of Art* (A.17.). Although it is now more than twenty years old, this tool has been updated and supplemented by a 1975 publication also provided by the NAEA, its *Curriculum Guides in Art Education* (A.86.). At the college level, the College Art Association of America published a *List of the Needs of Visual Arts in Higher Education* (A.34.) in 1966 which is still useful.

Somewhat earlier but still useful for the individual instructor in the grade school art curriculum is Harold Arthur Schultz's *Art Education for Elementary Teachers: A Selected Bibliography* (A.98.). Since reading materials for younger pupils that concentrate on art subjects may be difficult to select with confidence, the NAEA has also provided a *Bibliography of Children's Art Literature* (A.81.), edited by Kenneth Marantz and published in 1965.

Teachers in the public school systems often are primarily academic instructors and have little background in art. Nevertheless, they may be expected to include art in the curriculum, regardless of their lack of

preparation. For this reason, some sources for the teacher are included here so that "boning up" need not be too much of a chore.

In 1968, Katherine E. La Mancusa prepared a *Source Book for Art Teachers* (B.43.) which also provides useful listings and suggestions for general grade school teachers who must teach art as well. Although it is somewhat outdated now, it may be supplemented with a good one-volume dictionary such as the *Thames and Hudson Dictionary of Art Terms* (B.45.) compiled by Edward Lucie-Smith, plus some reading in basic art education texts located through the Bunch bibliography cited above. In addition, materials for use in class may be found through directories such as the *Directory of Art Libraries and Visual Resource Collections in North America* (D.42.).

CLASSROOM ACTIVITIES

Projects for classroom art activities must walk a narrow line between simple ones that inspire creativity and ambitious ones that challenge the talented but discourage beginners. Much material may be found on the basics of various art media in the last chapter, especially those manuals and encyclopedias that deal with inexpensive crafts. Others that are especially helpful for this purpose are reviewed here.

Craft encyclopedias that provide detailed instructions, illustrations, and ideas for projects include the *Practical Encyclopedia of Crafts* (C.7.) by Maria and Louis Di Valentin, published in 1970, and the 1978 *Illustrated Encyclopedia of Crafts and How to Master Them* (C.42.) by Grace Berne Rose. Laura Torbet's 1980 *Encyclopedia of Crafts* (C.48.) is also useful for classroom ideas. Many crafts materials can be gleaned from scraps and discards around the home, or purchased inexpensively in dime and department stores. More specialized materials can often be obtained by mail from large school-supply firms, but if further sources are needed, the *Directory of Arts and Crafts Materials* (D.27.) published by the *Art Material Trade News* may be of use.

The basics of some art media may be located in handbooks and manuals for the student such as Gerald F. Brommer's *Drawing, Ideas, Materials, Techniques* (E.7.), published in its revised edition in 1978. Likewise, some media that adapt themselves readily to classroom art or craft are provided with their own student manuals, some of which are so comprehensive as to be almost encyclopedic in nature. One of these, readily adaptable to classroom projects, is Verla Leone Birrell's *Textile Arts: A Handbook of Weaving, Braiding, Printing, and Other Textile Techniques* (E.6.). For ceramics, there is also *Ceramics: A Potter's Handbook* (E.24.) by Glenn C. Nelson.

AUDIOVISUAL RESOURCES

The study of art in the classroom is greatly enhanced by the use of audiovisual aids, such as slides or films. Most public school systems offer some assistance to teachers in locating materials of this type, as well as by providing the equipment necessary to use them. However, the choice is sometimes limited by the use of selected suppliers or a lack of knowledge as to what may be available.

Slides

The classroom teacher who has access to a slide projector is in luck, since there are literally thousands of slides available depicting the works of great artists. The trick lies in knowing the sources through which they may be obtained. One of the standard sources for several decades has been the American Library Color Slide Company, which publishes a comprehensive guide for teachers and librarians to its collections and individual slides entitled *Teachers' Manual for the Study of Art History and Related Courses* (F.1.). Teachers at the high school and college level may also find the *Slide Buyer's Guide* (D.26.) by Nancy DeLauris, published in 1974 by the College Art Association of America, a useful supplement.

Films and Other Media

Since the animation of films is more likely to hold students' interests for longer periods of time, art teachers at the elementary and secondary school level may find this medium more suitable to their needs. To locate films, there are two sources that will prove useful. The first, published in 1966 by the National Art Education Association, is entitled *Films on Art* (F.14.) and was compiled by Alfred W. Humphrys. Somewhat later is a similarly titled work from the Canadian Centre for Films on Art, edited for the American Federation of Arts, *Films on Art: A Source Book* (F.6.).

Even more recent, and including not only films but sound recordings as well, is the 1984 publication *From Museums, Galleries, and Studios: A Guide to Artists on Film and Tape* (F.4.), edited by Susan P. Besemer and Christopher Crosman. This reference includes not only materials about art, but also interviews and conversation with the artists, an added facet that may keep students at all levels enthralled to a greater extent than third-person narrations.

COUNSELING RESOURCES

Beyond the demands of classroom teaching, there is often a need, especially at elementary and secondary school levels, for counseling.

This may include individual and group counseling in choosing careers, or in determining the college or other advanced institution best suited to a student's needs. In addition, the teacher may be called upon to help determine sources of financial aid for further schooling, or to locate sources of financial support for school art instructional programs.

School and College Choices

The choice of schools is aided by two general tools in the field of the arts. Since 1944 the National Association of Schools of Art has published its *National Association of Schools of Art Directory* (D.69.) on an annual basis. In addition, a tool that is likely to be on the shelves of most libraries, the *American Art Directory* (D.2.), also lists art schools and colleges with art programs throughout this country.

If a particular medium has already been chosen by the student, the professional organization for that medium may be able to provide guidance to schools. There are also several general directories to colleges and universities that offer narrative descriptions of programs offered, such as the *College Blue Books*,[3] *Peterson's Annual Guides to Undergraduate Studies*,[4] and *Peterson's Annual Guides to Graduate Studies*.[5] In addition, the publisher of the last two titles also provides a regularly updated guide called *Architecture Schools in North America* (F.17.), an invaluable tool if this is the direction in which a student's interest lies.

Career Choices

Career choices may be facilitated by Donald Holden's *Art Career Guide* (D.43.), the fourth edition of which appeared in 1983. Substantial information may be found here on salary ranges, placement, and preparation for various art careers. Other, more general career sources, such as the *Dictionary of Occupational Titles*[6] may also help with this task. If a student has chosen the graphic and commercial art field for a career field, an excellent tool to consult is James Craig's *Graphic Design Career Guide* (E.16.).

FUNDING SOURCES

A key aspect of maintaining art education programs in the schools, or for undertaking any major research in art education, is obtaining the necessary financing. One possibility for funding such projects is the securing of grants or loans from government or private organizations

whose interests lie in this area. To identify possible sources of such funding, several directories may be consulted.

From the U.S. government, most funding for projects in the arts is available through the National Foundation on the Arts and Humanities, the National Endowment for the Arts (NEA), or the National Endowment for the Humanities (NEH). The National Foundation on the Arts and Humanities publishes a report annually entitled *Programs of the National Endowment for the Arts* (D.93.) which details requirements for funding from this source and describes projects that have received such funding during the previous year. Perusal of these reports can provide much information for the researcher contemplating application to NEA for a grant.

When it comes to private-sector financing for the arts, the most helpful sources are published by the *Washington International Arts Letter* as the Arts Patronage Series. All are edited by Daniel W. Millsaps, and each directory covers a specific type of organization that may be approached for financial aid in the arts and education. The first, entitled *Private Foundations and Business Corporations Active in Arts, Humanities, and Education* (D.67.), was published in 1974. Although it is outdated now, it has been superseded by three later directories. For individuals seeking financial aid there is the 1983 source *National Directory of Grants and Aid to Individuals in the Arts, International* (D.66.). For funding of projects under the aegis of a group, there are two others, the *National Directory of Arts Support by Private Foundations* (D.65.), published in 1983, and the *National Directory of Arts and Education Support by Business Corporations* (D.64.), published in 1982.

NOTES

1. *Current Index to Journals in Education* (Bethesda, Md.: Educational Resources Information Clearinghouse; Distributed by Oryx Press, Phoenix, Ariz.: 1969 to date). Monthly with annual cumulations.

2. *Resources in Education* (Bethesda, Md.: Educational Resources Information Clearinghouse, 1966 to date). Monthly with annual cumulations.

3. *College Blue Book*, 19th ed. 5 vols. (New York: Macmillan, 1983).

4. *Peterson's Annual Guides to Undergraduate Studies* (Princeton, N.J.: Peterson's Guides, 1971 to date).

5. *Peterson's Annual Guides to Graduate Studies.* (Princeton, N.J.: Peterson's Guides, 1966 to date).

6. *Dictionary of Occupational Titles*, 4th ed. (Washington, D.C.: U. S. Department of Labor, 1979).

9

Visual Arts Periodicals

This list of periodicals is representative of the standard selection available in most large university and other art research libraries. It is provided here to give some idea of the range of materials available in this format.

With each title is given basic data on the history of the periodical, its frequency, and the name and address of its publisher. In addition, a brief annotation is appended for each title indicating what types of materials it publishes. From this list, it should be possible for art libraries to choose suitable periodicals for a basic collection, or for art students to determine which are likely to contain information on a topic of interest to them.

AIA Journal. 1900 to date. Monthly. American Institute of Architects, 1735 New York Ave. NW, Washington, D.C. 20006.Contains professional news for practicing architects; book reviews; articles on current architectural projects and management of architectural firms.

American Art Journal. 1969 to date. Semi-annual. Kennedy Galleries and Israel Sack, Inc., 40 W. 57th St., New York, N.Y. 10019. An illustrated, scholarly journal dealing with American art history, especially pre-twentieth century.

American Art Review. 1973 to date. Bimonthly. Martha Hutson Kellaway Publishing Co., P.O. Box 65007, Los Angeles, Calif. 90065. A lavishly illustrated, scholarly publication on American art history, with some emphasis on West Coast art.

American Artist. 1937 to date. Monthly. Published by American Artist Magazine,

subsidiary of Billboard Publications, Inc., 1515 Broadway, New York, N.Y. 10036. Features popular how-to articles on drawing and painting; book reviews; illustrated.

American Craft. 1941 to date. Bimonthly. American Crafts Council, 44 W. 53rd St., New York, N.Y. 10019. Covers a wide range of crafts, with exhibition news, market news, serious articles for artists, craftspersons, and collectors; illustrated; book reviews.

American Institute of Graphic Arts Journal. 1965 to date. 3 issues/year. AIGA, 1059 Third Ave., New York, N.Y. 10021. Contains catalogues of the association's award shows, with editorial comment and association news; illustrated; book reviews.

American Journal of Art Therapy: Art in Education, Rehabilitation, and Psychotherapy. 1961 to date. Quarterly. Elinor Ulman, 6010 Broad Brand Rd. NW., Washington, D.C. 20015. A specialized forum for educators, therapists, psychologists, psychiatrists, etc.; illustrated.

Antique Collector. 1930 to date. Bimonthly. Antique Collector, 16 Strutton Ground, London SW1P 2HP, England. A magazine for collectors, artists, curators, historians; articles on fine antiques, their makers, etc., with good illustrations; book reviews.

Antique Dealer and Collector's Guide. 1946 to date. Monthly. City Magazines, 1–3 Wine Office Court, Fleet Street, London EC4A 3AL, England. Features articles on antique art objects, ceramics, silver, dolls, etc., with news on European collectors' acquisitions, sales, historical associations, importers, etc.

Antique Monthly. 1967 to date. Monthly. Antique Monthly, Drawer 2, Tuscaloosa, Ala. 35401. Contains articles on historical aspects, values, museum acquisitions, and news items on shows, auctions; color and black-and-white illustrations; book reviews.

Antiques. 1922 to date. Monthly. Straight Enterprises, 551 Fifth Ave., New York, N.Y. 10017. A high-quality antiques journal, with excellent photography; emphasis on furniture and furnishings; museum notes; book reviews.

Antiques Journal. 1946 to date. Monthly. Babka Publishing Co., P.O. Box 1046, Dubuque, Iowa 52001. Antiques publication with emphasis on nineteenth-century collectibles, with a range from earrings and small items to snuff boxes, furniture, etc; illustrated; book reviews.

Apollo: The International Magazine of Art and Antiques. 1925 to date. Monthly. Apollo Magazine, 22 Davies Street, London W1, England. Lavish illustrations and informative articles on antiques and the decorative arts, primarily for collectors: book reviews.

Arbiter. 1927 to date. 10 issues/year. Italian Publications, 1103 46th Ave., Long Island City, N.Y. 11101. Text in English and Italian; top quality articles and illustrations on design, interior and exterior, city planning, and environmental planning.

Architectural Design. 1930 to date. Monthly. Standard Catalogue Co., 26 Bloomsbury Way, London WC1A 2SS, England. Publishes single-theme issues on aspects of building design, energy, city planning, sociology of architecture, etc.; book reviews; index.

Architectural Digest. 1920 to date. 9 issues/year. John C. Brasfield Publishing Co.,

5900 Wilshire Blvd., Los Angeles, Calif. 90036. Carries emphasis on interior design, rather than exterior; lavish illustration and some architectural articles.

Architectural History: Journal of the Society of Architectural Historians of Great Britain. 1958 to date. Annual. Society of Architectural Historians of Great Britain, 8 Belmount Ave., Melton Park, Newcastle upon Tyne, NE3 5QD, England. Treats architectural history in fascinating, well-written articles; illustrated; emphasis on British topics.

Architectural Record. 1891 to date. Monthly. McGraw-Hill, Inc., 1221 Ave. of the Americas, New York, N.Y. 10020. A journal for architects and engineers, but emphasis on homes and layman's language in articles makes it popular; illustrations; news and features on architectural design.

Architectural Review. 1896 to date. Monthly. Architectural Press, 9–13 Queen Anne's Gate, London SW1, England. Articles on architectural trends, modern design; international scope; excellent illustrations; occasional articles on other arts.

Archives of American Art Journal. 1960 to date. Quarterly. Archives of American Art, 41 E. 65th St., New York, N.Y. 10021. Focuses on American art history, centered on the Archives' collections, the largest on fine arts in the world; illustrated.

Archives of Asian Art. 1956 to date. Annual. Asia Society, 112 E. 64th St., New York, N.Y. 10021. Publishes scholarly articles on Asian art, and lists of Asian art recently obtained by American museums; illustrated.

Art and Artists. 1966 to date. Monthly. Hansom Books, Artillery Mansions, 75 Victoria St., London SW1 HOHZ, England. Contains illustrated, scholarly articles on a full range of art topics, in language a layman can understand as well.

Art and Australia. 1962 to date. Quarterly. Fine Arts Press, 1 Hamilton St., Sydney, Australia. Publishes articles on Australian art, artists, and exhibitions; illustrated; covers all the art media.

Art and Craft in Education. 1946 to date. Monthly. Evans Bros., Ltd., Montague House, Russell Square, London, WC1B 5BX, England. Illustrated articles on art projects and crafts for use in the classroom; primarily for elementary and junior high school art teachers.

Art and Man. 1970 to date. 8 issues/year. Scholastic Magazines for the National Gallery of Art, 902 Sylvan Ave., Englewood Cliffs, N.J. 07632. A classroom teaching aid for junior high school level; carries reproductions of art works in a theme in each issue.

Art Bulletin. 1912 to date. Quarterly. College Art Association of America, 149 Madison Avenue, New York, N.Y. 10016. A scholarly journal of art history, research, and criticism; lengthy book reviews; exhibition and collection critiques.

Art Direction: The Magazine of Visual Communication, Serves the Field of Advertising Art, Photography, Typography and Related Graphic Arts Fields. 1950 to date. Monthly. Advertising Trade Publications, 19 W. 44th St., New York, N.Y. 10036. Each issue has about 300 illustrations and editorial material on every phase of the graphic and commercial arts; book reviews.

Art Education. 1948 to date. 8 issues/year. National Art Education Association,

1916 Association Drive, Reston, Va. 22091. Carries scholarly articles on the theory of art education for primary and secondary school art teachers; illustrated; book reviews.

Art Gallery Magazine. 1957 to date. Bimonthly. Hollycroft Press, Ivoryton, Conn. 06442. An illustrated guide to art gallery shows on an international basis; articles on galleries, collections, and personnel; columns on gallery news.

Art in America. 1913 to date. Quarterly. Published by Art in America, Inc., a subsidiary of Whitney Communications Corp., 850 Third Ave., New York, N.Y. 10022. Not restricted to American art; the emphasis is on modern art; includes socioeconomic aspects of the arts; book reviews; charts; lavishly illustrated.

Art International. 1956 to date. 5 issues/year. James Fitzsimmons, Via Maraini 17-A, 6900 Lugano, Switzerland. Treats avant-garde subjects in high-quality literary style; illustrations of excellent quality; book and exhibition reviews.

Art Journal. 1912 to date. Quarterly. College Art Association of America, 16 E. 52nd St., New York, N.Y. 10022. News on exhibitions, museum acquisitions, new college art buildings; book reviews; articles on art teaching at college level, art history, etc.; illustrations.

Art Language. 1969 to date. 3 issues/year. Art and Language Press, 103 Clarendon St., Leamington Spa, Warwickshire, England. A journal dedicated to conceptual art, with articles by conceptual artists; good quality exposure to modern trends in art.

Art Letter: Art World Intelligence for Professionals. 1972 to date. Monthly. Art in America, Inc., 150 E. 58th St., New York, N.Y. 10022. Contains news on exhibitions, museums, business and art, art law, taxes, etc. for professionals.

Art News. 1902 to date. Monthly-May; summer issue combined. Artnews, 122 E. 42nd St., New York, N.Y. 10168. The oldest U.S. art journal still being published; balanced coverage of art and artists; exhibition reviews, book reviews; liberally illustrated; scholarly criticism.

Artes de México. 1953 to date. Monthly. José Losada Tomé, Amores 262, Mexico 12, D.F. Publishes articles in Spanish, with brief translations in English, French, or German, on the arts of Mexico; beautifully produced and illustrated.

Artes Visuales. 1973 to date. Quarterly. Museo de Arte Moderno, Bosque de Chapultepec, Paseo de la Reforma y Gandhi, Mexico 5, D. F. Treats contemporary visual arts of Mexico; articles in Spanish, with English translation of each; illustrated.

Artforum. 1962 to date. 10 issues/year. Joseph Masheck, 667 Madison Ave., New York, N.Y. 10021. Deals with recent artistic trends and the avant garde, including photography and film; illustrated.

Artibus Asiae. 1925 to date. Quarterly. Alexander C. Soper, 6612 Ascona, Switzerland. Subscriptions to: Institute of Fine Arts, New York University, 25 W. 4th Street, New York, N.Y. 10012. Scholarly, photographically illustrated articles on the art of the Near East, Far East, India, and Southeast Asia; includes book reviews.

ArtMagazine. 1969 to date. Bimonthly. ArtMagazine, Suite 403, 234 Eglinton Ave.

E., Toronto, Ontario, M4P 1K5, Canada. Glossy illustrated publication on the Canadian art world; good quality articles on museum collections and Canadian artists, etc., despite an initial shallow impression.

Arts and Activities: Creative Activities for the Classroom. 1937 to date. Monthly, September-June. Publisher's Development Corp., 8150 N. Central Park Blvd., Skokie, Ill. Presents ideas and instructions for classroom art projects and lessons; illustrated and often featuring children's art; for teachers to use with students.

Arts in Ireland. 1972 to date. Quarterly. Trinity Publishing Ltd., Calcott House, 15–17 S. King St., Dublin 2, Ireland. A top-quality presentation of Irish arts, historical and present; good illustrations; includes all the arts, but emphasis is on the visual arts.

Arts Magazine: Ideas in Contemporary Art. 1926 to date. 10 issues/year. Art Digest, Inc., 23 E. 26th St., New York, N.Y. 10010. Covers current art trends; includes book reviews, illustrations, exhibition reviews, critiques.

ArtsCanada. 1943 to date. Bimonthly. Society for Art Publications, 3 Church St., Toronto, Ontario, M5E 1M2, Canada. A beautifully illustrated journal with articles on Canadian arts, particularly modern arts and crafts; book reviews; museum news.

Burlington Magazine. 1903 to date. Monthly. Burlington Magazine Publications, Ltd., Elm House, 10–16 Elm St., London, England. Offers scholarly articles on art research and history topics; extensive book and exhibition reviews; collection news; annotated list of British theses and dissertations.

Canadian Architect. 1956 to date. Monthly. Southam Business Publications, 1450 Don Mills Rd., Don Mills, Ontario, Canada. Publishes articles on traditional and modern styles; illustrated; directed at the professional and the expert.

Ceramic Review. 1970 to date. Bimonthly. Craftsmen Potters Association, 7 Marshall St., London W1V 1FD, England. A professional potters' magazine, featuring new materials, methods, exhibits, equipment, etc.; illustrated.

Communication Arts Magazine. 1958 to date. Bimonthly. Richard Coyne, P. O. Box 10300, 410 Sherman Ave., Palo Alto, Calif., 94303. The American equivalent of *Graphis*, with the same concept and appearance; articles on designers, illustrators, advertising design, posters, packaging, etc.; illustrated.

Connoisseur. 1901 to date. Monthly. Hearst Magazines, *Connoisseur*, 250 W. 55th St., New York, N.Y. 10019. Provides articles and news for collectors of antiques and decorative arts; some general art topics; book reviews; gallery news.

Crafts. 1973 to date. Bimonthly. Crafts Advisory Committee, 12 Waterloo Place, London SW1Y 4AU, England. Illustrated publication for and about craftspeople of Britain; news, technical articles, general features, reviews, etc.

Criss Cross Art Communications. 1976 to date. Semiannual. Criss Cross Art Communications, P.O. Box 2022, Boulder, Colo. 80302. A magazine dedicated to covering the art world of mid-America; heavily illustrated interviews, articles, reviews, on art between Chicago and the West Coast.

Design. 1949 to date. Monthly. Design Council, Design Center, 28 Haymarket, London SW1, England. A British publication promoting excellence of

design in industry, in all types of objects, from jewelry to household items; illustrated.

Design News. 1946 to date. Semimonthly. Cahners Publishing Co., Inc., 221 Columbus Ave., Boston, Mass. 01772. Contains articles on design ideas for small items to large machinery, for professional design engineers; illustrated.

Design Quarterly. 1946 to date. Quarterly. Walker Art Center, Vineland Place, Minneapolis, Minn. 55403. Provides useful, illustrated articles on all areas of design; each issue on a theme from the design field.

Design: The Magazine of Creative Art, for Teachers, Artists and Craftsmen. 1899 to date. Bimonthly. Saturday Evening Post Co., 1100 Waterway Blvd., Indianapolis, Ind. 46206. Covers art appreciation, art and craft instruction for teachers from elementary level through college; illustrated; book reviews.

Domus. 1928 to date. Monthly. Editoriale Domus, Viale del Ghisallo 12, Milan, 20151, Italy. Italian articles, with English summaries, on the best of design; luxuriously illustrated; book reviews.

Drawing. 1979 to date. Bimonthly. Drawing Society, 500 Park Avenue, New York, N.Y. 10022. Publishes essays, reviews, on exhibits, auctions, catalogues, books; interviews, notices; illustrated.

Feminist Art Journal. 1972 to date. Quarterly. Cindy Nemser and Chuck Nemser, 41 Montgomery Pl., Brooklyn, N.Y. 11215. A well-designed, authoritative magazine on women in art and female artists today and in the past; illustrated; book reviews.

Flash Art: The International Arts Review. 1967 to date. Bimonthly. Giancarlo Politi, 36 Via Conatello, Milan 20131, Italy. Includes debates, interviews, and articles on current cultural-political art scene; Italian, with most pieces translated into English; lavishly illustrated.

Furniture History. 1965 to date. Annual. Furniture History Society, Department of Furniture and Woodworking, Victoria and Albert Museum, London, England. Carries scholarly articles on history of furniture and woodworking; illustrated; lengthy book reviews.

Gazette des Beaux-Arts. 1859 to date. 10 issues/year. The Gazette, 140 Faubourg Saint Honoré, Paris 75008, France. One of the oldest and most respected art journals; lavishly illustrated articles, in French and English, on all periods and all schools of art; scholarly and basic.

Graphic Arts Monthly and the Printing Industry. 1929 to date. Monthly. Dun-Donnelly Publishing Corp., 222 S. Riverside Plaza, Chicago, Ill. 60606. Includes illustrated items and longer articles on technology, trends, news in the graphic, commercial, and advertising art fields.

Graphis Annual. 1952/53 to date. Annual. Published in Switzerland, distributed in the United States by Hastings House, 10 E. 40th St., New York, N.Y. 10016. An annual compilation of the best in graphic and commercial art; lavishly illustrated; the epitome itself of the printer's art.

Graphis: International Journal for Graphic and Applied Art. 1944 to date. Bimonthly. Published in Switzerland, distributed in the United States by Hastings House, 10 E. 40th St., New York, N.Y. 10016. Regular coverage of exhibits,

artists, and awards in graphic arts, with exquisite illustrations liberally used; book reviews; authoritative writing.

Harvard Architecture Review. 1978 to date. Irregular. MIT Press, 28 Carleton Street, Cambridge, Mass. 02142. Carries articles and symposia in each issue on a specific theme in architectural design.

Historic Preservation. 1949 to date. Quarterly. National Trust for Historic Preservation, 740–748 Jackson Place NW. Washington, D.C. 20006. Presents articles on preservation of historic buildings and landmarks; well written and illustrated.

Illustrator. 1916 to date. Semiannual. Art Instruction Schools, 500 South Fourth St., Minneapolis, Minn. 55415. Articles on technique and materials, as well as sources of supplies, for the practicing illustrator.

Interior Design. 1932 to date. Monthly. Whitney Communications Corp., 150 E. 58th St., New York, N.Y. 10022. A trade magazine covering residential and commercial interior design; illustrated.

Interiors. 1888 to date. Monthly. Distributed by Billboard Publications, Inc. One Astor Plaza, New York, N.Y. 10036. A quality illustrated journal for design professionals; emphasis on commercial and institutional interiors; high design standards.

JAE: Journal of Architectural Education. 1947 to date. Quarterly. Association of Collegiate Schools of Architecture, 1735 New York Ave. NW, Washington, DC 20006. Contains articles on history and concepts of architecture, of interest to the general reader as well as teachers; illustrated.

Japan Architect. (International edition of *Shinkenchiku.*) 1925 to date. Monthly. Shinkenchiku Co., Ltd. 31–2 Yushima, 2-chome, Tokyo, Japan. Offers well-illustrated and well-written articles on Japanese and international building trends and newest ideas in architecture.

Journal of Aesthetics and Art Criticism. 1941 to date. Quarterly. American Society for Aesthetics, C. W. Post Center of Long Island University, Greenvale, N.Y. 11548. Carries studies of the arts and their relation to society in the broadest sense; scholarly articles; book reviews.

Journal of Glass Studies. 1959 to date. Annual. Corning Museum of Glass, Corning Glass Center, Corning, N.Y. 14830. Provides learned articles on the art and design of glass, and lengthy bibliographies of books and articles on glass publications during previous year; illustrated.

Leonardo: Art Science and Technology. 1968 to date. Quarterly. Pergamon Press, Maxwell House, Fairview Park, Elmsford, N.Y. 10523. Publishes articles on the technology of modern art, aimed at the practicing artist, not the layman; illustrated; book reviews; theory and technique.

Master Drawings. 1963 to date. Quarterly. Master Drawing Association, Inc., 33 E. 36th St., New York, N.Y. 10016. Carries historical and theoretical articles on drawing; bibliographies and book reviews; quality illustrations and layout.

Metropolitan Museum Journal. 1968 to date. Annual. Metropolitan Museum of Art, Fifth Ave. and 82nd St., New York, N.Y. 10028. A vehicle for scholarly work in art history, not for promoting the museum and its collections, although they are sometimes used as illustrations.

Metropolitan Museum of Art Bulletin. 1942 to date. Quarterly. Metropolitan Mu-

seum of Art, Fifth Ave. and 82nd St., New York, N.Y. 10028. A lavish
publication on special collections and exhibitions at the museum; in the
late 1970s many issues were published irregularly like a hardbound mon-
ograph series.

Mobilia: For Furniture, Art Handicraft, Art, and Architecture. 1955 to date. Monthly.
Per Mollerup, 3070 Snekkersten, Denmark. A Danish journal, with articles
in four languages, including English; deals with design, furniture, crafts,
decorative arts, graphics; lavish illustrations, exquisite layout.

National Sculpture Review. 1951 to date. Quarterly. National Sculpture Society,
777 Third Ave., New York, N.Y. 10017. Publishes high-quality articles
and photographs on sculpture, theory, techniques, history, aesthetics;
exhibit and museum news.

Nineteenth Century. 1975 to date. Quarterly. Victorian Society in America. Sub-
scriptions to: Forbes, Inc., 60 Fifth Ave., New York, N.Y. 10011. Provides
articles on Victoriana in England and America, with reviews of shows
and auctions; full range of antique objects; lavish illustrations.

*Novum Gebrauchsgraphik/Internationale Monatszeitschrift fuer Visuelle Kommunikation
+ Grafik-Design.* 1924 to date. Monthly. F. Bruckmann KG., Nymphen-
burger Strasse 86, 8000 Munich 2, West Germany. Carries articles in Ger-
man, English, and French on model solutions to graphic problems;
illustrated; book reviews.

Oppositions. 1973 to date. Quarterly. Institute for Architecture and Urban Studies,
8 W. 40th St., New York, N.Y. 10018. Treats avant-garde topics with an
emphasis on controversial alternatives in architecture; well written and
illustrated.

Oriental Art: Devoted to the Study of all Forms of Oriental Art. 1955 to date. Quarterly.
Oriental Art Magazine, Ltd., 12 Ennerdale Road, Richmond, Surrey, Eng-
land. Offers scholarly articles on Oriental art objects, history, etc.; illus-
trated with black-and-white plates; book reviews; bibliography in English.

Pantheon: Internationale Zeitschrift fuer Kunst. 1928 to date. Bimonthly. F. Bruck-
mann KG., Nymphenburger Strasse 86, 8000 Munich, West Germany.
An international publication, with excellent articles and impressive color
plates; text in original languages, with summaries in English and German;
exhibitions; current projects.

Perspecta: The Yale Architectural Journal. 1964 to date. Annual. MIT Press, 28
Carleton Street, Cambridge, Mass. 02142. Publishes articles on scholarly
topics in architectural theory, design, and practice; illustrations; excellent
design.

Pictures on Exhibit: Worldwide Reviews of the Art Shows. 1937 to date. Monthly,
October-June. Pictures Publications Co., 30 E. 60th St., New York, N.Y.
10022. A report with reviews of exhibitions, with many black-and-white
photographs; objective, accurate writing.

Pottery Quarterly. 1954 to date. Quarterly. Northfields Studio, Northfields, Tring.
Herts., England. A professional potters' journal, with illustrations, in-
formation on clays, glazes, etc.

Prairie School Review. 1963 to date. Quarterly. Prairie School Society, Ltd., 12509
S. 89th Ave., Palos Park, Ill. 60464. Carries three or four articles each

issue on the Prairie School architects, such as Sullivan and Wright, and
followers; high standards of design and illustration.

Print: America's Graphic Design Magazine. 1939 to date. Bimonthly. *Print,* 355
 Lexington Ave., New York, N.Y. 10017. Publishes articles and features
 on developments in the graphic arts, advertising, typography, packaging,
 book design, etc.; lavishly illustrated.

Print Collector's Newsletter. 1970 to date. Bimonthly. Print Collector's Newsletter,
 205 E. 78th St., New York, N.Y. 10021. A loose-leaf publication covering
 prints and graphic artists, with an emphasis on data for the collector;
 covers photography as well as other methods; book reviews.

Print News. 1979 to date. Bimonthly. World Print Council, P.O. Box 26010, San
 Francisco, Calif. 94126. Contains articles on artists, techniques, exhibi-
 tions; book reviews; news of events and people in the graphic arts.

Progressive Architecture. 1920 to date. Monthly. Reinhold Publishing Co., 600
 Summer St., Stamford, Conn. 06904. A journal with an emphasis on the
 avant garde, individual architects, photography, and the international
 scene; illustrated.

Revue de l'Art. 1968 to date. Quarterly. National Center of Scientific History of
 Art. Edition CNRS, 15 quai Anatole France, Paris 75700, France. A schol-
 arly art-history journal, with an emphasis on France and Europe; many
 illustrations; French articles, with summaries in English.

RIBA Journal. 1879 to date. Monthly. Royal Institute of British Architects, 66
 Portland Place, London WIN 4AD, England. Contains reports on asso-
 ciation activities and lengthy articles on British architecture and planning;
 illustrated and scholarly in tone.

Royal Society of Arts Journal. 1852 to date. Monthly. Royal Society of Arts, 6–7
 John Adam St., Adelphi, London WC2N 6EZ, England. One of the oldest
 scholarly art journals in English; carries items on all the arts, with an
 emphasis on British issues.

School Arts Magazine: The Magazine for Art Education. 1901 to date. Monthly. Davis
 Publications, Inc., Printers Building, Worcester, Mass. 01608. A publi-
 cation for elementary and secondary school art teachers, with project
 ideas; occasional pieces on theory or philosophy; illustrated; book reviews.

Society of Architectural Historians Journal. 1940 to date. Quarterly. Society of Ar-
 chitectural Historians, Room 716, 1700 Walnut St., Philadelphia, Penna.
 19103. Carries scholarly articles on architectural history; international in
 scope and well illustrated.

Stained Glass: Devoted to the Craft of Painted and Stained Glass. 1906 to date. Quart-
 erly. Stained Glass Association of America, 1125 Wilmington Ave., St.
 Louis, Mo. 63111. Features brief articles on craftspeople and outstanding
 examples of stained and painted glass, historic and current; illustrated.

Studies in Art Education: A Journal of Issues and Research in Art Education. 1959 to
 date. 3 issues/year. National Art Education Association, 1201 16th St. NW,
 Washington, D.C. 20036. A journal for art teachers at all levels, with an
 emphasis on scholarly issues and reports of research; illustrated; book
 reviews.

Studio International. 1893 to date. 6 issues/year. Studio International Journal, Ltd.,
 14 W. Central St., London WC1A 1JH, England. A prestige British journal,

with a British viewpoint, on contemporary art and artists; book reviews; illustrations; biannual index.

Studio Potter. 1972 to date. Semiannual. Daniel Clark Foundation, P.O. Box 65, Goffstown, N.H. 03045. An illustrated, well-designed journal dedicated to the serious, full-time potter of today; interviews, articles on technique, etc.

Tracks: A Journal of Artistic Writings. 1974 to date. 3 issues/year. Herbert George, P.O. Box 557, Old Chelsea Station, New York, N.Y. 10011. A publication devoted to the writings of practicing artists; substantial, illustrated issues of a very informative nature.

U&LC (Upper and Lower Case): The *International Journal of Typographics*. 1974 to date. Quarterly. International Typeface Corp., 216 E. 45th St., New York, N.Y. 10017. Carries articles on graphic artists, technology of the printing and graphics industries; original design, appealing articles; book annotations.

Urban Design. 1970 to date. Quarterly. R. C. Publications, 6400 Goldsboro Rd. NW, Washington, D.C. 20034. Publishes articles on architecture and planning in the context of the urban community, with an emphasis on conserving the environment; illustrated.

Via. 1978 to date. Annual. MIT Press, 28 Carleton Street, Cambridge, Mass. 02142. Features scholarly articles, symposia, illustrations on modern architecture, architectural theory, and planning.

Vie des Arts. 1956 to date. Quarterly. André Paradis, 360 rue McGill, 4e étage, Montreal H2Y 2E9, Canada. Offers international coverage of art in a Canadian journal, in French with English translation; scholarly but readable; illustrated; book reviews.

XXe Siècle. 1938 to date. Biannual. Distributed by Tudor Publishing Co., 221 Park Ave. South, New York, N.Y. 10003. In French, with English summaries; scholarly articles, lavishly illustrated, documenting most of twentieth-century art.

Vision. 1976 to date. Irregular (ca. 3/year). Crown Point Press, 1555 San Pablo Ave., Oakland, Calif. 94612. Treats the modern art of a given state, city, or country featured in each issue; scholarly articles; well illustrated.

Visual Dialog. 1975 to date. Quarterly. Roberta Loach, P.O. Box 1438, Los Altos, Calif. 94022. Theme issues cover current art topics; articles on established and obscure artists; emphasis on West Coast; illustrated.

Women Artists Newsletter. 1976 to date. 10 issues/year. Midmarch Associates, P.O. Box 3304, Grand Central Station, New York, N.Y. 10017. Contains lively, informative articles and news on women artists and their art; illustrated; book reviews.

Zeitschrift fuer Kunstgeschichte. 1924 to date. Quarterly. Deutscher Kunstverlag, 8000 Munich 21, West Germany. Offers articles in English, French, German, and other languages on scholarly art topics; illustrated; lengthy book reviews; annual research bibliography.

Bibliography

A. BIBLIOGRAPHIES

1. Abrams, Leslie E. *History and Practice of Japanese Printmaking: A Selectively Annotated Bibliography of English Language Materials.* Art Reference Collection, no. 5. Westport, Conn.: Greenwood Press, 1984.
2. American Crafts Council, Research and Education Department. *Bibliography, Fiber.* New York: American Crafts Council, 1975.
3. Archives of American Art. *The Card Catalog of the Oral History Collections of the Archives of American Art.* Wilmington, Del.: Scholarly Resources, 1984.
4. Archives of American Art. *Collection of Exhibition Catalogs.* Boston: G. K. Hall, 1979.
5. Arnone, Vincent, and Neil, Hugh M. *Annotated Bibliography of Art Education.* Buffalo, N.Y.: State University of New York at Buffalo, 1969.
6. Arntzen, Etta, and Rainwater, Robert. *Guide to the Literature of Art History.* Chicago: American Library Association, 1980.
7. *Art Books, 1876–1949, Including an International Index of Current Serial Publications.* New York: R. R. Bowker, 1981.
8. *Art Books, 1950–1979, Including an International Directory of Museum Permanent Collection Catalogues.* New York: R. R. Bowker, 1980.
9. *Art Books, 1980–1984.* New York: R. R. Bowker, 1984.
10. Avery Architectural Library. *Catalog of the Avery Memorial Architectural Library of Columbia University.* 2d enl. ed. Boston: G. K. Hall, 1968.
11. Avery Architectural Library, Columbia University, *Avery Obituary Index of Architects and Artists.* Boston: G. K. Hall, 1963.
12. Axford, Lavonne B. *Weaving, Spinning, and Dyeing.* Spare Time Guides, no. 7. Littleton, Colo.: Libraries Unlimited, 1975.

13. Bachmann, Donna G. and Piland, Sherry. *Women Artists: An Historical, Contemporary, and Feminist Bibliography.* Metuchen, N.J.: Scarecrow Press, 1978.

14. Bailey, Joyce Waddell, ed. *Handbook of Latin American Art.* 3 vols. in 4 planned. Santa Barbara, Calif.: ABC-Clio, 1984 to date.

15. Baker, Charles. *Bibliography of British Book Illustrators, 1860–1900.* Birmingham, England: n.p., 1978.

16. Bamford, Lawrence Von. *Design Resources: A Guide to Architecture and Industrial Design.* Jefferson, N.C.: McFarland Publishers, 1984.

17. Beelke, Ralph G. *Curriculum Development in Art Education: An Annotated Listing of Publications Prepared for the Teaching of Art.* Washington, D.C.: National Art Education Association , 1962.

18. Bell, Doris L. *Contemporary Art Trends, 1969–1980: A Guide to Sources.* Metuchen, N.J.: Scarecrow Press, 1981.

19. Besterman, Theodore. *Art and Architecture: A Bibliography of Bibliographies.* Totowa, N.J.: Rowman and Littlefield, 1971.

20. *Bibliographic Guide to Art and Architecture.* Boston: G. K. Hall, 1975 to date.

21. Boni, Albert, ed. *Photographic Literature: An International Bibliographic Guide to General and Specialized Literature.* Dobbs Ferry, N.Y.: Morgan and Morgan, 1962.

22. Bradfield, Valerie J., ed. *Information Sources in Architecture.* Butterworth's Guides to Information Sources. London and Boston: Butterworth's, 1983.

23. Brady, Darlene, and Serban, William. *Stained Glass: A Guide to Information Sources.* Art and Architecture Information Guides, no. 10. Detroit: Gale Research Company, 1980.

24. Brenni, Vito Joseph. *Book Illustration and Decoration: A Guide to Research.* Art Reference Collection, no. 1. Westport, Conn.: Greenwood Press, 1980.

25. Bridson, Gavin, and Wakeman, Geoffrey. *Printmaking and Picture Printing: A Bibliographical Guide to Artistic and Industrial Techniques in Britain 1750–1900.* Williamsburg, Va.: The Bookpress, 1984.

26. Bronner, Simon J. *American Folk Art: A Guide to Sources.* New York: Garland Publishing, 1984.

27. Buckley, Mary. *Color Theory: A Guide to Information Sources.* Art and Architecture Information Guides, no. 2. Detroit: Gale Research Company, 1975.

28. Bunch, Clarence. *Art Education: A Guide to Information Sources.* Art and Architecture Information Guides, no. 6. Detroit: Gale Research Company, 1978.

29. Campbell, James Edward, ed. *Pottery and Ceramics: A Guide to Information Sources.* Art and Architecture Information Guides, no. 7. Detroit: Gale Research Company, 1978.

30. Carrick, Neville. *How to Find Out About the Arts: A Guide to Sources of Information.* New York: Pergamon Press, 1965.

31. Caviness, Madeline H., and Staudinger, E. R. *Stained Glass Before 1540: An Annotated Bibliography.* Reference Publications in Art History. Boston: G. K. Hall, 1983.

32. Chamberlin, Mary W. *Guide to Art Reference Books.* Chicago: American Library Association, 1959.

33. Chase, Frank H. *Bibliography of American Art and Artists Before 1835.* Boston: G. K. Hall, 1918.

34. College Art Association of America, Resources and Planning Committee. *List of the Needs of Visual Arts in Higher Education.* New York: College Art Association of America, 1966.

35. College Art Association of America. *Répertoire International de la Littérature de l'Art: RILA Abstracts.* Williamstown, Mass.: Sterling and Francine Clark Art Institute, 1975 to date.

36. Colvin, H. M. *English Architectural History: A Guide to Sources.* Pinhorn Handbooks, no. 1. 2d ed. Shalfleet Manor, England: Pinhorns, 1976.

37. Coulson, Anthony J. *Bibliography of Design in Britain, 1851–1970.* London: Design Council, 1979.

38. Coulson, William D. E. *Annotated Bibliography of Greek and Roman Art, Architecture, and Archaeology.* Garland Reference Library of the Humanities, no. 28. New York: Garland Publishers, 1976.

39. Creswell, Keppel A. C. *Bibliography of the Architecture, Arts, and Crafts of Islam to 1960.* New York: Oxford University Press, 1960.

40. Curcic, Slobodan. *Art and Architecture in the Balkans: An Annotated Bibliography.* Boston: G. K. Hall, 1984.

41. Cutul, Ann-Marie. *Twentieth-Century European Painting: A Guide to Information Sources.* Art and Architecture Information Guides, no. 9. Detroit: Gale Research Company, 1980.

42. Davis, Jinnie Y., and Richardson, John V. *Calligraphy: A Sourcebook.* Littleton, Colo.: Libraries Unlimited, 1982.

43. Davis, Lenwood G., and Sims, Janet. *Black Artists in the U. S.: An Annotated Bibliography of Books, Articles, and Dissertations on Black Artists, 1779–1979.* Westport, Conn.: Greenwood Press, 1980.

44. *Design.* Modern Art Bibliographical Series, no. 3. Santa Barbara, Calif.: ABC-Clio, 1983.

45. Dixon, Penelope, and Ryan, Fortune. *Photographers of the Farm Security Administration: An Annotated Bibliography, 1930–1980.* New York: Garland Publishing, 1983.

46. Doumato, Lamia. *American Drawing: A Guide to Information Sources.* Art and Architecture Information Guides, no. 11. Detroit: Gale Research Company, 1979.

47. Ehresmann, Donald L. *Applied and Decorative Arts: A Bibliographic Guide to Basic Reference Works, Histories, and Handbooks.* Littleton, Colo.: Libraries Unlimited, 1977.

48. Ehresmann, Donald L. *Architecture: A Bibliographic Guide to Basic Reference Works, Histories, and Handbooks.* Littleton, Colo.: Libraries Unlimited, 1984.

49. Ehresmann, Donald L. *Fine Arts: A Bibliographic Guide to Basic Reference Works, Histories, and Handbooks.* 2d ed. Littleton, Colo.: Libraries Unlimited, 1979.

50. Ekdahl, Janis. *American Sculpture: A Guide to Information Sources.* Art and Architecture Information Guides, no. 5. Detroit: Gale Research Company, 1977.

51. Evans, David. *Bibliography of Stained Glass.* London: Boydell Press, 1983.

52. Findlay, James A. *Modern Latin American Art: A Bibliography.* Art Reference Collection, no. 3. Westport, Conn.: Greenwood Press, 1983.

53. Franklin, Linda Campbell. *Antiques and Collectibles: A Bibliography of Works in English, 16th Century to 1976.* Metuchen, N.J.: Scarecrow Press, 1978.

54. Georgi, Charlotte. *Arts and the World of Business.* 2d ed. Metuchen, N.J.: Scarecrow Press, 1979.

55. Glass, Dorothy F. *Italian Romanesque Sculpture: An Annotated Bibliography.* Reference Publications in Art History. Boston: G. K. Hall, 1983.

56. Goldman, Bernard. *Reading and Writing in the Arts: A Handbook.* Rev. ed. Detroit: Wayne State University Press, 1978.

57. Gordon, Beverly. *Domestic American Textiles: A Bibliographic Sourcebook.* Pittsburgh, Penna.: Center for the History of American Needlework, 1978.

58. Hanes, Kathleen Mileski. *Art Therapy and Group Work: An Annotated Bibliography.* Westport, Conn.: Greenwood Press, 1981.

59. Hanks, Elizabeth, comp. *Australian Art and Artists to 1950: A Bibliography Based on the Holdings of the State Library of Victoria.* Melbourne, Australia: Library Council of Victoria, 1982.

60. Harvard University, Fine Arts Library. *Catalogue of the Harvard University Fine Arts Library.* 15 vols. (including Catalogue of Auction Sales catalogues). Boston: G. K. Hall, 1971.

61. Harvard University, Graduate School of Design. *Catalog of the Library of the Graduate School of Design.* Boston: G. K. Hall, 1968.

62. Havlice, Patricia Pate. *Earth Scale Art: A Bibliography, Directory of Artists, and Index of Reproductions.* Jefferson, N.C.: McFarland Publishers, 1984.

63. Hitchcock, Henry Russell. *American Architectural Books: A List of Books, Portfolios, Pamphlets on Architecture and Related Subjects Published in America before 1895.* 3rd ed. 1946. Reprinted. Minneapolis: University of Minnesota Press, 1962.

64. Holmes, Oakley N. *Complete Annotated Resource Guide to Black American Art.* Spring Valley, N.Y.: Macgowan Enterprises, 1978.

65. Hubbard, Theodora K., and McNamara, K. *Bibliography of Planning, 1928–1935: Supplement to Manual of Planning Information.* Harvard City Planning Studies. Cambridge: Harvard University Press, 1936.

66. Igoe, Lynn Moody, and Igoe, James. *250 Years of Afro-American Art: An Annotated Bibliography.* New York: R. R. Bowker, 1981.

67. Jones, Lois Swan. *Art Research Methods and Resources: A Guide to Finding Art Information.* 2d ed. Dubuque, Iowa: Kendall/Hunt, 1984.

68. Kamen, Ruth H. *British and Irish Architectural History: A Bibliography and Guide to Sources of Information.* London: Architectural Press, Ltd., 1981.

69. Karpel, Bernard. *Arts in America: A Bibliography.* 4 vols. Washington, D.C.: Smithsonian Institution Press, 1979.

70. Keaveney, Sydney Starr. *American Painting: A Guide to Information Sources.* Art and Architecture Information Guides, no. 1. Detroit: Gale Research Company, 1974.

71. Kempton, Richard. *Art Nouveau: An Annotated Bibliography.* Art and Architecture Bibliographies, no. 4. Los Angeles: Hennessey and Ingalls, 1977—.

72. Lackschewitz, Gertrud. *Interior Design and Decoration: A Bibliography Com-*

piled for the American Institute of Decorators. New York: New York Public Library, 1961.

73. London University, Courtauld Institute. *Annual Bibliography of the History of British Art*. Vols. 1–6, 1934–48. Cambridge: Cambridge University Press, 1939–1957.

74. Lovell, Hin-Cheung. *Annotated Bibliography of Chinese Painting Catalogues and Related Texts*. Michigan Papers in Chinese Studies, no. 16. Ann Arbor: University of Michigan Center for Chinese Studies, 1973.

75. Lucas, Edna Louise. *Art Books: A Basic Bibliography of the Fine Arts*. Greenwich, Conn.: New York Graphic Society, 1968.

76. Lucas, Edna Louise. *Harvard List of Books on Art*. Cambridge: Harvard University Fine Arts Library, 1952.

77. Lucas, Samuel Thomas. *Bibliography of Water Colour Painting and Painters*. Totowa, N.J.: Rowman and Littlefield, 1977.

78. Ludman, Joan, and Mason, Lauris. *Fine Print References: A Selected Bibliography of Print-Related Literature*. Print Reference Series. Millwood, N.Y.: Kraus International Publications, 1982.

79. McColvin, Eric Raymond. *Painting: A Guide to the Best Books with Special Reference to the Requirements of Public Libraries*. London: Grafton, 1934.

80. McCoy, Garnett. *Archives of American Art: A Directory of Resources*. New York: R. R. Bowker, 1972.

81. Marantz, Kenneth. *Bibliography of Children's Art Literature*. Washington, D.C.: National Art Education Association, 1965.

82. Markowitz, Arnold L. *Historic Preservation: A Guide to Information Sources*. Art and Architecture Information Guides, no. 13. Detroit: Gale Research Company, 1980.

83. Mason, Lauris. *Print Reference Sources: A Select Bibliography, 18th–20th Centuries*. 2d ed. Millwood, N.Y.: Kraus Thomson, 1979.

84. Muehsam, Gerd. *Guide to Basic Information Sources in the Visual Arts*. Information Resources Series. Santa Barbara, Calif.: ABC-Clio, 1978.

85. Museum of Modern Art. *Catalog of the Library of the Museum of Modern Art*. 14 vols. (also on microfilm, 28 reels). Boston: G. K. Hall, 1976.

86. National Art Education Association. *Curriculum Guides in Art Education*. Reston, Va.: National Art Education Association, 1975.

87. New York Public Library. *Dictionary Catalog of the Art and Architecture Division of the New York City Research Libraries*. 30 vols. Boston: G. K. Hall, 1975.

88. New York Public Library. *Dictionary Catalog of the Prints Division of the New York City Research Libraries*. 5 vols. Boston: G. K. Hall, 1975.

89. New York. Metropolitan Museum of Art. *Library Catalog of the Metropolitan Museum of Art*. 48 vols. 2d rev. ed. Boston: G. K. Hall, 1980.

90. *Olana's Guide to American Artists: A Contribution Toward a Bibliography*. 2 vols. Poughkeepsie, N.Y.: Apollo Books, 1980.

91. O'Neal, William B., ed. *Papers of the American Association of Architectural Bibliographers*. Charlottesville, Va.: University of Virginia Press, 1965 to date.

92. Pacht, Otto, and Alexander, J. J. G. *Illuminated Manuscripts in the Bodleian Library, Oxford*. 3 vols. London: Oxford University Press, 1969–1973.

93. *Photography*. Modern Art Bibliographical Series, no. 2. Oxford, England: Clio Press, 1982.

94. Ralston, Valerie H. *Textile Reference Sources: A Selective Bibliography*. Reference Bibliography Series, no. 1. Storrs, Conn.: University of Connecticut Library, 1973.

95. Roos, Frank J., Jr. *Bibliography of Early American Architecture: Writings on Architecture Constructed Before 1860 in Eastern and Central United States*. New ed. Urbana: University of Illinois Press, 1968.

96. Rowland, Benjamin, Jr. *Harvard Outline and Reading Lists for Oriental Art*. 3rd ed. Cambridge: Harvard University Press, 1967.

97. Royal Institute of British Architects. *Catalogue of the Library of the RIBA*. London: Royal Institute of British Architects, 1937–1938.

98. Schultz, Harold Arthur. *Art Education for Elementary Teachers: A Selected Bibliography*. Washington, D.C.: National Art Education Association, 1959.

99. Semowich, Charles J. *American Furniture Craftsmen Working Prior to 1920: An Annotated Bibliography*. Art Reference Collection, no. 7. Westport, Conn.: Greenwood Press, 1984.

100. Smith, Robert Chester, and Wilder, Elizabeth. *Guide to the Art of Latin America*. 1948 ed. Reprint. New York: Arno Press, 1971.

101. Sokol, David M. *American Architecture and Art: A Guide to Information Sources*. American Studies Information Guides. Detroit: Gale Research Co., 1976.

102. Sokol, David M. *American Decorative Arts and Old World Influences: A Guide to Information Sources*. Art and Architecture Information Guides, no. 14. Detroit: Gale Research Company, 1980.

103. Spalek, John M. *German Expressionism in the Fine Arts: A Bibliography*. Art and Architecture Bibliographies, no. 3. Los Angeles: Hennessey and Ingalls, 1977.

104. Strong, Susan R. *History of American Ceramics: An Annotated Bibliography*. Metuchen, N.J.: Scarecrow Press, 1983.

105. Stubblebine, James H. *Dugento Painting: An Annotated Bibliography*. Boston: G. K. Hall, 1983.

106. *Tribal and Ethnic Art*. Modern Art Bibliographical Series, no. 1. Oxford, England: Clio Press, 1982.

107. Tubesing, Richard. *Architectural Preservation and Urban Renovation: An Annotated Bibliography of United States Congressional Documents*. New York: Garland Publishing, 1982.

108. Tufts, Eleanor. *American Women Artists: A Selective Bibliographical Guide*. New York: Garland Publishing, 1984.

109. Weidner, Ruth Irwin. *American Ceramics before 1930: A Bibliography*. Art Reference Collection. Westport, Conn.: Greenwood Press, 1982.

110. Weinrich, Peter H. *Bibliographic Guide to Books on Ceramics*. Ottawa, Canada: Canadian Crafts Council, 1976.

111. Western, Dominique Coulet. *Bibliography of the Arts of Africa*. Waltham, Mass.: African Studies Association, Brandeis University, 1975.

112. *Where to Look: A Guide to Preservation Information*. Washington, D.C.: Advisory Council on Historic Preservation, 1982. Distributed by the Government Printing Office.

113. Whitney Museum of American Art. Library. *Catalogue of the Library of the Whitney Museum of American Art.* 2 vols. Boston: G. K. Hall, 1979.

114. Whiton, Augustus Sherrill. *Interior Design and Decoration.* 4th ed. Philadelphia: Lippincott, 1974.

115. Willis-Thomas, Deborah. *Black Photographers, 1840–1940: An Illustrated Bio-Bibliography.* New York: Garland Publishing, 1984.

116. Wodehouse, Lawrence. *American Architects: A Guide to Information Sources.* Art and Architecture Information Guides, nos. 3–4. Detroit: Gale Research Co., 1976–1977.

117. Wodehouse, Lawrence. *British Architects, 1840–1976: A Guide to Information Sources.* Art and Architecture Information Guides, no. 8. Detroit: Gale Research Co., 1978.

118. Wodehouse, Lawrence. *Indigenous Architecture Worldwide: A Guide to Information Sources.* Art and Architecture Information Guides, no. 12. Detroit: Gale Research Co., 1980.

119. *World Museum Publications 1982.* New York: R. R. Bowker, 1982.

120. *Worldwide Art Catalogue Bulletin.* 1st ed. to date. Boston: Worldwide Books, 1963 to date.

121. Yuan, Tung-Li. *T. L. Yuan Bibliography of Western Writings on Chinese Art and Archaeology.* Edited by Harrie A. Vanderstappen. London: Mansell, 1975.

B. DICTIONARIES

1. Adeline, Jules. *Adeline Art Dictionary.* Translated from the 1891 French ed. New York: Ungar, 1966.

2. Avery, Catherine B., ed. *New Century Handbook of Greek Art and Architecture.* New York: Appleton Century Crofts, 1972.

3. Baigell, Matthew. *Dictionary of American Art.* New York: Harper & Row, 1979.

4. Baumgart, Fritz Erwin. *History of Architectural Styles.* Translated from the German. New York: Praeger Publishers, 1970.

5. Benezit, Emmanuel. *Dictionnaire critique et documentaire des peintres, sculpteurs, dessinateurs et graveurs de tous les temps et de tous les pays.* New ed. Paris: Grund, 1956–1961.

6. Berckelaers, Ferdinand Louis. *Dictionary of Abstract Painting: With a History of Abstract Painting.* Translated from the French of Michel Seuphor. New York: Tudor Publishing Company, 1957.

7. Berman, Harold. *Encyclopedia of Bronzes, Sculptors, and Founders, 1800–1930.* 4 vols. Chicago: Abage Publications, 1974–1980.

8. Boger, Louise Ade. *Dictionary of World Pottery and Porcelain.* New York: Charles Scribner's Sons, 1971.

9. Boger, Louise Ade, and Batterson, H., eds. *Dictionary of Antiques and the Decorative Arts: A Book of Reference for Glass, Furniture, Ceramics, Silver, Periods, Styles, Technical Terms, etc.* 2d ed., enl. New York: Charles Scribner's Sons, 1967.

10. Boyce, Charles. *Dictionary of Furniture.* New York: Facts on File, 1985.

11. Caplan, H. H. *Classified Directory of Artists' Signatures, Symbols, and Monograms.* 2d ed. Detroit: Gale Research Co., 1982.

12. Cirlot, Juan Eduardo. *Dictionary of Symbols.* 2d ed. London: Routledge and Kegan Paul, 1971.

13. Claret Rubira, José. *Encyclopedia of French Period Furniture Designs.* New York: Sterling Publishing Co., 1983.

14. Clayton, Michael. *Collectors' Dictionary of the Silver and Gold of Great Britain and North America.* New York: World Publishing Co., 1971.

15. Contag, Victoria, and Wang, Chi-chi'en. *Seals of Chinese Painters and Collectors of the Ming and Ch'ing Periods.* Rev. ed. with supplement. Hong Kong: Hong Kong University Press, 1966.

16. Curl, James Stevens. *English Architecture: An Illustrated Glossary.* North Pomfret, Vt.: David and Charles, 1977.

17. *Dictionary of Architecture, Building Construction, and Materials/Wörterbuch für Architektur, Hochbau, und Baustoffe.* 2d ed. 2 vols. Philadelphia: International Publications Service, 1983.

18. *Dictionary of Italian Painting.* New York: Tudor Publishing Company, 1964.

19. Drake, Wilfred James. *Dictionary of Glass Painters and 'Glasyers' of the Tenth to Eighteenth Centuries.* New York: Metropolitan Museum of Art, 1955.

20. Drepperd, Carl William. *Dictionary of American Antiques.* Garden City, N.Y.: Doubleday, 1952.

21. Edwards, Ralph. *Dictionary of English Furniture.* Rev. ed. 3 vols. London: Country Life, Ltd., 1954.

22. Elspass, Margy Lee. *Dictionary of Art Terms.* Cincinnati, Ohio: North Light, 1984.

23. Ferguson, George Wells. *Signs and Symbols in Christian Art, with Illustrations from Paintings of the Renaissance.* New York: Oxford University Press, 1959.

24. Fletcher, Sir Banister Flight. *History of Architecture on the Comparative Method for Students, Craftsmen, and Amateurs.* 18th ed. Revised by J. C. Palmes. New York: Charles Scribner's Sons, 1975.

25. Fournier, Robert. *Illustrated Dictionary of Pottery Form.* New York: Van Nostrand Reinhold, 1981.

26. Gloag, John. *Short Dictionary of Furniture: Containing over 2,600 Entries that Include Terms and Names Used in Britain and the United States of America.* Rev. and enl. ed. London: George Allen and Unwin, Ltd., 1969.

27. Grimwade, Arthur. *London Goldsmiths 1697–1837: Their Marks and Lives from the Original Registers at Goldsmiths' Hall and Other Sources.* London: Faber & Faber, 1976.

28. Grow, Lawrence, comp. *Old House Catalogue: 2,500 Products, Services, and Suppliers for Restoring, Decorating, and Furnishing the Period House, from Early American to 1930s Modern.* New York: Universe Books, 1976.

29. *Guides to Exhibited Artists.* Santa Barbara, Calif.: ABC-Clio, 1985. 5 vols. Vol. 1, European Painters; Vol. 2, North American Painters; Vol. 3, Printmakers; Vol. 4, Sculptors; Vol. 5, Craftsmen.

30. Hainworth, Henry. *Collector's Dictionary.* London and Boston: Routledge and Kegan Paul, 1981.

31. Hall, James. *Dictionary of Subjects and Symbols in Art.* New York: Harper & Row, 1974.

32. Hamer, Frank. *Potter's Dictionary of Materials and Techniques.* New York: Watson-Guptill, 1975.

33. Harling, Robert, ed. *Studio Dictionary of Design and Decoration.* New York: Viking Press, 1973.

34. Harris, Cyril M., ed. *Historic Architecture Sourcebook.* New ed. New York: McGraw-Hill, 1977.

35. Harris, John, and Lever, Jill. *Illustrated Glossary of Architecture, 850–1830.* New York: Clarkson N. Potter, 1966.

36. Hill, Ann, ed. *Visual Dictionary of Art.* Greenwich, Conn.: New York Graphic Society, 1974.

37. Hinckley, F. Lewis. *Directory of Antique French Furniture, 1735–1800.* New York: Crown Publishers, 1967.

38. Jackson, Charles James. *English Goldsmiths and Their Marks: A History of the Goldsmiths and Plate Workers of England, Ireland, and Scotland.* 2d ed., 1921. Reprinted. New York: Dover Publishers, 1964.

39. Jobes, Gertrude. *Dictionary of Mythology, Folklore, and Symbols.* 3 vols. New York: Scarecrow Press, 1961.

40. Joy, Edward. *Pictorial Dictionary of British 19th-Century Furniture Design.* Woodbridge, Suffolk, England: Antique Collectors' Club, Ltd., 1977.

41. Kovel, Ralph and Terry. *Directory of American Silver, Pewter, and Silver Plate.* New York: Crown Publishers, 1961.

42. Kovel, Ralph and Terry. *New Dictionary of Marks: Pottery and Porcelain, 1850-Present.* New York: Crown Publishers, 1985.

43. La Mancusa, Katherine C., ed. *Source Book for Art Teachers.* Scranton, Penna.: International Textbook Company, 1968.

44. Lake, Carlton, and Maillard, Robert, eds. *Dictionary of Modern Painting.* Translated by Lawrence Samuelson, et al. 3rd ed., rev. New York: Tudor Publishing Company, 1964.

45. Lucie-Smith, Edward. *Thames and Hudson Dictionary of Art Terms.* London: Thames and Hudson, 1984.

46. McCulloch, Alan. *Encyclopedia of Australian Art.* London: Hutchinson, 1969.

47. MacKay, James. *Dictionary of Western Sculpture in Bronze.* Woodbridge, Suffolk, England: Antique Collectors' Club, Ltd., 1969.

48. Maillard, Robert, et al., eds. *Dictionary of Modern Sculpture.* Translated from the French. New York: Tudor Publishing Company, 1962.

49. Montgomery, Florence. *Textiles in America, 1650–1870.* New York: W. W. Norton, 1984.

50. Moskowitz, Ira. *Great Drawings of All Time.* 4 vols. New York: Shorewood Publishers, 1962.

51. Munsterberg, Hugo. *Dictionary of Chinese and Japanese Art.* New York: Hacker Art Books, 1981.

52. Murray, Peter, and Murray, Linda. *Dictionary of Art and Artists.* Baltimore: Penguin Books, 1959.

53. Newman, Harold. *Illustrated Dictionary of Glass: With an Introductory Survey of the History of Glass-Making.* London: Thames and Hudson, 1977.

54. Ormond, Richard, and Rogers, Malcolm, eds. *Dictionary of British Portraiture.* 4 vols. projected. New York: Oxford University Press, 1980 to date.

55. Osborne, Harold, ed. *Oxford Companion to Art*. Oxford, England: Clarendon Press, 1970.
56. Osborne, Harold, ed. *Oxford Companion to the Decorative Arts*. London, England: Oxford University Press, 1975.
57. Osborne, Harold, ed. *Oxford Companion to Twentieth-Century Art*. New York: Oxford University Press, 1981.
58. *Phaidon Dictionary of Twentieth-Century Art*. 2d ed. Oxford, England: Phaidon, 1978.
59. Phillips, Phoebe. *Encyclopedia of Glass*. London: Phillips/Heinemann; New York: Crown Publishers, 1981.
60. Pierce, James Smith. *From Abacus to Zeus: A Handbook of Art History*. 2d ed. Englewood Cliffs, N.J.: Prentice-Hall, 1977.
61. Polon, David D., ed. *Dictionary of Architectural Abbreviations, Signs, and Symbols*. Odyssey Science Library. New York: Odyssey, 1965.
62. Preston, Percy. *Dictionary of Pictorial Subjects from Classical Literature: A Guide to their Identification in Works of Art*. New York: Charles Scribner's Sons, 1983.
63. Putnam, R. E., and Carlson, G. E. *Architectural and Building Trades Dictionary*. 3rd ed. New York: Van Nostrand Reinhold, 1983.
64. Rainwater, Dorothy T. *Encyclopedia of American Silver Manufacturers*. New York: Crown Publishers, 1975.
65. Reynolds, Kimberly, and Seddon, Richard. *Illustrated Dictionary of Art Terms: A Handbook for the Artist and Art Lover*. New York: Peter Bedrick Books, 1984.
66. Savage, George, and Newman, Harold. *Illustrated Dictionary of Ceramics: Defining 3,054 Terms Relating to Wares, Materials, Processes, Styles, Patterns, & Shapes . . .* New York: Van Nostrand Reinhold, 1974.
67. Saylor, Henry Hodgman. *Dictionary of Architecture*. New York: John Wiley & Sons, 1952.
68. Scott, Michael. *Crafts Business Encyclopedia*. New York: Harcourt Brace Jovanovich, 1977.
69. Siren, Osvald. *Chinese Painting: Leading Masters and Principles*. 7 vols. 1956 ed. reprinted. New York: Hacker Art Books, 1974.
70. Stafford, Maureen, and Ware, Dora. *Illustrated Dictionary of Ornament*. New York: St. Martin's Press, 1974.
71. Stangos, Nikos, ed. *Thames and Hudson Dictionary of Art and Artists*. Rev. ed. London: Thames and Hudson, 1984.
72. Stevenson, George A. *Graphic Arts Encyclopedia*. New York: McGraw-Hill, 1968.
73. Stroebel, Leslie, and Todd, Hollis N. *Dictionary of Contemporary Photography*. Dobbs Ferry, N.Y.: Morgan and Morgan, 1974.
74. Sturgis, Russell. *Dictionary of Architecture and Building, Biographical, Historical, and Descriptive*. 1902 ed. Reprint. Detroit: Gale Research Co., 1966.
75. Taubes, Frederic. *Painter's Dictionary of Materials and Methods*. New York: Watson-Guptill, 1971.
76. Thieme, Ulrich, and Becker, Felix. *Allgemeines Lexikon der bildenden Kunstler von der Antike bis zur Gegenwart*. Leipzig, Germany: Seemann, 1907–1950.

77. Tufts, Eleanor. *Our Hidden Heritage: Five Centuries of Women Artists*. London: Paddington Press, 1974.

78. Urdang, Laurence, and Abate, Frank R. *Fine and Applied Art Terms Index*. Detroit: Gale Research Co., 1983.

79. Verhelst, Wilbert. *Sculpture: Tools, Materials, and Techniques*. Englewood Cliffs, N.J.: Prentice-Hall, 1973.

80. Vollmer, Hans. *Allgemeines Lexikon der bildenden Kunstler des XX. Jahrhunderts*. Leipzig, Germany: Seemann, 1953–1962.

81. Walker, John Albert. *Glossary of Art, Architecture, and Design Since 1945*. 2d rev. ed. Hamden, Conn.: Linnet Books, 1977.

82. Warman, P. S. *Antiques and Their Prices*. 15th ed. Elkins Park, Penna.: Warman Publishing Company, 1980.

83. Waterhouse, Ellis K. *Dictionary of British 18th-Century Art*. Woodbridge, Suffolk, England: Antique Collectors' Club, Ltd., 1981.

84. Weiss, Lillian. *Concise Dictionary of Interior Decorating*. Garden City, N.Y.: Doubleday, 1973.

85. Woodhouse, Charles Platten. *Victoriana Collector's Handbook*. New York: St. Martin's Press, 1970.

86. Young, Dennis. *Encyclopedia of Antique Restoration and Maintenance*. With an introduction by Dennis Young. 1st American ed. New York: Clarkson N. Potter/Crown Publishers, 1974.

87. Zigrosser, Carl, and Gaehde, Christa M. *Guide to the Collecting and Care of Original Prints*. New York: Crown Publishers, 1965.

C. ENCYCLOPEDIAS

1. Aronson, Joseph. *Encyclopedia of Furniture*. 3rd ed. New York: Crown Publishers, 1965.

2. Berlye, Milton K. *Encyclopedia of Working with Glass*. Dobbs Ferry, N.Y.: Oceana Publications, 1968.

3. Bishop, Robert, and Coblentz, Patricia. *World of Antiques, Art, and Architecture in Victorian America*. New York: E. P. Dutton, 1979.

4. *Britannica Encyclopedia of American Art*. Chicago: Encyclopedia Britannica Corp., 1973.

5. Cameron, Elisabeth. *Encyclopedia of Pottery and Porcelain: 1800–1960*. New York: Facts on File, 1985.

6. Chaffers, William. *Marks and Monograms on European and Oriental Pottery and Porcelain*. 15th ed. rev. 2 vols. New York: Dover Publications, 1965.

7. Di Valentin, Maria and Di Valentin, Louis. *Practical Encyclopedia of Crafts*. New York: Sterling Publishing Co., 1970.

8. Dizik, A. Allen. *Encyclopedia of Interior Design and Decoration*. Burbank, Calif.: Stratford House, 1976.

9. Durdik, Jan, et al. *Pictorial Encyclopedia of Antiques*. New York: Hamlyn, 1970.

10. *Encyclopedia of World Art*. New York: McGraw-Hill, 1958.

11. Evans, Paul E. *Art Pottery of the United States: An Encyclopedia of Producers and Their Marks*. New York: Charles Scribner's Sons, 1964.

12. Flemming, Ernst Richard. *Encyclopaedia of Textiles: Decorative Fabrics from An-*

tiquity to the Beginning of the 19th Century, including the Far East and Peru. New York: Praeger, 1958.

13. *Focal Encyclopedia of Photography.* 2 vols. Englewood Cliffs, N.J.: Prentice-Hall, 1974.

14. Garner, Philippe, ed. *Encyclopedia of Decorative Arts, 1890–1940.* New York: Van Nostrand Reinhold, 1979.

15. Godden, Geoffrey A. *Encyclopedia of British Pottery and Porcelain Marks.* New York: Crown Publishers, 1964.

16. Gowing, Sir Lawrence, gen. ed. *Encyclopedia of Visual Art.* 10 vols. American ed. Danbury, Conn.: Grolier Educational Publishers, 1983.

17. Guedes, Pedro, ed. *Encyclopedia of Architectural Technology.* New York: McGraw-Hill, 1979.

18. Haneman, John Theodore. *Pictorial Encyclopedia of Historic Architectural Details and Elements.* New York: Dover Publications, 1984.

19. Horn, Maurice. *World Encyclopedia of Comics.* 2 vols. New York: Chelsea House, 1976.

20. Hunt, William Dudley, Jr. *Encyclopedia of American Architecture.* New York: McGraw-Hill, 1980.

21. Huyghe, René, ed. *Larousse Encyclopedia of Byzantine and Medieval Art.* New York: Prometheus Press, 1963.

22. Huyghe, René, ed. *Larousse Encyclopedia of Modern Art, from 1800 to the Present Day.* New York: Prometheus Press, 1965.

23. Huyghe, René, ed. *Larousse Encyclopedia of Prehistoric and Ancient Art.* New York: Prometheus Press, 1967.

24. Huyghe, René, ed. *Larousse Encyclopedia of Renaissance and Baroque Art.* New York: Prometheus Press, 1964.

25. Lockwood, Luke Vincent. *Colonial Furniture in America.* 3rd ed. 2 vols. in 1. New York: Castle Books, 1967.

26. *McGraw-Hill Dictionary of Art.* 5 vols. New York: McGraw-Hill, 1969.

27. Meister, Michael W., ed. *Encyclopaedia of Indian Temple Architecture: South India, Lower Dravidadesa, 200 B.C.-A.D. 1324.* 2 vols. Philadelphia, Penn.: University of Pennsylvania Press, 1983.

28. Myers, Bernard S. *Encyclopedia of Painting.* 4th rev. ed. New York: Crown Publishers, 1979.

29. Norwich, John Julius. *World Atlas of Architecture.* 2d ed. Boston: G. K. Hall, 1984.

30. Nutting, Wallace. *Furniture Treasury (Mostly of American Origin).* 3 vols. in 2. New York: Macmillan, 1928.

31. Papworth, Wyatt, ed. *Encyclopedia of Architecture: Historical, Theoretical, and Practical,* by Joseph Gwilt. Rev. ed. New York: Crown Publishers, 1982.

32. Passeron, Rene, ed. *Phaidon Encyclopedia of Surrealism.* London: Phaidon, 1978.

33. Pehnt, Wolfgang, et al., eds. *Encyclopedia of Modern Architecture.* New York: H. N. Abrams, 1964.

34. *Picture Reference File: A Pictorial Encyclopedia in 25 Volumes.* (Plus index volume.) New York: Hart, 1976 to date.

35. Placzek, Adolf K., ed. *Macmillan Encyclopedia of Architects.* 4 vols. New York: Macmillan Publishing Co., Free Press, 1982.

36. Pothorn, Herbert. *Architectural Styles: An Historical Guide to World Design*. New York: Facts on File, 1982.
37. *Praeger Encyclopedia of Art*. 5 vols. New York: Praeger Publishers, 1971.
38. Quick, John, *Artists' and Illustrators' Encyclopedia*. 2d ed. New York: McGraw-Hill, 1977.
39. *Random House Encyclopedia of Antiques*. New York: Random House, 1973.
40. Richard, Lionel, ed. *Phaidon Encyclopedia of Expressionism*. London: Phaidon, 1978.
41. Roentgen, Robert E. *Marks on German, Bohemian, and Austrian Porcelain 1710 to the Present*. Exton, Penna.: Schiffer, 1981.
42. Rose, Grace Berne. *Illustrated Encyclopedia of Crafts and How to Master Them*. Garden City, N.Y.: Doubleday, 1978.
43. Runes, Dagobert, and Schrickel, Harry G. *Encyclopedia of the Arts*. 1946 ed. Reprinted. Detroit: Gale Research Co., 1982.
44. Sanderson, Warren, ed. *International Handbook of Contemporary Developments in Architecture*. Westport, Conn.: Greenwood Press, 1981.
45. Schiller, Gertrude. *Iconography of Christian Art*. 2 vols. Greenwich, Conn.: New York Graphic Society, 1972.
46. Serullaz, Maurice, ed. *Phaidon Encyclopedia of Impressionism*. London: Phaidon, 1978.
47. Stierlin, Henri. *Encyclopedia of World Architecture*. New York: Van Nostrand Reinhold, 1983.
48. Torbet, Laura, ed. *Encyclopedia of Crafts*. New York: Charles Scribner's Sons, 1980.
49. *TypEncyclopedia: A User's Guide to Better Typography*. Bowker's Composition Series, vol. 1. New York: R. R. Bowker, 1984.
50. Walker, Lester. *American Shelter: An Illustrated Encyclopedia of the American Home*. Woodstock, N.Y.: Overlook Press, 1981.

D. DIRECTORIES

1. Abse, Joan. *Art Galleries of Britain and Ireland: A Guide to their Collections*. Cranbury, N.J.: Fairleigh Dickinson University Press, 1976.
2. *American Art Directory*. Biennial. New York: R. R. Bowker, 1936/37—.
3. American Federation of Arts. *American Art Annual*. Vols. 1–36, pt.1. New York: Macmillan, 1898–1935.
4. American Institute of Architects. *American Architects Directory*. 2d edition. New York: R. R. Bowker, 1962.
5. *American Register of Printing and Graphic Arts Services, 1981*. San Francisco: In-Register, Inc. 1981.
6. Amstutz, Walter. *Who's Who in Graphic Art*. 2d ed. Zurich, Switzerland: Amstutz & Herdeg Graphis Press, 1983.
7. *Art in America Annual Guide to Galleries, Museums, Artists*. 1st ed. to date. New York: Neal-Schuman, 1982 to date.
8. Berman, Esme. *Art and Artists of South Africa: An Illustrated Biographical Dictionary and Historical Survey of Painters, Sculptors, and Graphic Artists since 1875*. Rotterdam, Netherlands: A. A. Balkema, 1983.

9. Bernt, Walther. *Netherlandish Painters of the 17th Century*. 3 vols. Translated from the 3rd German ed. London: Phaidon, 1970.

10. Bjerkoe, Ethel Hall. *Cabinetmakers of America*. Rev. ed. Exton, Penna.: Schiffer, 1978.

11. Bradshaw, David N., ed. *World Photography Sources*. New York: Directories, distributed by R. R. Bowker, 1982.

12. Browne, Turner, and Partnow, Elaine. *Macmillan Biographical Encyclopedia of Photographic Artists and Innovators*. New York: Macmillan, 1983.

13. Bryan, Michael. *Bryan's Dictionary of Painters and Engravers*. 1926–1934 ed. Enl. and rev. by George C. Williamson. 5 vols. Reprint. New York: Kennikat Press, 1964.

14. Burbidge, R. Brinsley. *Dictionary of British Flower, Fruit, and Still Life Painters*. 2 vols. London: A. & C. Black, 1981–1982.

15. Canaday, John Edwin. *Lives of the Painters*. New York: W. W. Norton, 1969.

16. Caplan, H. H. *Classified Directory of Artists' Signatures, Symbols, and Monograms*. Rev. ed. Detroit: Gale Research Co., 1982.

17. Cederholm, Theresa Dickason. *Afro-American Artists: A Bio-Bibliographical Directory*. Boston: Boston Public Library Trustees, 1973.

18. Collins, Jim, and Opitz, Glenn B. *Women Artists in America, 18th Century to the Present (1790–1980)*. 3 vols. in 1. Rev., enlarged ed. Poughkeepsie, N.Y.: Apollo Books, 1980.

19. Colvin, Howard. *Biographical Dictionary of British Architects, 1600–1840*. Rev. and enl. New York: Facts on File, 1980.

20. *Contemporary Designers*. Detroit: Gale Research Co., 1984.

21. Coysh, Arthur Wilfred. *Antique Buyer's Dictionary of Names*. New York: Praeger Publishers, 1970.

22. *Creative Canada: A Biographical Dictionary of Twentieth-Century Creative and Performing Artists*. Toronto: University of Toronto Press, 1971 to date.

23. Cummings, Paul. *Dictionary of Contemporary American Artists*. 4th ed. New York: St. Martin's Press, 1982.

24. Cummings, Paul, ed. *Fine Arts Marketplace*. Annual. New York: R. R. Bowker, 1973/74 to date.

25. Darmstadter, Robert. *Lives of Artists: A Biographical Dictionary*. New York: Abaris Books, 1982.

26. DeLauris, Nancy. *Slide Buyer's Guide*. New York: College Art Association of America, 1974.

27. *Directory of Arts and Crafts Materials*. Annual. Chicago: Art Material Trade News, 1961 to date.

28. Emanuel, Muriel, et al. *Contemporary Artists*. 2d ed. New York: St. Martin's Press, 1983.

29. Engen, Rodney K. *Dictionary of Victorian Engravers, Print Publishers and Their Works*. Cambridge, England: Chadwyck-Healey; Teaneck, N.J.: Somerset House, 1979.

30. Evans, Hilary; Evans, Mary; and Nelki, Andra, eds. *Picture Researcher's Handbook: An International Guide to Picture Sources—and How to Use Them*. New York: Charles Scribner's Sons, 1975.

31. Fielding, Mantle. *Dictionary of American Painters, Sculptors, and Engravers*. Enl. ed. by G. B. Opitz. Poughkeepsie, N.Y.: Apollo Books, 1983.

32. Foreman, Mary D., and Fundaburk, Emma Lila. *Pocket Guide to the Location of Art in the United States.* Luverne, Ala.: Fundaburk, 1977.

33. Foskett, Daphne. *Dictionary of British Miniature Painters.* 2 vols. New York: Praeger, 1972.

34. Foster, J. J. *Dictionary of Painters of Miniatures (1525–1850).* London: Allen, 1926.

35. Grant, Maurice H. *Dictionary of British Sculptors from the XIIIth Century to the XXth Century.* London: Rockliff, 1953.

36. Gunnis, Rupert. *Dictionary of British Sculptors, 1660–1851.* Rev. ed. London: The Abbey Library, 1968.

37. Hammond, Dorothy. *Pictorial Price Guide to American Antiques.* 6th ed. New York: E. P. Dutton, 1984.

38. Harvey, John H. *English Medieval Architects: A Biographical Dictionary Down to 1550.* London: Batsford, 1954.

39. Havlice, Patricia Pate. *Index to Artistic Biography.* 2 vols. Metuchen, N.J.: Scarecrow Press, 1973.

40. Havlice, Patricia Pate. *Index to Artistic Biography: First Supplement.* Metuchen, N.J.: Scarecrow Press, 1981.

41. Hinckley, F. Lewis. *Directory of Antique French Furniture, 1735–1800.* New York: Crown Publishers, 1967.

42. Hoffberg, Judith W., and Hess, Stanley W., eds. *Directory of Art Libraries and Visual Resource Collections in North America.* Published for the Art Libraries Society of North America. New York: Neal-Schuman, 1978.

43. Holden, Donald. *Art Career Guide.* 4th ed. New York: Watson-Guptill, 1983.

44. Honour, Hugh. *Cabinet Makers and Furniture Designers.* 1st American ed. New York: Putnam, 1969.

45. Houfe, Simon. *Dictionary of British Book Illustrators and Caricaturists 1800–1914.* Woodbridge, Suffolk, England: Antique Collectors' Club, Ltd., 1978.

46. Hunnisett, Basil. *Dictionary of British Steel Engravers.* London: A. & C. Black, 1980.

47. Hunt, William Dudley, Jr. *American Architecture: A Field Guide to the Most Important Examples.* New York: Harper & Row, 1984.

48. *Interior Decorator's Handbook.* Variable frequency. New York: Clifford and Lawton, Inc., 1922 to date.

49. *International Directory of Arts.* Biennial. 1st ed., to date. Berlin, Germany: Deutsche Zentral-Druckerei, 1952 to date.

50. *International Photography Index.* Annual. Vol. 1, to date. Boston: G. K. Hall, 1979 to date.

51. Jervis, Simon. *Facts on File Dictionary of Design and Designers.* New York: Facts on File, 1984.

52. Kay, Ernest, ed. *International Who's Who in Art and Antiques.* Irregular. Cambridge, England: Melrose Press, 1972 to date.

53. *Larousse Dictionary of Painters.* Translated from French. New York: Larousse, 1981.

54. Lubell, Cecil, ed. *France: An Illustrated Guide to Textile Collections in French Museums.* Textile Collections of the World, vol. 3. New York: Van Nostrand Reinhold, 1977.

55. Lubell, Cecil, ed. *United Kingdom and Ireland: An Illustrated Guide to the Textile*

Collections in the United Kingdom and Ireland. Textile Collections of the World, vol. 2. New York: Van Nostrand Reinhold, 1976.

56. Lubell, Cecil, ed. *United States and Canada: An Illustrated Guide to the Textile Collections in United States and Canadian Museums.* Textile Collections of the World, vol. 1. New York: Van Nostrand Reinhold, 1976.

57. McDonald, Colin S. *Dictionary of Canadian Artists.* Ottawa: Canadian Paperbacks, 1967 to date.

58. McGlauflin, Alice Coe. *Dictionary of American Artists.* Poughkeepsie, N.Y.: Apollo Books, 1983.

59. Mallalieu, H. L. *Dictionary of British Watercolour Artists up to 1920.* 2 vols. Woodbridge, Suffolk, England: Antique Collectors' Club, Ltd., 1976.

60. Mallett, Daniel Trowbridge. *Mallett's Index of Artists, International-Biographical.* New York: Peter Smith, 1948.

61. Marks, Claude. *World Artists 1950–1980.* New York: H. W. Wilson, 1984.

62. Mathews, Oliver. *Early Photographs and Early Photographers: A Survey in Dictionary Form.* London: Reedminster, 1973.

63. Micklethwait, Lucy, and Pippin, Brigid. *Book Illustrators of the Twentieth Century.* New York: Arco Publishing Co., 1984.

64. Millsaps, Daniel, ed. *National Directory of Arts and Education Support by Business Corporations.* 2d ed. Arts Patronage Series, no. 10. Washington, D.C.: Washington International Arts Letter, 1982.

65. Millsaps, Daniel, ed. *National Directory of Arts Support by Private Foundations.* 5th ed. Arts Patronage Series, no. 6. Washington, D.C.: Washington International Arts Letter, 1983.

66. Millsaps, Daniel, ed. *National Directory of Grants and Aid to Individuals in the Arts, International.* 5th ed. Arts Patronage Series, no. 5. Washington, D.C.: Washington International Arts Letter, 1983.

67. Millsaps, Daniel W., ed. *Private Foundations and Business Corporations Active in Arts, Humanities, and Education.* Arts Patronage Series, no. 2. Washington, D.C.: Washington International Arts Letter, 1974.

68. Morgan, Ann, ed. *International Contemporary Arts Directory.* New York: St. Martin's Press, 1984.

69. National Association of Schools of Art. *National Association of Schools of Art Directory.* Annual. New York: National Association of Schools of Art, 1944 to date.

70. Navaretta, Cynthia, ed. *Guide to Women's Art Organizations: Groups/Activities/ Networks/Publications.* New York: Midmarch Associates, 1979.

71. New York Historical Society. *Dictionary of Artists in America, 1564–1860,* edited by George C. Groce and David H. Wallace. New Haven, Conn.: Yale University Press, 1957.

72. Nordness, Lee. *Objects: U.S.A.* New York: Viking Press, 1970.

73. Norman, Jane, and Norman, Theodore. *Traveler's Guide to America's Art.* New York: Meredith Press, 1968.

74. Novotny, Ann, ed. *Picture Sources 3: Collections of Prints and Photographs in the U.S. and Canada.* 3rd ed. New York: Special Libraries Association, 1975.

75. Opitz, Glenn B. *Dictionary of American Artists, Sculptors, and Engravers.* Poughkeepsie, N.Y.: Apollo Books, 1983.

76. Opitz, Glenn B. *Dictionary of American Sculptors*. Poughkeepsie, N.Y.: Apollo Books, 1984.

77. Parry-Crooke, Charlotte. *Contemporary British Artists*. New York: St. Martin's Press, 1979.

78. Petteys, Chris, et al. *Dictionary of Women Artists: An International Dictionary of Women Artists Born Before 1900*. Boston: G. K. Hall, 1985.

79. Prather-Moses, Alice Irma, comp. *International Dictionary of Women Workers in the Decorative Arts: A Historical Survey from the Distant Past to the Early Decades of the Twentieth Century*. Metuchen, N.J.: Scarecrow Press, 1981.

80. Roberts, Laurance P. *Roberts' Guide to Japanese Museums*. Rev. ed. New York: Kodansha International, 1978.

81. Rubinstein, Charlotte Streifer. *American Women Artists: From Early Indian Times to the Present*. Boston: G. K. Hall, 1982.

82. Samuels, Peggy, and Samuels, Harold. *Illustrated Biographical Encyclopedia of the Artists of the American West*. New York: Doubleday, 1976.

83. Schwab, Arnold T. *A Matter of Life and Death: Vital Biographical Facts about Selected American Artists*. Garland Reference Library of the Humanities, no. 90. New York: Garland Publishing, 1978.

84. Sherman, Lila. *Art Museums of America: A Guide to Collections in the United States and Canada*. New York: William Morrow, 1980.

85. Shlien, Helen A. *Artists Associations in the USA: A Descriptive Directory*. Boston: Boston Visual Artists Union, 1977.

86. Smith, Ralph Clifton. *Biographical Index of American Artists*. 1929 ed. Reprinted. Detroit: Gale Research Co., 1976.

87. Smith, Veronica Babington. *International Directory of Exhibiting Artists*. Santa Barbara, Calif.: ABC-Clio Press, 1982.

88. Society of Friends of Eastern Art. *Index of Japanese Painters*. 2d ed. Rutland, Vt.: Charles E. Tuttle Co., Inc., 1958.

89. Soria, Regina. *Dictionary of Nineteenth-Century American Artists in Italy, 1760–1914*. East Brunswick, N.J.: Fairleigh Dickinson University Press. 1982.

90. Souchal, Francois. *French Sculptors of the 17th and 18th Centuries: The Reign of Louis XIV*. 2 vols. Oxford, England: Cassirer, 1977–1981.

91. Tazawa, Yutaka, ed. *Biographical Dictionary of Japanese Art*. Dictionary of Japan, 3. New York: Kodansha International, 1981.

92. Thomas, Brian, and Richardson, Eileen. *Directory of Master Glass-Painters*. Newcastle Upon Tyne, England: Oriel Press for the British Society of Master Glass-Painters, 1972.

93. U. S. National Endowment for the Arts. *Programs of the National Endowment for the Arts*. Annual. Washington, D.C.: National Foundation on the Arts and Humanities, 1968 to date.

94. Walsh, George; Naylor, Colin; and Held, M. *Contemporary Photographers*. New York: St. Martin's Press, 1982.

95. Waters, Clara Erskine Clement. *Women in the Fine Arts, from the Seventh Century B.C. to the Twentieth Century A.D.* 1904 ed. Reprint. Boston: Longwood Press, 1977.

96. Watson-Jones, Virginia. *Directory of American Women Sculptors*. Phoenix, Ariz.: Oryx Press, 1986.

97. Wehle, Harry B., and Bolton, Theodore. *American Miniatures, 1730–1850,*

and a Biographical Dictionary of the Artists. 1927 ed. Reprint. New York: Garden City Publishing Co., 1937.

98. *Who's Who in American Art.* Biennial. New York: R. R. Bowker, 1936/37 to date.
99. *Who's Who in Art.* 1st ed. to date. Irregular. Havant, Hants., England: Art Trade Press, Ltd., 1927 to date. (Distributed in the United States by Gale Research Co., Detroit, Mich.)
100. Withey, Henry F., and Rathburn, Elsie. *Biographical Dictionary of American Architects (deceased).* Los Angeles: Hennessey and Ingalls, 1970.
101. Wood, Christopher. *Dictionary of Victorian Painters: With Guide to Auction Prices, 300 Illustrations, and Index to Artists' Monograms.* Woodbridge, Suffolk, England: Antique Collector's Club, Ltd., 1971.
102. Young, W. *Dictionary of American Artists, Sculptors, and Engravers.* Poughkeepsie, N.Y.: Apollo Books, 1968.

E. HANDBOOKS

1. Abels, Alexander. *Painting: Materials and Methods.* Pitman Art Books, no. 28. New York: Pitman Publishing Corp., 1968.
2. American Institute of Architects. *Handbook of Architectural Practice.* 8th ed. Washington, D.C.: American Institute of Architects, 1958.
3. Amiet, Pierre, et al. *Art in the Ancient World: A Handbook of Styles and Forms.* New York: Rizzoli International, 1981.
4. André, Jean Michel. *Restorer's Handbook of Sculpture.* English translation. New York: Von Nostrand Reinhold, 1977.
5. Bailey, Joyce Waddell, ed. *Handbook of Latin American Art.* 3 vols.; fourth vol. planned. Santa Barbara, Calif.: ABC-Clio, 1984 (in progress).
6. Birrell, Verla Leone. *Textile Arts: A Handbook of Weaving, Braiding, Printing, and Other Textile Techniques.* 1959 ed. Reprinted. New York: Schocken Books, 1973.
7. Brommer, Gerald F. *Drawing: Ideas, Materials, and Techniques.* Rev. ed. Worcester, Mass.: Davis, 1978.
8. Brunner, Felix. *Handbook of Graphic Reproduction Processes.* New York: Hastings House, 1962.
9. Campbell, Alastair. *Graphic Designer's Handbook.* Philadelphia: Running Press, 1983.
10. Chamberlain, Betty. *Artist's Guide to the Art Market.* New ed. New York: Watson-Guptill, 1983.
11. Chieffo, Clifford T. *Contemporary Oil Painter's Handbook.* Englewood Cliffs, N.J.: Prentice-Hall, 1976.
12. Christe, Yves, et al., eds. *Art of the Christian World, A.D. 200–1500: A Handbook of Styles and Forms.* New York: Rizzoli International, 1982.
13. Clarke, Geoffrey. *Sculptor's Manual.* New York: Van Nostrand Reinhold, 1968.
14. Coleman, Ronald L. *Sculpture: A Basic Handbook for Students.* Dubuque, Iowa: W. C. Brown, 1968.
15. Copnall, Bainbridge. *Sculptor's Manual.* Commonwealth and International

Library: Painting, Sculpture, and Fine Arts. New York: Pergamon Press, 1971.

16. Craig, James. *Graphic Design Career Guide.* New York: Watson-Guptill, 1983.
17. De Chiara, Joseph, and Callender, Joseph. *Time-Saver Standards for Building Types.* 2d ed. New York: McGraw-Hill, 1980.
18. Diagram Group. *Designs on File.* New York: Facts on File, 1984.
19. Didron, Adolphe Napoleon. *Christian Iconography: The History of Christian Art in the Middle Ages.* 2 vols. Reprint of English translation. New York: Frederick Ungar, 1965.
20. Faison, S. Lane. *Art Museums of New England.* Boston: David R. Godine, 1982.
21. Field, Janet N., ed. *Graphic Arts Manual.* New York: Arno Press, 1980.
22. Jaspert, W. P.; Berry, W. T.; and Johnson, A. F. *Encyclopedia of Typefaces.* 5th rev. ed. England: Blandford Press. Distributed in the United States by Sterling Publishing Co., New York: 1983.
23. Kaplan, Ellen. *Prints: A Collector's Guide.* New York: Coward-McCann, 1983.
24. Nelson, Glenn C. *Ceramics: A Potter's Handbook.* 4th ed. New York: Holt, Rinehart & Winston, 1978.
25. Packard, Robert T., ed. *Architectural Graphic Standards.* 7th ed. Prepared by the American Institute of Architects. New York: John Wiley and Sons, 1981.
26. Snyder, John. *Commercial Artists' Handbook.* New York: Watson-Guptill, 1973.
27. Weinberger, Norman S. *Encyclopedia of Comparative Letterforms for Artists and Designers.* New York: Art Direction Book Co., 1971.
28. Woodruff, Helen. *Index of Christian Art at Princeton University: A Handbook.* Princeton, N.J.: Princeton University Press, 1942.

F. CATALOGUES

1. American Library Color Slide Company. *Teachers' Manual for the Study of Art History and Related Courses.* New York: American Library Color Slide Company, 1964.
2. American Philosophical Society. *Catalogue of Portraits and Other Works of Art in the Possession of the American Philosophical Society.* Philadelphia: American Philosophical Society, 1961.
3. Bartran, Margaret. *Guide to Color Reproductions.* 2d ed. Metuchen, N.J.: Scarecrow Press, 1971.
4. Besemer, Susan P., and Crosman, Christopher. *From Museums, Galleries, and Studios: A Guide to Artists on Film and Tape.* Art Reference Collection, no. 6. Westport, Conn.: Greenwood Press, 1984.
5. Bober, P. P., and Rubinstein, R. O. *Renaissance Artists and Antique Sculpture: A Handbook of Sources.* London: Harvey Miller, Ltd., 1984.
6. Canadian Centre for Films on Art. *Films on Art: A Source Book.* Comp. and ed. for the American Federation of Arts. New York: Watson-Guptill, 1977.
7. Cushion, J. P., and Honey, W. B. *Handbook of Pottery and Porcelain Marks.* 4th ed. Salem, N.H.: Faber & Faber, 1980.
8. Gardner, Albert Ten Eyck. *American Sculpture: A Catalogue of the Collection of*

the Metropolitan Museum of Art. New York: Metropolitan Museum of Art, 1965.

9. Grow, Lawrence, comp. *Old House Catalogue: 2,500 Products, Services, and Suppliers for Restoring, Decorating, and Furnishing the Period House—from Early American to 1930s Modern.* New York: Universe Books, 1976.

10. Hind, Arthur M. *Early Italian Engraving: A Critical Catalogue, with Complete Reproduction of all the Prints Described.* 7 vols. London: Quaritch, 1938–1948.

11. Hind, Arthur M. *Engraving in England in the Sixteenth and Seventeenth Centuries: A Descriptive Catalogue with Introductions.* 3 vols. Cambridge, England: Cambridge University Press, 1952–1964.

12. Hollstein, F. W. H. *Dutch and Flemish Etchings, Engravings, and Woodcuts: ca. 1450–1700.* 15 vols., to date. Amsterdam, Netherlands: Hertzberger, 1949– (in progress).

13. Hollstein, F. W. H. *German Engravings, Etchings, and Woodcuts: ca. 1400–1700.* Amsterdam, Netherlands: Hertzberger, 1954 to date.

14. Humphrys, Alfred W., comp. *Films on Art.* Washington, D.C.: National Art Education Association, 1966.

15. McCoy, Garnett. *Archives of American Art: A Directory of Resources.* New York: R. R. Bowker, 1972.

16. New York Graphic Society. *Fine Art Reproductions of Old and Modern Masters: A Comprehensive Illustrated Catalogue of Art Through the Ages.* Greenwich, Conn.: New York Graphic Society, 1965.

17. Ready, Barbara C., and McCommons, Richard E. *Architecture Schools in North America.* 3rd ed. Princeton, N.J.: Peterson's Guides, 1983.

18. Smith, Selma. *Printworld Directory of Prints and Prices, 1983.* New York: Printworld, 1983. Distributed by R. R. Bowker.

19. Strauss, Walter L., ed. *Illustrated Bartsch: A Complete Pictorial Catalogue of European Prints from the Fourteenth to the Nineteenth Century.* Vol. 1– (in progress) New York: Abaris Books, 1980 to date.

20. UNESCO. *Catalogue of Colour Reproductions of Paintings Prior to 1860.* 10th ed. New York: UNESCO, 1978. Distributed by Unipub.

21. UNESCO. *Catalogue of Colour Reproductions of Paintings, 1860–1963.* 11th ed. New York: UNESCO, 1981. Distributed by Unipub.

22. Van de Waal, Henry. *Iconclass: An Iconographic Classification System.* 17 vols. Amsterdam, Netherlands: Koninklijke Nederlandse Akademie van Wetenschappen, 1983–1987.

23. Wright, Christopher. *Old Master Paintings in Britain: An Index.* Totowa, N.J.: Sotheby Parke Bernet, 1977.

G. INDEXES TO ILLUSTRATIONS AND REPRODUCTIONS

1. Appel, Marsha C. *Illustration Index, 1967/71–1977/81.* Supplements to *Illustration Index* by Vance, 2d ed., 1966. 3 vols.: 1967/71; 1972/76; 1977/81; designated numbers III, IV, and V. Metuchen, N.J.: Scarecrow Press, 1974–1984.

2. Clapp, Jane. *Art in Life.* New York: Scarecrow Press, 1959.

3. Clapp, Jane. *Sculpture Index.* 2 vols. in 3. Metuchen, N.J.: Scarecrow Press, 1970–1971.

4. Ellis, Jessie Croft. *Index to Illustrations.* Useful Reference Series, no. 95. Boston: F. W. Faxon, 1967.

5. Havlice, Patricia Pate. *Art in Time.* Metuchen, N.J.: Scarecrow Press, 1970.

6. Havlice, Patricia Pate. *World Painting Index.* 2 vols. Metuchen, N.J.: Scarecrow Press, 1977.

7. Hewlett-Woodmere Public Library. *Index to Art Reproductions in Books.* Metuchen, N.J.: Scarecrow Press, 1974.

8. *Index of American Design.* Color microfiche in 10 parts, with consolidated catalogue and indexes. Cambridge, England: Chadwyck-Healey, 1983.

9. Korwin, Yala H. *Index to Two-Dimensional Art Works.* Metuchen, N.J.: Scarecrow Press, 1981

10. Monro, Isabel Stevenson, and Monro, Kate M. *Index to Reproductions of American Paintings: A Guide to Pictures Occurring in More than Eight Hundred Books.* New York: H. W. Wilson, 1948.

11. Monro, Isabel Stevenson, and Monro, Kate M. *Index to Reproductions of European Paintings: A Guide to Pictures in More than Three Hundred Books.* New York: H. W. Wilson, 1956.

12. Moss, Martha. *Photography Books Index: A Subject Guide to Photo Anthologies.* Metuchen, N.J.: Scarecrow Press, 1980.

13. Ohlgren, Thomas M., ed. *Illuminated Manuscripts: An Index to Selected Bodleian Library Color Reproductions.* Garland Reference Library of the Humanities, no. 89. New York: Garland Publishing, 1978.

14. Parry, Pamela Jeffcott. *Contemporary Art and Artists: An Index to Reproductions.* Westport, Conn.: Greenwood Press, 1978.

15. Parry, Pamela Jeffcott. *Print Index: A Guide to Reproductions.* Westport, Conn.: Greenwood Press, 1983.

16. Smith, Lyn Wall, and Wall, Nancy Dustin. *Index to Reproductions of American Paintings.* Metuchen, N.J.: Scarecrow Press, 1977.

17. Vance, Lucile E., and Tracey, Esther M. *Illustration Index.* 2d ed. New York: Scarecrow Press, 1966.

H. PERIODICAL INDEXES

1. *Architectural Index.* Boulder, Colo.: Architectural Index, 1950 to date.

2. *Art Design Photo: An Annual Bibliography on Modern Art, Graphic Design, Photography.* Vol. 1, to date. Hampstead, England: Alexander Davis Publications, 1973 to date.

3. *Art Index.* New York: H. W. Wilson Company, 1929 to date.

4. *ArtBibliographies Modern.* Santa Barbara, Calif.: ABC-Clio Press, 1969 to date.

5. *Arts and Humanities Citation Index.* Semiannual. Philadelphia: Institute for Scientific Information, 1977 to date.

6. Chicago Art Institute, Ryerson Library. *Index to Art Periodicals.* 11 vols. and suppl. Boston: G. K. Hall, 1962.

7. College Art Association of America. *Répertoire International de la Littérature de l'Art: RILA Abstracts.* Williamstown, Mass.: Sterling and Francine Clark Art Institute, 1975 to date.

8. Columbia University, Avery Architectural Library. *Avery Index to Architectural Periodicals.* 2d ed. 15 vols. Boston: G. K. Hall, 1973.

9. Corning Museum of Glass Library. *History and Art of Glass: Index of Periodical Articles, 1956–1979.* Boston: G. K. Hall, 1980.

10. ———. 1st supplement, 1980–1982. Boston: G. K. Hall, 1983.

11. *Design Index.* Edited by Carol S. Nielsen. Vol. 1, no. 1 to date. 3/yr. Evanston, Ill.: Design Information, 1982 to date.

12. *Education Index.* Quarterly, with annual cumulations. New York: H. W. Wilson, 1929 to date.

13. Frick Art Reference Library. *Frick Art Reference Library Original Index to Art Periodicals.* 12 vols. Boston: G. K. Hall, 1983.

14. *LOMA: Literature on Modern Art.* Vol. 1, 1969 to Vol. 3, 1971. Vol. 1 had title *Worldwide Art Book Bulletin.* Continued by *ArtBibliographies Modern* and *Art Design Photo.* Publisher varies.

15. Royal Institute of British Architects Library. *Comprehensive Index to Architectural Periodicals, 1956–1970.* Microfilm. London: World Microfilms, 1971.

16. Royal Institute of British Architects Library. *RIBA Annual Review of Periodical Articles.* London: Royal Institute of British Architects, 1966–1973.

17. Royal Institute of British Architects Library. *Architectural Periodicals Index.* London: British Architectural Library, 1972 to date.

I. SALES INDEXES

1. *Art Sales Index.* Surrey, Kent, England: Art Sales Index, Ltd., 1968 to date.

2. Hislop, Richard, ed. *Auction Prices of American Artists.* 1st ed. to date. 3 vols. to date. Weybridge, Surrey, England: Art Sales Index, Ltd., 1981 to date.

3. Hislop, Richard, ed. *Auction Prices of Impressionist and 20th Century Artists, 1970–1980.* Weybridge, Surrey, England: Art Sales Index, Ltd., 1981.

4. Hislop, Richard, ed. *Auction Prices of 19th Century Artists.* Weybridge, Surrey, England: Art Sales Index, Ltd., 1981.

5. Hislop, Richard, ed. *Auction Prices of Old Masters.* Weybridge, Surrey, England: Art Sales Index, Ltd., 1981.

6. *World Collectors Annuary.* Annual. Vol. 1, to date. New York: W. S. Heinman, 1950 to date.

Appendix A

Comparison of the Library of Congress Classification and the Dewey Decimal Classification for the Visual Arts

This chart is divided into three columns. The first shows the Library of Congress Classification (LCC) for a subject in the visual arts, the second gives a brief description of what is covered under that number or range of numbers, and the third shows the corresponding classification number(s) in the Dewey Decimal Classification (DDC).

This is not a comprehensive listing, as such a catalogue would require another small book by itself. For each broad subject area, inclusive classification numbers are listed, and a partial breakdown of the subject area follows. In some areas, blocks of numbers appear to be left out. These are areas where only selected examples of a category are provided in this synopsis. Since there is not always an exact correspondence, notes are given under some topics to indicate what part of the topic is covered, that there is no equivalent class (NEC), or that the topic is covered within a completely different section of the classification than the rest of the visual arts.

Students using this table should be aware that classifications are sometimes altered by individual libraries to best serve the needs of their clientele. Therefore, occasionally it will be necessary to inquire of the reference staff as to how a particular topic is handled. For general browsing purposes, however, this table can be used as a handy guide for most topics, whichever classification system is in use.

LCC	TOPICS COVERED	DDC
N	VISUAL ARTS IN GENERAL	701–719
1–55	General, Periodicals, Organizations, etc.	701, 705, and 706
61–72	Theory, Philosophy, Aesthetics	701.1–701.17
81–390	Study and Teaching	707
400–4040	Art Museums, Galleries, etc.	708
4390–5098	Exhibitions	708
5200–5299	Private Collections	708
5300–7418	Art History and Biography	709
7420–7525	General Works	709
7420–7525	Criticism	701.18
7560–8266	Special Subjects, Iconography	704.9
8350–8356	Art as a Profession	702.3
8510–8553	Art Studios, Materials, etc.	702.8
8555–8580	Examination and Conservation	708
8600–8675	Economics and Business of Art	706.5
8700–9165	Art and the State, Public Art	710–719
NA	ARCHITECTURE	720–729
1–60	General, Periodicals, Organizations, etc.	720
100–130	Architecture and the State	725
200–1613	History and Biography	722—724
1995–1997	Architecture as a Profession	720
2000–2320	Study and Teaching	720.07
2335–2360	Competitions	720.074
2400–2460	Museums, Exhibitions	720.074
2500–2599	General Technique, Construction	720–720.028
2700–2800	Architectural Design	720–720.028
2810–4050	Details and Decoration	729
4100–8480	Special Classes of Buildings	725–728
4100–4145	Classed by Material	covered in 690s
4150–4160	Classed by Form	with technology
4170–8480	Classed by Use	725–728
4170–7010	Public Buildings	725
4590–6199	Religious, Churches	726
7100–7880	Domestic, Dwellings	728
7910–8125	Clubhouses, Guildhouses	727
8200–8260	Farm Buildings	728
8300–8380	Minor Buildings, Miscellaneous	725.9, 726.9, 727.9, 728.9
9000–9425	Aesthetics of Cities, City and Regional Planning	711
NB	SCULPTURE	730–735
1–50	General, Periodicals, Organizations, etc.	730

LCC	TOPICS COVERED	DDC
60–1115	History and Biography	732–735
1120–1133	Study and Teaching	730.07
1135–1150	General Works, Criticism	730
1160–1195	Design and Technique	731
1199	Restoration of Sculpture	731
1208–1270	Special Materials	736
1272–1291	Motion, Color, etc.	731
1293–1880	Special Forms	731.5
1293–1310	Portrait Sculpture	731.5
1312	Equestrian Statues	731.5
1330–1684	Sculptural Monuments	731.5
1750–1793	Religious Monuments and Shrines	731.5
1800–1880	Sepulchral Monuments	731.5
1910–1950	Special Subjects	731.8
NC	DRAWING, DESIGN, ILLUSTRATION	740–744
1–45	General, Periodicals, Organizations	740
50–376	History and Biography	741.09
390–670	Study and Teaching	740.07
703–725	General Works, Criticism	740
730–757	Technique	742–744
760–825	Special Subjects	743
850–915	Graphic Art Materials	741.2, 744.2
930	Conservation and Restoration	741
950–995.8	Illustration	741.6
997–1003	Commercial Art	741.6
1280	Popular Imagery	741
1300–1766	Pictorial Humor, Caricature, Cartooning, etc.	741
1800–1855	Posters	741
1860–1890	Greeting Cards, Invitations, etc.	741
1920–1940	Copying, Enlarging, and Reduction of Drawings	744.5
ND	PAINTING	750–759
25–47	General, Periodicals, etc.	750–750.27
49–1113	History and Criticism	759
1115–1120	Study and Teaching	750.07
1130–1156	General Works	750–750.27
1290–1460	Special Subjects	753–758
1290–1293	Human Figure	757
1300–1337	Portraits	757.7–757.8
1340–1367	Landscapes	758.1
1370–1373	Marine Painting	758.2
1380–1383	Animals, Birds	758.3
1385–1388	Sports, Hunting, etc.	758.9

LCC	TOPICS COVERED	DDC
1390–1393	Still Life	758.4
1400–1403	Flowers, Fruit	758.42–758.49
1410–1460	Other Subjects	758.5–758.9
1470–1660	Technique and Materials	751.2–751.49
1700–2495	Watercolor Painting	751.422–751.424
2550–2888	Mural Painting	751.73
2890–3416	Illumination of Manuscripts and Books	745.67
NE	PRINT MEDIA	760–769
1–978	Printmaking and Engraving	NEC
1–90	General, Periodicals, etc.	760.1–760.9
218–310	Engraved Portraits	769.42
380	Conservation and Restoration	769.1
390–395	Collected Works	760.1–760.8
400–820	History	769.9
830–885	General Works, Criticism	760.1–760.8
953–962	Special Subjects	769.4
965–965.3	Tradesmen's Cards	769.5
970–973	Study and Teaching	760.07
977–978	Equipment	760.028
1000–1352	Wood Engraving, Woodcuts, Xylography	761
1000–1027	General, Periodicals, etc.	761.1
1030–1200	History	769
1220–1227	General Works, Criticism	761
1310–1325	Japanese Prints	769
1330–1336	Linoleum Block Prints	761.3
1340	Fish Prints	769.4
1350–1352	Other Materials Used in Relief Printing	761.9
1400–1879	Metal Engraving	761.8
1400–1422	General, Periodicals, etc.	761.8
1620–1630	General Works, Criticism	761.8
1634–1749	History	764
1750–1775	Copper Engraving	761.8
1850–1879	Color Prints	764
1940–2230	Etching and Aquatint	765–767
1940–1975	General, Periodicals, etc.	765
		(For etching 767, mezzotint 766.2, aquatint 766.5)
1980–2110	History	765
2120–2135	General Works, Criticism	765
2141–2149	Special Subjects	769.4
2220–2230	Dry Point	767.3
2236–2240	Serigraphy	764.8
2242–2246	Monotype (Printmaking)	764

LCC	TOPICS COVERED	DDC
2250–2570	Lithography	763
2685	Lumiprints	766
2690	Engraving on Glass	748.6
2800–2890	Printing of Engravings	655 under Printing Technology
NK	DECORATIVE ARTS, APPLIED ARTS, DECORATION AND ORNAMENT	730s AND 740s
1–1149	Decorative Arts in General	745
1–570	General, Periodicals, etc.	745
600–1133	History	745
1135–1149	Arts and Crafts Movement	745.444
1160–1678	Decoration and Ornament, Design	745.2–745.9
1160–1170	General, Periodicals, etc.	745.001–745.009
1175–1496	History	745.44
1510–1535	General Works, Criticism	745.01–745.09
1550–1590	Special Subjects	745
1648–1678	Religious Art	704.948
1700–3505	Interior Decoration	746–747, 749
1700–2138	General, Periodicals, etc.	747.09–747.2
2140–2180	Decorative Painting	745.72
2190	Church Decoration	747.8
2200–2750	Furniture	749
2775–2896	Rugs and Carpets	746
2975–3096	Tapestries	746
3175–3296	Upholstery	746
3375–3505	Wallpaper, etc.	747.3
3600–9955	Other Arts and Art Industries	NEC
3700–4695	Ceramics	738
5100–5440	Glass	748
6400–8459	Metalwork	739
8800–9505	Textiles	746
9600–9955	Woodwork	736.4
NX	ARTS IN GENERAL	NEC
Covers visual and performing arts and literature treated together		Treated to some extent in 701–709
TR	PHOTOGRAPHY	770–779

Library of Congress provides an alternate classification for photography as an art form in NH, and it may be located there in some libraries

Appendix B

Printed Equivalents of Online Databases

Many of the online databases available for research evolved from the computer files upon which printed indexes and abstracting services were based, as noted in chapter 3. In some libraries, both printed and online versions are available, and for the researcher with limited financial resources whose information needs are fairly straightforward, these may prove sufficient. This appendix lists bibliographical data for the printed equivalents of those databases. It should also be noted that, in their print versions, many of these sources extend back much further in time than their online counterparts.

America: History and Life. Santa Barbara, Calif.: ABC-Clio, 1964 to date.

ArtBibliographies Modern. Semiannual. Santa Barbara, Calif.: ABC-Clio, 1969 to date.

Art Index. Quarterly, with annual cumulations. New York: H. W. Wilson, 1929 to date.

Biography and Genealogy Master Index. 2d ed. Detroit: Gale Research Co., 1980. Supplements for 1981–1982 (3 vols.), 1983 (2 vols.), and 1984 (1 vol.) Online as *Biography Master Index.*

Current Index to Journals in Education. Monthly. Phoenix, Ariz.: Oryx Press for the National Institute of Education, 1969 to date.

Dissertation Abstracts. Monthly. Ann Arbor, Mich.: University Microfilms International, 1861–1937. Title changed in 1938; see next entry. Online as *Dissertation Abstracts Online.*

Dissertation Abstracts International. Monthly. Ann Arbor, Mich.: University Microfilms International, 1938 to date. Online as *Dissertation Abstracts Online.*

Education Index. Monthly, with quarterly and annual cumulations. New York: H. W. Wilson, 1929 to date.

Historical Abstracts. Quarterly. Santa Barbara, Calif.: ABC-Clio, 1955 to date.

Humanities Index. Formerly *Social Sciences and Humanities Index*, 1965–1974, and *International Index*, 1905–1965. Quarterly, with annual cumulations. New York: H. W. Wilson, 1974 to date.

Magazine Index. Monthly on microfilm. Belmont, Calif.: Information Access Corporation, 1959-March 1970; 1973 to date.

MLA International Bibliography of Books and Articles on the Modern Languages and Literatures. Annual. New York: Modern Language Association of America, 1922 to date. Online as *MLA Bibliography*.

National Newspaper Index. Monthly on microfilm. Belmont, Calif.: Information Access Corporation, 1979 to date. Updated online as *Newsearch*.

Philosopher's Index. Bowling Green, Ohio: Bowling Green State University Press, Philosophy Documentation Center, 1967 to date.

Psychological Abstracts. Monthly, with annual index. Washington, D.C.: American Psychological Association, 1927 to date. Online as *PsycInfo*.

Resources in Education. Monthly, with annual cumulations. National Institute of Education and the ERIC Processing and Reference Facility, 1966 to date. Online as *ERIC*.

Répertoire International de la Littérature Musicale (RILM) Abstracts. 3/year, with annual index. New York: International RILM Center, City University of New York, 1971 to date. Online as *RILM Abstracts*.

Social Science Citation Index. 3/year. Philadelphia: Institute for Scientific Information, 1969 to date. Online as *Social Scisearch*.

Social Sciences Index. Quarterly, with annual cumulations. Formerly *Social Sciences and Humanities Index* 1965–1974, and *International Index* 1905–1964. New York: H. W. Wilson, 1974 to date.

Sociological Abstracts. 5/year, with annual index. San Diego,Calif.: Sociological Abstracts, Inc., 1953 to date.

Index

About the Author

ELIZABETH B. POLLARD is Head of Acquisitions in the Library, and Associate Professor of Bibliography, at the University of Alabama in Huntsville. She has written on art reference sources for *Reference Services Review*.